ICONS

15th Century Paintings

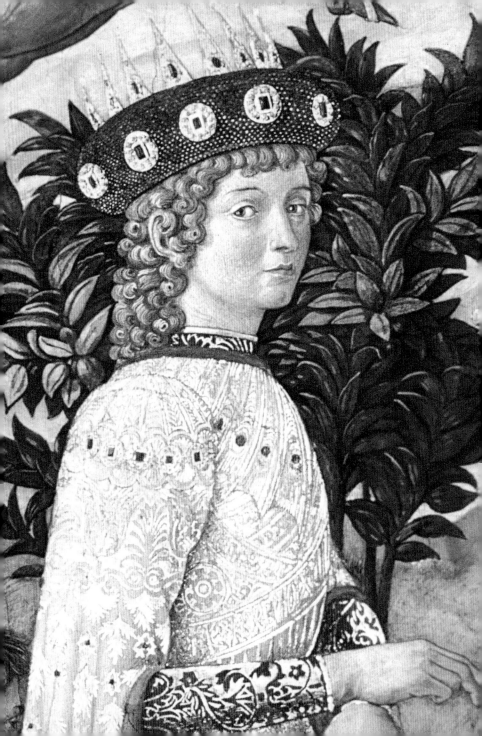

15th Century Paintings

Rose-Marie and Rainer Hagen

TASCHEN

KÖLN LONDON MADRID NEW YORK PARIS TOKYO

Illustration page 2:
Benozzo Gozzoli
Procession of the Magi, 1459
(detail)
Florence, fresco in the chapel
of the Palazzo Medici-Riccardi
Photo: Scala, Florence

© 2001 TASCHEN GmbH
Hohenzollernring 53, D–50672 Köln
www.taschen.com

Cover design: Angelika Taschen, Claudia Frey, Cologne
Design: Catinka Keul, Cologne
English translation: Iain Galbraith, Wiesbaden;
Karen Williams, Whitley Chapel
Editorial coordination: Kathrin Murr, Cologne
Production: Horst Neuzner, Cologne

Printed in Italy
ISBN 3–8228–5551–0

Contents

Preface

What is Christ doing beside Lake Geneva? How did the Florentine banker Tommaso Portinari find his way into an altarpiece by the Flemish artist Hugo van der Goes? Who is the beautiful young woman lying dead on the sand and why are there dogs around her? What was Botticelli really trying to say with his celebration of the birth of Venus? The majority of paintings from the 15th century portray figures from the Bible and the world of mythology, but they also tell us much about the era in which they arose – about the conflicts between ruling forces, about the hopes of the poor, about everyday life, and about the meaning and symbolism which were attached to the past.

The masterpieces selected for this volume are intended not to teach art history, but to focus our attention in each case on a specific image. The authors discuss what we are seeing and provide background information which makes the pictures more accessible. They see each painting not just as a work of art, but as a document of its day. The articles were originally published under the title "What Great Paintings Say" in the magazine *art*.

Upper Rhenish Master: The Little Garden of Paradise, c. 1410

"A garden inclosed is my spouse"

The painting, measuring 26.3 x 33.4 cm, is approximately the size of our reproduction. The work dates from c. 1410, and is now in the Städel, Frankfurt. It shows a detail of a past world: the sequestered corner of a garden within castle walls.

The sole function of castles at that time was to provide protection. Conflicts between nobles were far less likely to be resolved by the emperor or his courts than by attack and defence. Fighting was a part of life at every level of society. The wall in the picture shields the peaceful garden scene from a violent world.

The scene is also secluded from the confusion and discomforts of everyday life: excrement on the roads, stray dogs and pigs everywhere, the stench, cramped gloom and cold of the dwellings, the constant presence of sickness and poverty. The garden idyll shows a pictorial antidote to the hardships endured by the people of the time.

Gardens designed for pleasure were less common in 1410 than today. The first gardens in northern climes dated from the Roman occupation, but these disappeared with the collapse of the Roman Empire and the subsequent chaos of mass migration. With the spread of monastic life the idea of the garden again crossed the Alps, though the new horticulture was generally motivated by pragmatic rather than aesthetic considerations. Spices and medicinal herbs were grown in the cloister quadrangle, at whose centre stood a well. Part of the quadrangle was often set aside as a burial ground for the monks.

Monastic herb gardens soon expanded to include vegetables and fruit. The monasteries spread northward, bringing new agricultural techniques to the rural population and awakening their sympathy for Nature. There is a famous story about Abbot Walahfried, who, from 838, was head of Reichenau Abbey

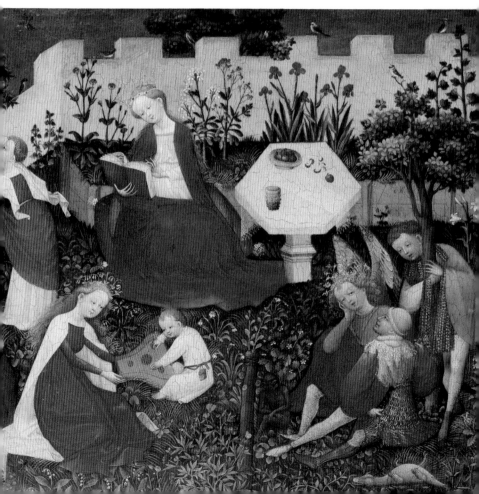

on Lake Constance: "When the seeds sprout tender shoots, Walahfried fetches fresh water in a large vessel and carefully waters the tiny shoots from the cupped palm of his hand so that the seeds are not hurt by a sudden gush of water …"

Abbot Walahfried was mainly concerned with questions of labour and harvesting. It was not until 1200 that the garden was reinvented as a place of relaxation and enjoyment. Beauty emerged as a central criterion: the visitor was to spend his time in a pleasurable manner. Albertus Magnus (c. 1200–1280) of Cologne, a wise and learned father of the church, was a passionate advocate of gardens, and much of his advice relating to their design is found on the present panel. Entitled *The Little Garden of Paradise*, it was executed some two hundred years later by an unknown Upper Rhenish master. According to the 13th-century sage, a garden should have "a raised sward, decked with pleasant flowers … suitable for sitting … and delightful repose". The trees were to stand well apart "for they may otherwise keep out the fresh breeze and thus impair our well-being". A "pleasure garden" should contain "a spring set in stone … for its purity will be a source of much delectation".

The artist has filled the castle garden with holy personages. The largest figure is Mary, wearing her heavenly crown and looking down at a book. She has no throne, but sits on a cushion in front of, and therefore below, the terraced part of the lawn. Contemporary spectators attributed significance to the relative height at which a figure sat. Though Mary was the Queen of Heaven, she was also humble and modest: "Behold the handmaid of the Lord."

Contemporaries of the Upper Rhenish master would have had little trouble naming the other women. They would not have identified

A legend for every saint

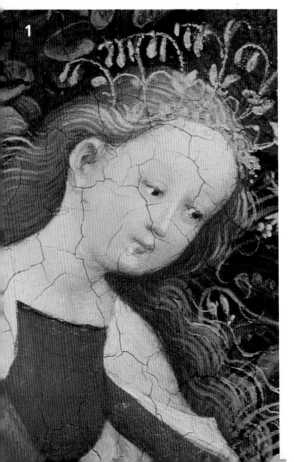

1

them by their faces, however, to each of which the artist has lent the same gentle charm: small, very dark eyes, a small mouth with a spot of shadow under the lower lip.

Saints and other holy persons could be identified by the objects or activities attributed to them. St. Dorothy, for example, is shown with a basket. According to legend, she was asked on her way to a martyr's death to send flowers and fruits from heaven; she prayed before her execution, and immediately a boy appeared with the divine gift – in a basket. Here, beyond the grave, she picks her cherries herself.

A legend was attributed to every saint, so a painting of this kind would have been full of stories to a contemporary spectator. However, some figures may have been more difficult to identify than St. Dorothy. St. Barbara, seen here drawing water from a spring, is shown without her usual attributes: a tower and chalice. Apparently, the artist could not find a place for them in his garden scene. Those who were acquainted with her legend, however, knew that her bones could work miracles, bringing water to dried up rivers and ending droughts. In contrast to the verdant growth of the surrounding garden, the area around the well is dry and stony. A realist might infer that the grass around the well had been trodden down by the many people who came to draw water. However, a pious spectator would recognize

the dry ground referred to in the legend, which the saint waters with a chained spoon to make it fertile.

The woman holding the medieval string intrument, a psaltery, for the child Jesus is probably St. Catherine of Alexandria. It was said that Mary and Jesus appeared to her in a dream. Touching her finger, Jesus had told her he was wedded to her through faith. On waking, she found a ring on her finger. According to medieval belief St. Catherine was closer to Jesus than any woman

but Mary, which explains the position given to her by the artist.

Although the gospels make no reference to Jesus making music, medieval art often portrayed him as a musician. An illumination of c. 1300 shows him playing a violin, while an inscription reads: "Manifold joys Lord Jesus brings, to souls he is the sound of strings." Music was a sign of spiritual, or heavenly joy. The artist, unable to depict bliss by facial expression, chose a stringed instrument as a vehicle instead, a gesture understood by the contemporary spectator.

Like the stringed instrument, many details of the *Little Garden of Paradise* stand for something other than themselves. They are the signs and symbols of a pictorial language with which the majority of people in the Middle Ages were acquainted. Very few people could read at the time; in order to spread the faith, the church therefore needed a language of pictures, or, as we might call it today, a form of non-verbal communication.

Even the garden itself was a symbol, not merely the appropriate scene for a congregation of holy persons. Gardens were synonymous with paradise, presumably because of the Old Testament Garden of Eden. The unknown artist emphasizes the paradisiacal character of the garden by showing flowers in blossom which usually bloom in different seasons. He also avoids any sign of toil, to which Adam and Eve were condemned on their expulsion from the Garden of Eden.

A paradisiacal scene with a wall would be interpreted as a *hortus conclusus*, an enclosed garden. Walls do not usually have a place in paradise, but this one symbolizes Mary's virginity, underlining the special status of "Our Blessed Lady"; for according to Christian belief Mary conceived without penetration. This pictorial symbol, too, derives from the Old Testament, from an image in the *Song of Solomon*: "A garden inclosed is my sister, my spouse…"

Various superimposed layers of imagery interlace and merge in this painting; their independence is not painstakingly defined in the way we might wish it today. Thus paradise is represented not only by the garden but also by Mary herself: like paradise, where sexuality does not exist, Mary's immaculate conception places her in a permanently paradisiacal state. In a paean composed by the poet Conrad of Würzburg, who died in 1287, Mary is "a living paradise filled with many noble flowers".

The table situated in Mary's immediate proximity emphasizes, like the height at which she sits, the Queen of Heaven's modesty, her status as the "handmaid" of God's divine purpose. In practice, the stone-carved hexagonal tables found in

Red rose and
white lily –
flowers in
praise of
Mary

5

modesty, while the white lilies represent the Virgin's purity. The rose was a medieval symbol of the Holy Virgin and, indeed, of virginity in general; the branches with roses have no thorns.

The flowers in this garden would make up a veritable bouquet of virtues – gathered, of course, with the female spectators of the painting in mind.

These signs, allusions and symbols stand for something which eludes direct representation. Modern man has learned to distinguish clearly and coolly between the thing and the symbol. People 500 years ago saw one within the other: Mary was painted as a humble woman, an enclosed garden and a rose, her purity revered in the whiteness of the lily; thus God's history of salvation revealed itself through Nature. A painting of this kind was more than a theological treatise.

How a sinless Madonna could possibly spring from a humanity burdened by original sin and expelled from paradise was a subject which gave rise to much racking of brains. The artist of the *Little Garden of Paradise* makes a contribution to the debate in the form of a tree stump from which grow two new shoots: which is as much as to say that even an old tree can bring forth new life.

To ensure spectators knew the tree stump stood for sinful humanity, the Upper Rhenish master paint-

A tree stump stands for sinful humanity

many paintings of the time were used for picnics and board-games.

Various flowers also characterize the Holy Virgin. In several parts of Germany the primrose – seen at the right edge of the painting – is still known as the *Himmelsschlüssel*, or "key to heaven"; for it was Mary who opened Man's door to heaven. The violets are another symbol of

ed a small devil next to it. To contend that devils, dead dragons or pollarded trees do not really belong in paradise would be to grant inappropriate weight to logic.

The fact that the three figures near the devil and dragon are male can be ascertained from the colour of their faces, which are darker in hue than those of the women. Apart from colour, however, their faces follow the same pattern as those of the women: men and women have the same eyes, the same mouths, and even the same tapering fingers.

Two of the three male figures are easily identified. The one wearing greaves and chain mail is St George who liberated a virginal princess from the power of a dragon. Paintings that show George doing battle with the dragon generally make the mythical beast enormous and threatening; here it is shrunk to little more than a trademark. The angel with the headdress and the beautiful wings is Michael. He it was who hurled devils into the abyss, one of whom sits, well-behaved, at his feet: dragons and devils are powerless in paradise.

The identity of the standing male figure remains obscure, with no hint of the artist's intention. If we look hard enough, however, we find a black bird just behind his knees. Black is the colour of death. Perhaps the panel was painted in memory of a young man who died. Its small format suggests it was in-

tended for a private dwelling rather than a church. The tree around which the young man's arms are clasped appears to grow from his heart – an ancient symbol of eternal life.

On the other hand, it is possible that the young man was St Oswald. In Oswald's legend a raven acts as a divine messenger, carrying away the pious man's right arm when he falls in battle against the heathens. Yet another story! The spectator of 1410 would have found the picture full of stories combining religious teaching and entertainment. As an act of veneration dedicated to the Virgin Mary, the painting itself became an object of reverence, bringing solace to the faithful. It showed a better world in store for those who left this vale of tears. The artistic quality of the painting, so fascinating to today's museum visitor, was undoubtedly admired at the time. In terms of the panel's significance as a religious work, however, it meant relatively little.

Bliss in the life hereafter was not the only subject of paintings like this. Besides the garden of paradise there were also Gardens of Love, celebrations of worldly happiness. These did not depict sensuality in a crude manner, but harked back to the Arcadia of heathen antiquity, itself closely related to the idea of paradise. The effect was to show heaven on earth, so to speak.

The Little Garden of Paradise, c. 1410 15

6

Woodpecker, goldfinch and waxwing

As the subject of religious art, the garden of paradise did not last more than a few decades. By the second half of the 15th century it had practically disappeared: a late blossom, embedded in a medieval language of symbols. The worldly Garden of Love, however, a more readily comprehensible topic, appeared again and again in a variety of different forms. Manet's *Déjeuner sur l'herbe* is a more recent example.

The Garden of Love was a literary topos before it found its way into painting. The most well-known example today is Boccaccio's *Decameron*, written in Florence some 60 years before the *Little Garden of Paradise* was painted in the region of the Upper Rhine. The setting of these works is remarkably similar: the young Florentines tell each other stories in a garden "surrounded by walls", in the middle of which is a

"lawn of fine grass adorned with a thousand brightly coloured flowers" where water gushes from a little fountain "gently splashing … into a wonderfully clear well". Here men and women did not sit apart on their best behaviour, for all who were present "strolled together, weaving the loveliest wreathes of manifold sprigs" and telling each other erotic tales.

The French *Romance of the Rose* predates the Italian *Decameron* by over a century. It also sings of love's joys and complaints, is set in a garden and, like Boccaccio's *Decameron*, was read widely in Europe by the educated élite of the day. In both books, feelings of happiness are accompanied by birdsong. In the *Romance of the Rose* we read: "Their song was comparable to that of the angels in heaven." And only three sentences later: "One was inclined to

believe it was not birdsong at all but the voices of sea-sirens." Whether angels or sirens, divine messengers, or seductresses who were half beast, half human, whether Christian figures or those of antiquity, the example shows the essential ambiguity of all pictorial symbols at the time. Even spectators of a Christian garden of paradise would know that painted birds were there not only to sing God's praises.

The birds in the *Little Garden of Paradise* are rendered accurately. Zoologists have distinguished at least ten different species: great tit, oriole, bullfinch, chaffinch, robin, woodpecker, goldfinch, waxwing, hoopoe and blue tit. Had he been concerned solely with angelic music, the artist might have painted the birds as schematically as the faces of his saints. But he evidently wished to emphasize their variety, just as he did with the plants. He wanted to show what he saw; he wanted to be exact. The plants testify to this, with some 20 identifiable species.

Exact zoological observation betrays an interest in natural science. This was new in a painting of c. 1410. While it is true that birds and flowers were frequently painted with some degree of accuracy, they had rarely been rendered with such a powerful inclination to catalogue empirical data. Medieval painting was usually dominated by religion. While this painting might appear to confirm the rule, it also illustrates a growing awareness of Nature; no longer mere adornment, the distinctive presence of a natural world is felt as strongly here as that of the holy figures. However, it was not until the next century that the first botanic gardens were created in Germany: at Leipzig in 1580, and at Heidelberg in 1597.

The discovery and scientific exploration of Nature were first steps on the long road to modernity. *The Little Garden of Paradise* lends visibility to that phase of intellectual history. However, the beauty of the painting also resides in the harmony, evidently still attainable, between religious and realistic views of the world: two types of experience which did not appear to present the dichotomy felt by Christians in the Western world today.

The Limburg Brothers: February miniature from the "Très Riches Heures du Duc de Berry", c. 1416

A deceptive idyll

The reality was often harsher than the peaceful scene in the picture (15.4 x 13.6 cm): marauding soldiers, fear of wolves in extreme winters, bad harvests, famine and plague were all common features of French peasant life. The miniatures painted by the three Limburg brothers are nonetheless among our most important pictorial records of life in the Middle Ages. The Très Riches Heures is kept in a safe at the Musée Condé, Chantilly, near Paris.

A rolling snowscape beneath a low, overcast sky. In the background a village with a church spire, in the foreground a farm. A man drives a loaded donkey toward the village, another fells a tree. The house in the foreground is open to reveal three figures seated at a hearth. They have lifted their dresses to warm themselves at the fire. The portrayal of French peasant life in the February miniature of the *Très Riches Heures du Duc de Berry* shows a world of peace and harmony. All is well, it seems.

But the real world of the 15th century looked very different from ours, and contemporary spectators probably would not have found the illustration quite as idyllic as we might think it today. Snow, ice and cold were a threat to survival. During a hard winter wolves came out of the forest and attacked the cattle; firewood would be scarce. If a late frost nipped the seed in spring, and the harvest was meagre, famine left people more vulnerable to epidemics. Several hard winters in succession could decimate the population.

Most of the pages in the *Très Riches Heures* were painted between 1408 and 1416, and at least two winters during this period were extreme. Contemporary chroniclers also mention repeated floods and

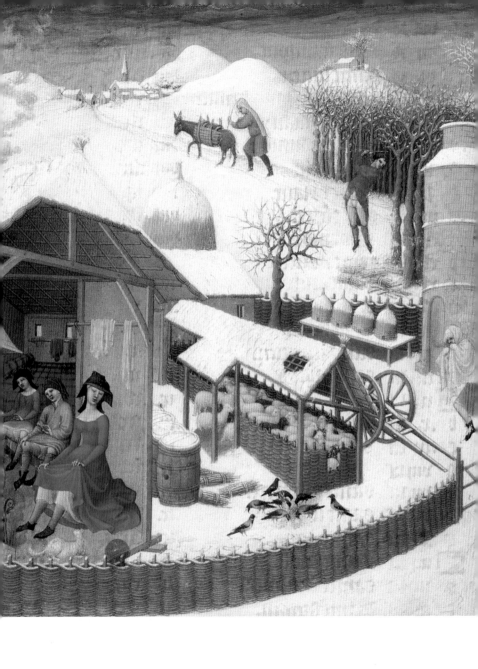

February miniature, c.1416

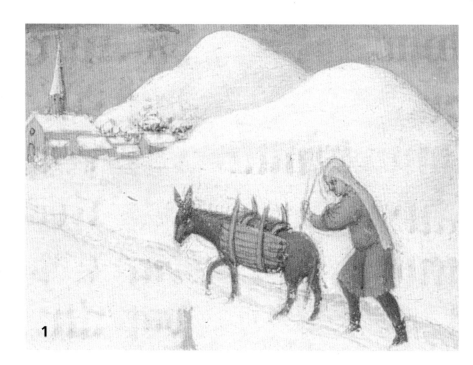

1

A hard life on the land

droughts, as well as hordes of soldiers, skirmishing and full-scale battles. Since 1337 France had been at war with England, whose kings laid claim to the French throne.

War with an external enemy was compounded by internal squabbles. The French king, Charles VI, had become insane in 1392, leaving the mighty of the land to fight among themselves and, often enough, call on the English to help them defeat their rivals.

France was thus in the grip of chaos, its inhabitants exposed to constant threats. Some protection could be found within castles or town walls, but those who dwelt on the land were left to the mercy of marauding soldiers. If they could, the population fled to the forests. To warn them of approaching danger they relied on look-outs posted on church towers who signalled the advance of enemy troops by sounding the bells or blowing horns. Church towers in those days were not only associated with prayer.

The chronicles of the time were commissioned by powerful lords. They therefore contain little or nothing about the life of the peasants; if they appeared at all, they were relegated to decorations in the margins, or to elaborately illuminated initials. Calendar miniatures were

also painted for the rich and mighty. It was the peasants' way of life, however, which best helped illustrate the passing seasons. Thus the most lowly class found its way into European painting. In time, certain motifs became traditionally associated with each month. Some were taken from the courtly world of nobles, but most showed rustic scenes: in February they warm themselves at the hearth; in March they till the soil; in June they harvest the hay.

It has never been satisfactorily explained why the Book of Hours, which was intended for private devotion, should contain twelve calendar pages preceding the religious texts. Was it a reminder of the transience of all earthly things? Was its purpose to illustrate the will of God, manifest in the changing seasons? Perhaps it was merely that the rulers of the land wanted to see pictures of their own contemporaries, their own environment, as well as the more conventional biblical figures. Love of allusions to mythology and astrology may also have played a role. The only thing of which we can be certain is that calendar illustrations are among our most important historical records of the peasants' way of life in the Middle Ages, especially those by the Limburg Brothers, Herman, Jean and Paul. Born in Nijmegen, they worked for the Duc de Berry from about 1405. By 1416, all three were dead, presumably the victims of an epidemic.

It is difficult to make out the donkey's load, but it is probably wood. Only branches and brushwood were burned by the villagers for cooking and heating. Tree-trunks were reserved for the duke's own hearth, or were used to build houses.

The man driving the donkey is wearing a coarse smock, the usual attire of peasants and labourers at the time. He has probably pulled a sack over his head to protect himself from the cold. Unlike the burghers and nobles, he would not be allowed to wear fur; for even if he could afford it, he would be acting in contravention of the sumptuary laws which regulated dress. "The peasant works hard to provide purple for the king," a contemporary verse epic related, "but his own body is scratched by a hemp smock."[1]

Feudal society during the Middle Ages was divided into three orders – nobility, clergy and peasantry: those who fought and received land in reward for their services, those who prayed and preached, and those who produced food for everyone. About 90 percent of the population were peasants and agricultural labourers, the lowest class, who served – much as the donkey served the peasant – as beasts of toil for the ruling classes. "Jacques Bonhomme" was the condescending term for a peasant – something like Honest John, where "honest" means both good-natured and simple-minded. But "Jacques" was not always good-natured. The

first peasants' revolt took place in 1358, and was brutally suppressed.

The rebellion was not directed against the feudal order itself, since this was considered divine right: "The countryman is born to the sieve and the milking pail," as the verse epic cited above puts it, "while the king receives choice dishes and pepper, meats and wine." The reason for the rebellion was the heavy tax imposed by a war-worn aristocracy. Serfdom no longer existed in most regions of France. The peasants were allowed to own the land they worked, but were nonetheless obliged to pay taxes to their various masters: to landowning nobles, to the clergy, and also to the king.

In times of war, when their expenditure increased, the nobles and king not only squeezed more money out of the peasants, but also took corn, meat and fowls. "When the poor man has paid his taxes," the tax collectors return "to take his pots and his straw. The poor man will soon have not a crust left to eat."[2]

At the same time, the villagers were not all equally poor. Research on a village in Picardy shows that two out of ten landowning peasants had a relatively good standard of living, while four others had enough to eat. The remaining four eked out a meagre existence and, like unpropertied (and usually therefore unmarried) labourers, were constantly threatened by hunger.

The confusion of the Hundred Years' War added to their misery. The French Herald at Arms, in dispute with his English counterpart, might proudly proclaim: "We have many things which you do not have … Before all else, we have wine … so much, that our countrymen do not drink beer, they drink wine!"[3]

At the same time, however, an English general, plundering the French countryside with his army, wrote: "The peasants drink only water."[3]

Another traditional February motif, besides peasants warming themselves by the fire, was the man cutting wood. However, the round, grey building on the right of the painting, a dovecot, was more unusual.

Doves were not there to be eaten, at least not primarily so. Nor were they particularly significant as messengers. Their most important function at the time was to produce manure. Pigeon dung, used to fertilise herb gardens, had a higher value than manure produced by sheep, pigs or cattle. It was also essential for sowing hemp. Pigeon manure did not really lose its significance in Europe until the appearance of artificial fertiliser.[4]

Dovecots were therefore fertiliser factories, built according to economic principles. The inner walls provided niches for the nests. The niches started at a certain height above ground level, where the drop-

pings collected, and ended a certain distance from the flight-holes, since doves will not sit near heavily frequented exit-holes. Doves like quiet places which are not too windy; dovecots were therefore built away from the centre of the farmyard, in the lee of a forest if possible – like the one in the painting.

The artists have even included the typical, cornice-like rings around the walls. These were not decorative, but served to protect the doves by hindering entry to the dovecot by rats, weasels or martens.

Although important producers of manure, doves were greatly feared as grain-feeders. Huge flocks of them would descend upon the freshly sown fields and devour the seed. Their numbers were therefore strictly controlled. The simple peasant was allowed to keep only a few pairs nesting under his roof. A separate building for doves was the exclusive prerogative of the landowner. However, he too was required to limit his doves to a number related to the extent of his lands. The rule was one nest per arpent: about one and a quarter acres. These regulations had emerged gradually during the Middle Ages and, by the Duc de Berry's time, the dovecot had become a status symbol: the size of a dovecot indicated the size of its owner's property.

The dovecot's size would have allowed contemporary spectators of the *Très Riches Heures* to deduce that

its painters had not chosen a poor peasant's smallholding as their subject: the buildings shown here must have belonged to a noble landowner.

The law governing the right to dovecot ownership remained in force until the French Revolution.

February miniature, c.1416 23

It was finally repealed, together with a number of other feudal privileges (of more far-reaching consequence), on 4 August 1789. Jacques Bonhomme had asserted his rights.

The beehives ranged on the wooden surface in front of the wicker fence were empty. Every autumn they were held over a smoking fire. The bees suffocated and the honey flowed out, followed by the wax.

At the time, honey was practically the only available sweetener, for only the very rich could afford imported sugar-cane. Wax was used to fashion candles, then considered the finest of all forms of lighting. In spring, the peasants would go into the forest to attract new swarms of bees.

Bees and sheep

The only herd animals to be seen in the painting are sheep. They were the most commonly kept domestic animals on farms in the Middle Ages, for they provided meat, milk and wool and, unlike cows, were able to graze poor ground.

One of the few authentic contemporary accounts by a member of the peasant class[4] states that while hundreds of sheep were raised in a certain village, there were only a dozen milking cows. This ratio was probably fairly typical, and is mentioned by the narrator, Jean de Brie, in connection with an account of his own vocational training, which began when he was seven years old.

For it was then that his childhood came to an end and Jean was expected to look after the village geese. At the age of eight he was entrusted with the pigs: "raw beasts of low discipline". The memories he retained of these animals were anything but

3

fond; he found life with them "unbearable".

At the age of nine he helped the ploughman with his oxen. Later, he looked after the village's twelve milking cows. Finally, at the age of eleven, he was given "80 good-natured, innocent lambs who neither jostled nor hurt" him. He saw himself as their "tutor and guardian", and soon a large herd of 200 ewes and 120 lambs was given into his keeping: Jean's task was to make sure they had food, to shear them, and to protect them from wolves. By the age of fourteen, when few of today's youngsters would even have begun their vocational training, Jean had completed his apprenticeship. Girls, too, were obliged to look after the animals. Joan of Arc was the century's most famous shepherdess.

Of course, the artist may have had quite a different reason – besides their greater numbers – for painting sheep rather than other herd animals. Sheep were loved, not only by shepherd-boys, or for their wide range of practical uses by the peasantry in general, but also by noble ladies.

This was the era of the first pastoral plays, a tradition which became very fashionable during the later Rococo: noble ladies had little, prettily-decorated sheep-stalls built, kept favourite animals, bound ribbons around the necks of their lambs. They played at being shepherdesses, sang songs and received their suitors in the meadows. The housekeeping books of the French court give an exact account of the sum spent in 1398 by Queen Isabelle of Bavaria on her sheep at Saint Ouen: 4000 golden thalers.

Although the miniature depicts the property of a noble landowner, we see neither manor house nor castle. Nor does the painting show us many of the other buildings typically found on such an estate. According to an account written in 1377, a manor would include, as well as stalls and barns, a separate kitchen outhouse with servants' and farm-labourers' quarters, a chapel, and a farmhouse with two rooms for the the factor, or bailiff.

It is the factor's house we see here. Its inhabitants were evidently not poor. Labourers' huts had a fire in the middle of a single room, the smoke rising directly to the roof without passing through a chimney, whereas here a walled fireplace is visible on the left of the interior. Poor people slept on straw sacks, but here a bed is seen in the background. While the poor possessed only one set of clothes, here several pieces of spare clothing are shown hanging on bars along the walls. It is true that the interior contains very little in the way of furniture, but that was the case even in the houses of the very rich.

The three figures sitting in front of the fire have raised their dresses

to warm themselves, the two furthest lifting them so high that their genitals are exposed. The Limburg Brothers were showing nothing out of the ordinary: "Folk in many communities go about almost naked in summer," a contemporary priest complained. "Though they have no hose, they do not fear the gaze of passers-by."[5]

The factor's house

Our own view of the Middle Ages is largely conditioned by pictures commissioned for churches by the clergy. Genitalia, of course, were concealed in these pictures. But Christian doctrines directed against the body and its pleasures were hardly concordant with the behavioural norms of the people themselves. Cramped living space made intimacy unthinkable; whole families sleeping in one bed left little opportunity for privacy. Nor did people show particular concern for the "gaze of passers-by" when relieving themselves. For centuries to come, codes of courtly manners would find it necessary to remind readers that there were better places to urinate than at a window, or on the stairs.

The threshold of shame is not innate, but determined anew in every era, usually by the members of the ruling strata, whose manners and behavioural norms the lower strata adopt. Undoubtedly, this also applied to the degree of nakedness considered appropriate for the lower abdomen. The figures in the background reveal their genitals without the least sign of embarrassment. The lady in the foreground, however, whose finer clothes and bearing suggest a higher class, has raised her dress only slightly. In time, the other two will follow her example.

The Limburgs knew nothing of subliminal processes at work in society. What struck them was the enormous difference between the nobility and the peasantry. Dangers to life and limb also remain largely outside the scope of their painting. Here they show the snow and the cold, but epidemics, armies and civil wars do not feature in their work. They spent much of their time in their chambers at the duke's castle, painting "idyllic" miniatures with the aid of a magnifying glass. Meanwhile, all around them raged a chaos to which they may eventually have fallen victim themselves.

An Italian in Bruges

An aristocratically dressed couple in middle-class surroundings: slippers and clogs lie on the floor, and the woman's artfully pleated train tumbles not onto the gleaming marble tiles of some grand palace but onto plain floorboards. There is much that appears contradictory and mysterious in this panel.

It was executed in 1434 in Bruges, the leading centre of trade in northern Europe. Wood and furs arrived here from Russia and Scandinavia, silks, carpets and spices from merchants in Genoa and Venice, and lemons, figs and oranges from Spain and Portugal. Bruges was a wealthy place, "the most famous city in the world on account of the goods that are traded there and the merchants who live there",[1] according to Philip the Good, Duke of Burgundy from 1419 to 1467. It was the chief port of his own duchy.

Burgundy stretched from the shores of the North Sea right down to the Swiss border, and for several decades was the most powerful political unit in Europe. Its dukes owned many palaces, including one in Bruges, and were lovers of luxury. Recognizing that Burgundy's might rested on the industriousness of its workforce, and in particular on the trading activities and textile industries of the Flemish towns, Philip the Good let his citizens improve their own standard of living and grow wealthy under Burgundian rule.

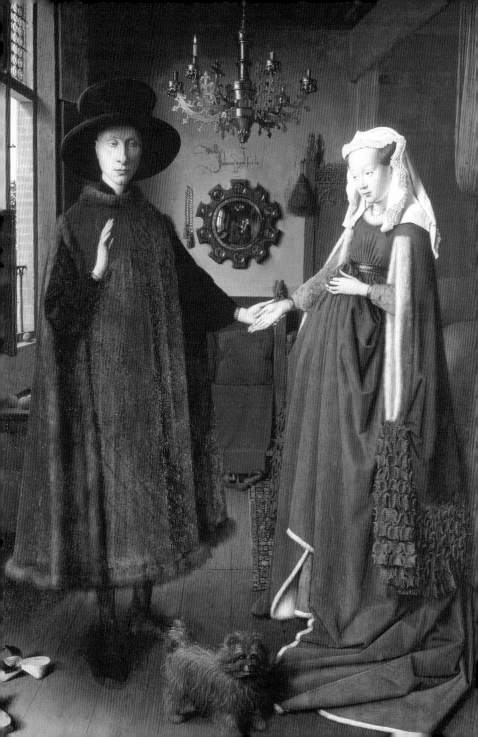

The couple in van Eyck's painting are undoubtedly rich. This is most evident in their clothing: the woman's outer garment, with its voluminous swathes of material, is trimmed with ermine. The folds at the bottom could only have been arranged so skilfully with the help of a maid, and the train, too, would have needed a second person to carry it when moving about. To walk at all in such a dress presupposed a degree of practice normally only acquired in aristocratic circles.

The man is wearing a sumptuous velvet cloak trimmed or even lined with mink or sable. But the cloak is only calf-length and is slit down the sides, allowing movement and activity. The fact that this man does not belong to the aristocracy is indicated by the wooden clogs in front of him, which were slipped on to avoid having to wade through the dirt in the streets. The high and mighty didn't need clogs – they travelled on horseback or were carried in litters.

Van Eyck gives no indication of the identity of his sitters either on the panel or in any other document, and it was only some 100 years after the work was executed that it was described in an inventory as: "A large panel painting, Hernoult le Fin with his wife in a room."[2] Hernoult le Fin was the French version of the Italian surname Arnolfini. The Arnolfinis belonged to a family of merchants and bankers, originally from Lucca, who had opened an office in Bruges.

This foreign businessman was thus living in Bruges in aristocratic luxury. He owned oriental carpets, chandeliers and mirrors; he had glazing in at least the top half of his windows; he could even afford expensive oranges. The room's cramped dimensions, however, are those of a middle-class home. As in all private chambers, the bed is dominant. During the day, the curtains were tied up into a ball; people sat on the edge of the bed and even received visitors lying on top of the covers. At night, the curtains were drawn around the bed to create a new living space, a room within a room. In the Italian city-republics, the middle classes were permitted to live in their own palaces if they could afford it; in the Burgundy of van Eyck's day, however, that was uncommon. Only one man is said to have done it in Bruges – a Florentine compatriot of the Arnolfinis, the manager of the powerful Medici bank.[3]

In the central axis of the composition, on the far wall of the room, hangs a mirror. Its frame is adorned with ten painted medallions containing scenes from the Passion of Christ. Glass mirrors in a middle-class home were unusual in van Eyck's day; people normally made do as best they could with polished metal. Only princely households could afford flat mirrors, which were considered a valuable rarity

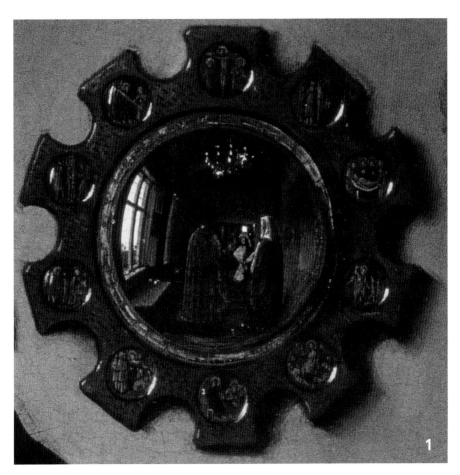

because they were so difficult to manufacture – the crystal base usually shattered when the hot liquid metal was poured over it. It would still be some time before a mixture of mercury and tin was invented which could be applied cold. Augsburg glass-blowers, however, had arrived at an interim solution whereby they poured a metal mixture – evidently heated to not quite such a high temperature – into a glass sphere, and thereby obtained a convex mirror such as the one hanging behind the Arnolfinis.

These curved mirrors were more affordable than flat ones. In French they were called *sorcières*, or "witches", because they magically expanded the viewer's field of vision. In this picture, we can see in the mirror the beams of the ceiling and a second

A mirror with magic properties

The Arnolfini Marriage, 1434

window. Behind us, so to speak, we can see another room, and where we ourselves are standing the mirror shows us two figures who are just entering the room.

This effect was repeated 200 years later by the Spanish painter, Veláz-quez, in the flat mirror which appears in his large canvas *The Maid of Honour*. It is probable that van Eyck's *Arnolfini Marriage* was at that time part of the Spanish Royal Collection, of which Velázquez was the curator.

The woman lays her right hand carefully in the man's left. There is a solemnity to this joining of hands, which the artist places in almost the very centre of the composition and which is thereby lent particular significance. The two figures themselves adopt very formal poses within their everyday surroundings. The woman's train has been carefully arranged, and the man raises his right hand to take the oath. For van Eyck's contemporaries, the joining of hands and the gesture of oath-taking were sure indications that two people were pledging each other their troth.

In the 15th century, you needed neither a priest nor witnesses to enter into a Christian and legal marriage. A wedding could be performed anywhere, including – as here – in a private bedchamber. The sacrament of marriage was conducted not by priests but by husband and wife themselves. To officially announce their marriage, the newly-weds would attend Communion together the following morning, although even this was not compulsory.

Only at the Council of Trent a good century later did the Church succeed in making the attendance of a priest and two witnesses a necessary element of the marriage ceremony. It did so not for religious reasons, but in order to clamp down on the abuse and deception possible under the old system. Even after this, however, the ceremony still did not have to take place before the altar, but at most in front of a church door.

Although witnesses are not required at the Arnolfini wedding, two are nevertheless clearly visible in the mirror. They are needed for a different reason, namely to legalize a written contract of marriage. Such contracts were common where – as here – large amounts of money were involved; they regulated financial matters between the marriage partners and had to be signed by two witnesses.

It may well be that the financial agreement in the present case was particularly important, since this is clearly a "left-handed" marriage. The man takes the woman's hand in his left hand, not his right as was otherwise the convention. Such marriages were concluded between partners of unequal rank, and are still occasionally practised in ruling houses in

Jan van Eyck

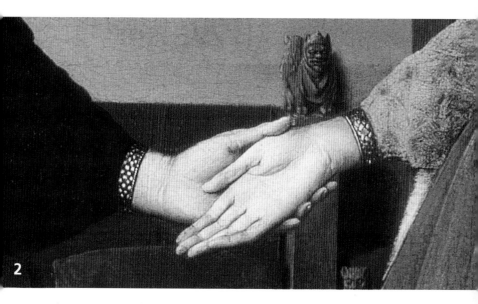

2

our own times. More precisely, it was always the woman who came from the lower class. She had to relinquish all rights of inheritance for herself and her children and thus could not continue the family lineage, but was guaranteed sufficient financial means to support herself in the event of widowhood. These means, or title-deeds relating to them, were originally presented on the morning after the marriage. It is from the Low Latin *morganatica*, meaning a gift from a bridegroom to a bride, that we derive the term more politely given to this sort of union, namely a "morganatic" marriage.

The bride in this painting is not getting married in white – that would only become the convention in the second half of the 19th century – but in her most sumptuous Sunday best. Her bulging figure is not intended to indicate that she is pregnant, but like her small, high-laced bosom illustrates the ideal of beauty held in the Late Gothic era. The copious folds of cloth which she carries with her also reflect the fashion and lavish style of the Burgundian empire – and elsewhere besides. Women dressed in such ample robes and often wearing large bonnets were compared by contemporary writers to ships under full sail, and an unkind French tongue commented that it was hard to distinguish the "empty" vessels from the pregnant ones.[4]

The bride in van Eyck's picture must have been very young. The carved monster above her hand forms part of a seat standing against

**A very
private
ceremony**

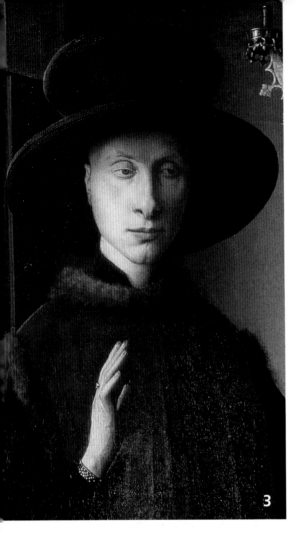

3

**An indust-
rious banker**

ions that were extravagant – so, too, were the men's. They wore elaborately wound turbans or top hats of monstrous proportions. Philip the Good introduced dark colours for official occasions, as worn by Arnolfini here. These would later evolve into the black of Spanish court dress.

The bridegroom's hands are as white and well manicured as those of his bride. His narrow, sloping shoulders also indicate that he does not need physical strength to assert his position in society. Some see hints of a cool, calculating sophistication in his face. It is possible that the French version of his name, Hernoult le fin,[5] is also intended to characterize him – as Hernoult the Refined, the Shrewd.

His forename is sadly missing from the inventory. Around 1434, however, at least two male members of the Arnolfini family were living in Bruges. The more prominent of them, Giovanni di Arrigo Arnolfini, was financial adviser to the Burgundian dukes and the French king, and wed an Italian banker's daughter, Giovanna Cenami, who inherited his estate after his death. This seems to rule out a morganatic marriage. It is possible, however, that his brother Michele made such a marriage, for we only know the first name of his wife. Perhaps he went against convention and married not a wealthy young woman from his home town, but a local Flemish girl.

the back wall. It recalls the gargoyles which served as waterspouts on cathedral roofs. These, like the pose of the bride, were typical of the era which we call the Gothic.

At the Burgundian court and amongst the social circles surrounding it, it was not just women's fash-

No document bothers to record her surname – evidently it was not worth mentioning.

The two Arnolfinis in Bruges dealt not just in goods, but also in money. In those days, Italians had virtually the monopoly on banking across the whole of Europe. Italy was the leading economic power and developed the techniques of banking, bills of exchange, letters of credit and even double-entry bookkeeping. Italian banks opened branches in all the major centres of trade. In Bruges, their representatives met daily with the city's merchants in the house of a Mr van der Burse. He would give his name to capitalism's most important institution: the bourse, or as we more familiarly know it, the stock exchange.

The customers of the Italian banks included not just businessmen, but also monarchs. The relationship between the bankers from Lucca, the city from which the Arnolfini brothers came, and the dukes of Burgundy was particularly close. One of the former had put up the enormous ransom needed to buy the freedom of a Burgundian heir imprisoned in the Orient. Lending money to rulers implied great honour, but also increased risk – they didn't always pay it back. Enforcement was out of the question. Every political defeat meant losses for the banks. Thus the death in battle in 1477 of the last Duke of Burgundy, Charles the Bold, also meant

fatal losses for the Bruges branch of the Medici bank – the bank that had allowed itself to own a palace there. In the long term, the bank's ruin in Flanders probably also contributed to the fall of the Medici in Florence.

Hanging above the couple's heads is an ornate chandelier of a kind manufactured in Flanders by art metalsmiths of the day. We know from records from the Bruges branch of the Medici bank that a similar chandelier was shipped in pieces to Italy.

A solitary candle burns in the chandelier. There is no obvious practical reason why just one flame should be lit; symbolically, however, it ties in with a popular medieval tradition, whereby a large burning candle was carried at the head of wedding processions or handed ceremonially by the bridegroom to the bride. The flame signified the all-seeing Christ, who is witness to the marriage vows. Earthly witnesses to the ceremony were thus not really required.

Visible beneath the right arm of the chandelier is a wooden figure forming part of the tall back of a chair. It represents St Margaret, the patroness of pregnant women, subduing the dragon. The chair stands directly beside the marriage bed. Like the candle and the carved chair decoration, most of the other objects in this room also have a hidden meaning. At the same time as giving us one of the earliest realistic portrayals of a middle-class interior,

The secret language of everyday objects

van Eyck also gives us symbols. For him, as for his contemporaries, objects carried a message. They spoke. Sadly, it is no longer always possible for us to decipher this secret language of objects.

A little dog, like the one between the bride and groom for example, was a symbol of prosperity, but also of faithfulness. On tombstones of the day, a lion is frequently found at the feet of the husband, symbolizing strength and courage, and a dog at the feet of the wife. Fidelity in marriage was clearly only expected from the woman.

Several of the seemingly random objects in the room speak of the pu-

rity of the bride – the spotless mirror, for example, and the translucent beads of the rosary hanging beside it. These symbols are familiar from paintings of the Virgin and altarpieces. Indeed, it was in the churches of the Middle Ages that this type of imagery arose: a congregation which couldn't read needed "talking" images which it could contemplate and learn from.

Van Eyck himself painted a number of famous altarpieces, but he lived in a century in which devotional subjects began to be overtaken by secular images. *The Arnolfini Marriage* testifies to this process of transition: it uses the pictorial lan-

guage of religious art to portray a domestic interior and a scene which, although it incorporates the presence of Christ, records not saints or martyrs but a banker and his wife.

Also to be understood symbolically are the slippers and clogs. Taken literally, they might indicate unseemly haste or an untidiness inappropriate for such a solemn ceremony. For van Eyck's contemporaries, however, they contained a reference to the Old Testament: "Do not come any closer. Take off your sandals, for you are standing on holy ground."[6] Thus God spoke to Moses (Ex. 3:5). When a bride and groom administered the sacrament to each other, then even a simple wooden floor became "holy ground".

Van Eyck's painting illustrates the transition not just from sacred to secular art, but also from aristocratic to bourgeois subject-matter. Portraits of the nobility had existed for a number of decades, some of them executed by van Eyck himself in his capacity as court painter. Philip the Good of Burgundy made him a chamberlain and occasionally also his envoy in confidential affairs. But Philip also allowed him to work for the middle classes, because he knew that his own power rested on their industriousness, their contribution to the economy and also their willingness to take financial risks.

Of particular significance in this painting is the signature of the artist. It is placed not modestly in the bottom right-hand corner, as was otherwise the convention, but prominently on the rear wall between the mirror and the chandelier. Even its formulation is unusual: instead of "Johann de Eyck fecit" (Jan van Eyck did this), it says "fuit hic" (was here). This inscription transforms the panel into a document. The artist signs not as the painter of the picture, but as a witness to the marriage. Perhaps the man who can be seen in the convex mirror, entering the room wearing a turban and a light blue gown, is in fact the artist himself.

Monument to a military leader

The battle of San Romano was portrayed by Paolo Uccello in a cycle of three panels. Five centuries ago, all three hung together in the Medici Palace in Florence, in the large ground-floor room known as the Sala di Lorenzo.[1] This we know from an inventory of 1492. Today, the panel discussed here hangs in the National Gallery in London, with the second in the Uffizi in Florence and the third in the Louvre in Paris.

We do not know the exact year in which Uccello executed his cycle of paintings, but we do know the date of the battle: 1 June 1432. San Romano is located halfway between Florence and Pisa. The battle itself represented a minor defeat by the Florentines of the Sienese and, were it not for Uccello, would have long been forgotten; it was one of the countless skirmishes which characterized the political situation in 15th-century Italy.

Italy differed from most of the rest of Europe at that time in lacking a central ruling power. Its nominal

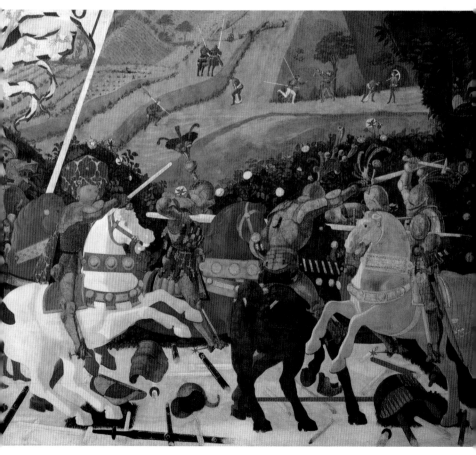

The Battle of San Romano, c. 1435 39

head, the Emperor, came only on brief visits from Germany; the Pope had no political authority, and no more or less power than any of Italy's other princes and cities. With no one above them to settle their disputes, these latter were constantly at war with one other, frequently switching their allegiances but usually with Milan on one side and Florence on the other.

It was during this period of permanent warfare that Renaissance culture experienced its greatest flowering – a culture which also infuses Uccello's panels. The fact that art and warfare flourished side by side shows that normal life in the cities and courts was largely unaffected by the many conflicts of the day. Nor did the citizens, courtiers or priests do any of the fighting themselves. They let others do that for them. As Niccolò Macchiavelli (1469-1527) would later write: "Italy thus found itself almost entirely in the hands of the Church and a few republics, but since neither priests nor civilians were accustomed to taking up arms, they began to hire armies."[2]

The word for such a hire agreement was *condotta*, and the military commanders with whom they were signed were *condottieri*. These contracts set out what the employer had to pay weekly or monthly, how any spoils were to be divided, and the numbers of cavalry and infantry which the condottiere promised to supply. The condottiere guaranteed to fight on his employer's behalf as long as the money kept coming. Should the employer run out of funds, the contract immediately became void and the condottiere could hire himself and his troops out to another power. The condottiere was a professional soldier who feared only one thing: peace. A condottiere is once said to have tossed a coin to a beggar, who thereupon thanked him with the words "Peace be with you". Incensed, so the story goes, the condottiere turned around, shouted at the beggar and snatched back the money.[3]

Uccello paints his condottieri with their troops. There were two reasons why the use of hired armies had become so widespread in Italy. Firstly, the absence of a central ruling dynasty also meant that Italian society lacked the class which was granted land by its lords and which raised armies for them in return. Secondly, the growth of the mining industry in the 15th century had boosted the money supply across Europe, and much of this money found its way into the commercial centres of Italy. The city states were rich and could afford to pay for private armies.

The relationship between the warring republics and their condottieri was characterized by money and mistrust. For military power lay in the hands of the condottieri, not with the cities themselves. A city never allowed the army it was pay-

ing to pass through its own gates – only its commander. Wherever possible, the city fathers tried to keep back the wife or children of the condottiere as a sort of deposit. Or they employed several condottieri within the same army, in the hope that, in the event of attack, at least one of them would consider it to his advantage to defend the city. This naturally gave rise to issues of hierarchy amongst the various commanders.

Condottieri came from all classes of society. We know that the father of the condottiere in the Louvre panel was a peasant. All his sons became mercenaries; some of them rose up in the world, and the most famous of them produced a son who, as a condottiere in his own right, became Duke of Milan: Francesco Sforza. He was not the only one to rise up to become a ruling prince. In the words of one contemporary: "In our change-loving Italy, where nothing is set in stone and there is no long-established ruling house, stable-lads can easily become kings."[4]

The chances of advancement were great, but so were the risks. The condottiere Carmagnola, for example, won an important battle for Venice, but subsequently upset his employers with his – to their minds – dwindling military zeal. The Venetians suspected that he was more eager to make pacts with the enemy than to fight for Venice's interests. So they instructed him to

report to the Doge. Instead of being granted an audience, however, Carmagnola was imprisoned in the Doge's palace and then beheaded. This took place on 5 May 1432, just a few weeks before the battle of San Romano. Macchiavelli is matter-of-fact about Carmagnola's fate: "As soon as they realized his commitment was waning, in other words that they were unlikely to profit further from him, but that they could not dismiss him, or they would lose what they had gained, they felt compelled to kill him for their own safety."[5]

Death and transfiguration

Lack of enthusiasm was an accusation levelled at many condottieri, but it arose directly out of the nature of their business: soldiers, horses and arms were their capital, and they naturally wanted to keep their assets more or less intact. And since they all felt the same way, they developed a certain professional etiquette: enemy horses were spared, and prisoners not killed but returned on payment of a ransom. Although Uccello portrays a terrifying war machine on two of his three panels, it seems that the battle of San Romano, like most others, was bloodless. There are no reports, at least, of any dead or injured. Macchiavelli again: "The wars in Italy were begun without fear, fought without danger and finished without losses."[6] They sooner resembled military ceremonies than real battles.

Niccolò Mauruzi da Tolentino is the name of the condottiere with the general's staff. Uccello portrays him wearing a magnificent hat of red and gold velvet brocade. Tolentino might have worn such hats at official receptions or military parades, but certainly not on the battlefield. The page riding behind him is carrying his master's helmet, but this is itself too ostentatious for a real battle. Realism, however, was simply not on the agenda. All three paintings were intended to serve as visual propaganda and in particular to celebrate the feats of Niccolò Mauruzi da Tolentino.

The condottiere's praises had already been publicly sung a year after the battle of San Romano, when Florence's official speaker, Leonardo Bruni, declared that Tolentino possessed all the virtues of a great military leader: "courage in the midst of danger, perseverance, an overview of all operations and the gift of foresight".

Many Florentines held a quite different view, however. Giovanni Cavalcanti, for example, considered Tolentino a reckless fighter and a poor tactician. He describes how, at San Romano, Tolentino advanced too deep with a small unit of men and involuntarily embroiled them all in a fight. "When the battle went badly, Tolentino despaired and could hardly hold back his tears. He saw no escape until Micheletto [the condottiere in the Louvre panel] appeared and rescued us from the serious danger into which Niccolò had led us."[7]

Matteo Palmieri (1406-1475)[8] disagreed: Tolentino advanced so deep not out of recklessness, but in order to lure the enemy into a trap. The arrival of Micheletto had been a precisely planned outflanking manoeuvre, not a piece of good luck. What really happened, who won the battle of San Romano, we do not know; we have only conflicting reports, partisan commentaries.

Such partisanship arose out of the political situation in Florence. Cosimo de' Medici ruled the city via middlemen, but in 1433 was ousted and

imprisoned by Rinaldo degli Albizzi. Cosimo had engaged Tolentino's services and lent him financial support, and his opponents now claimed that Cosimo was seeking to set himself up as absolute ruler with Tolentino's help. Rightly or wrongly, Tolentino was branded a member of the Medici camp. When the condottiere heard that Cosimo had been taken prisoner, he rode up to the city with his troops and only withdrew when he was told that Cosimo would be killed immediately if Tolentino attempted to force his way in.

Cosimo was spared execution but was exiled to Venice, while Rinaldo's men sent Tolentino north, as far from Florence as possible. On 28 August 1434 he was captured by the Milanese near Bologna. As his employer, Cosimo would normally have bought his release; in this case, however, Rinaldo didn't. With no prospect of fetching a ransom, Tolentino was of no value to the Milanese – he fell off his horse and died. To what extent he was pushed is unknown, but whatever the case, it was an inglorious end.[9]

According to one anecdote from the period, the city fathers were discussing how best to get rid of a condottiere who had rendered good service but who had now grown dangerous. The solution: have him killed and then proclaim him one of the city's patron saints.[10] Something similar happened to Niccolò Mauruzi da Tolentino. His inglorious

end was followed by his apotheosis. After the Medici party had seized back the reins of power and Cosimo had returned from Venice, he had the condottiere's body brought back to Florence and buried in the cathedral. An uncommon honour for someone who was not a native Florentine. The service, which was held on 20 March 1435, was even attended by Pope Eugenius, freshly expelled from Rome.[11]

Flags as a means of orientation

Tolentino became a martyr for the Medici cause, but it is unlikely that this was the sole reason why Cosimo honoured his memory so publicly. Through the celebrations surrounding Tolentino, Cosimo celebrated himself. He showed himself a man who remained loyal to those who fought on his side, and reminded the world that the (supposedly) magnificent victory at San Romano was won for Florence under his rule. More propaganda, in other words. The fact that he commissioned no less than three paintings of the battle can probably be explained in the same way. Paintings, like commemorations of the dead, served to glorify the house of Medici.

In 1456 Cosimo commissioned Andrea del Castagno to paint a fresco of Tolentino mounted on his horse in Florence cathedral. To be immortalized on horseback in a public place was evidently the wish of many condottieri, and in his eulogy Leonardo Bruni made discreet reference to the fact that the ancient Romans also honoured their heroes with equestrian statues. This tradition had been forgotten in the Middle Ages but was revived around 1450, when Donatello executed the first equestrian statue of the Renaissance. It was, moreover, dedicated to a condottiere, Erasmo da Narni, known as Gattamelata, and stands in Padua. Venice also erected an equestrian statue of its condottiere Colleoni, although not – as the lat-

ter had wished – on St Mark's Square. The Florentines, economically-minded as ever, held back; their condottieri were commemorated not in bronze, but in paint.

Like most flags in the Middle Ages, Tolentino's pennant is not rectangular, but ends in two long tongues. The emblem of the mercenary leader is a ring of rope with knots.[12] He may have chosen this himself, or it may have been awarded to him. Coats of arms in those days could be made up of anything and were constantly changing.

The condottiere Muzi Attendolo Sforza, for example, chose a quince as his emblem.[13] He was then granted permission to adopt the lion from the arms of the prince employing him. He combined the two by placing his quince on the paw of a lion, and later added a dragon.

The practice of adopting a visual emblem had established itself during the Crusades, when knights from different countries and speaking different languages had to fight in the same army. Flags, like coats of arms, became particularly important following the introduction of visors. Since knights could no longer be recognized by their faces, they needed other forms of identification. Condottieri often omitted coats of arms from their shields, however, so as not to attract their enemies' attention unnecessarily. But flags showed friend and foe

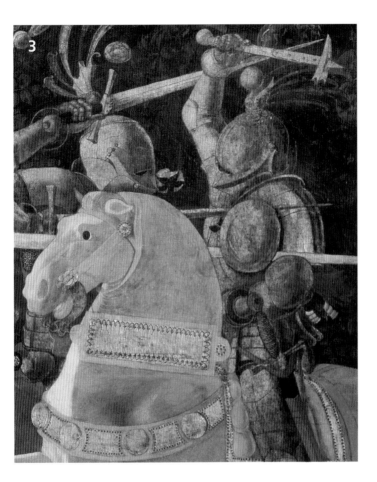

alike where everyone was. They acted, as one contemporary described it, "like a torch in a room that lights everything up. If, by some misfortune, they should go out, everyone is left floundering in the dark and will be defeated."[14]

Tolentino is said to have had 2000 cavalry and 1500 infantry under his command, but only the cavalry really counted. In attacks, the foot soldiers – armed with pikes and crossbows – advanced first. They cleared any obstacles for the horses, shot their arrows from as close to as possible, and then let themselves be overtaken by the cavalry. After this they withdrew, usually to the side, to harrass the enemy from there. A few individuals stayed with the riders in order to help them if

The cavalry decide the battle

4

they were unseated. They were purely auxiliaries.

The condottieri skirmishes of the 15th century were always decided by the cavalry. With their heavy horses, they trotted towards each other at moderate speed. The blow of a lance was not normally fatal, but could lift a rider out of his saddle. Weighted down by some 20-30 kg of armour,

he was unable to get back onto his feet unaided and was thus temporarily out of the fight.

After their lances, riders used maces or swords. A sword could only wound or kill, however, if it found a chink in the opponent's armour. As Uccello illustrates, swords were forged with sharp tips so as to better penetrate such chinks. A par-

ticularly vulnerable part of the body was the armpit, and the rider with the mace in Uccello's panel protects it with a so-called "floating disk".

The unhorsed riders and numerous pieces of broken lance are precisely positioned along lines which converge in the head of Tolentino's white mount at the centre of the panel. But although the effect is almost academic, as if taken straight out of a textbook, Uccello was in fact here deploying something entirely new. He was namely one of the first artists to attempt the mathematical representation of space in painting. "Oh, what a lovely thing this perspective is!"[15] he is said to have declared.

The perspective composition extends only as far as the hedge, however. The landscape behind fails to take up the receding lines of the foreground composition and remains spatially ill-defined. It is impossible to tell just how far apart the fields, the trees and the soldiers drawing their crossbows are supposed to be. The composition thus falls into two parts. Perhaps Uccello was not yet capable of continuing into the background the perspective system which he achieves in the foreground. Perhaps, however, he simply wasn't as interested in what was happening on the far side of the hedge. There are reasons why this might be so – and they arise out of 15th-century military tactics. Battles were decided

by the cavalry, and the riders needed level terrain on which to attack. They couldn't fight uphill, nor could they jump obstacles. They needed firm ground to mount their charge. In front, therefore, we have the carefully chosen – and mathematically idealized – battleground, and behind it the surrounding, militarily less important landscape.

The calculation of distances was important not just in art, but also in the burgeoning science of artillery. Gunners had to be able to use a plumb and square and, like painters, have a firm grasp of the basics of geometry. In 1453 Mohammed II destroyed the walls of Constantinople with his cannon; his biggest gun fired cannon-balls almost a metre in diameter a distance of 1600 metres. The advent of artillery signalled the end of the arms wielded by Uccello's condottieri – it arrived in the same century as perspective in painting.

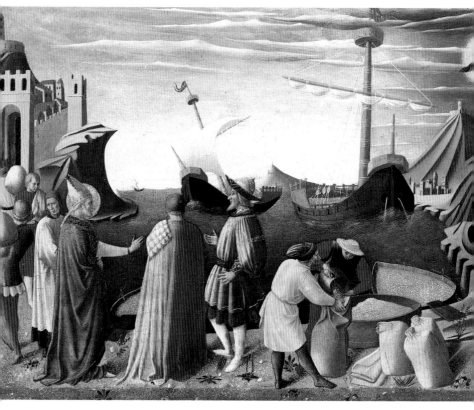

A saint with a practical turn of mind

The life of St Nicholas, the popular patron saint of merchants and sailors, is surrounded by a wealth of legends. In Early Renaissance Florence, a monk by the name of Fra Angelico – Brother Angelic – portrayed a number of his miracles in paintings which "seem to have been made in heaven rather than in this world".

Two miracles associated with St Nicholas are depicted in this panel. The saint accordingly appears twice: in the heavens, top right, he is helping shipwrecked mariners in distress, while bottom left he is thanking a captain who has given him part of his consignment of grain. According to legend, St Nicholas miraculously caused the grain to multiply and thereby saved the inhabitants of the city of Myra from starvation.

The panel was originally flanked by two works identical to it in size and also depicting scenes from the life of St Nicholas. They each measured 34 x 60 cm and together made up the front of a predella, the long,

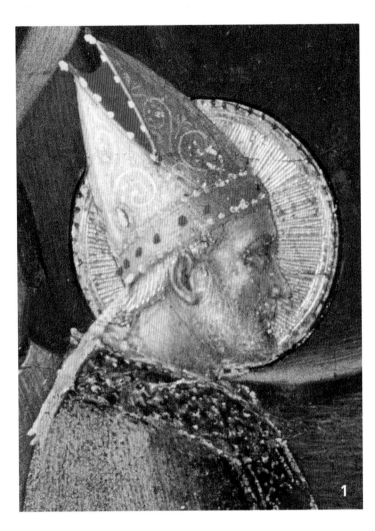

1

Successor to the ancient gods

narrow plinth beneath an altarpiece. The three main panels above were each over 1 metre tall and showed the Madonna and Child with four saints in traditional, statuesque poses against a gold background. While these large paintings provided the centrepiece for worship, the St Nicholas scenes served as edifying entertainment in story form. In the 19th century the altar was broken up; two panels, including the one shown here, are today housed in the Vatican Museum in Rome, while the remaining parts are located in Perugia.

Fra Angelico

The altar was commissioned in 1437 for the Dominican Chapel of St Nicholas in Perugia. It was executed in Fiesole, a town just outside Florence, by a painter-monk, Guido di Pietro, who was born around 1400 and died in 1455. He initially took the name Fra Giovanni upon entering the Dominican order, but later became known as Fra Angelico – "Brother Angelic". He painted the altar at a time of political as well as artistic upheaval: the mercantile magnate Cosimo de' Medici, already the dominant economic force in Florence, had just secured himself political power in the city republic. And just a year earlier, in 1436, the city's new cathedral had been consecrated; with its mighty cupola, it stood as the soaring symbol of a new movement – the Renaissance.

At the time when Fra Angelico painted his altar, St Nicholas ranked amongst the most popular of the non-biblical saints. More than a dozen pious and miraculous acts were ascribed to him in the *Golden Legend*, the famous collection of readings on the saints compiled in the 13th century by Jacobus de Voragine. Over 2000 monuments to his memory, dating from the years before 1500, have been recorded in Germany, the Netherlands and France alone.

Yet despite this, Nicholas was never officially beatified, and he probably never even existed. It is more likely that a number of different miracles were attributed to one name, which subsequently came to be associated with the real-life figure of Bishop Nicholas of Myra. The *Golden Legend* records that the bishop is supposed to have died in AD 343, on 6 December – St Nicholas' day.

6 December was an important date even before the spread of Christianity. It is around this time that winter storms start to hit the Mediterranean, making seafaring more dangerous and the help of supernatural or submarine powers all the more important. The role formerly played by Poseidon and Neptune, the gods to whom the peoples of antiquity had addressed their prayers, was now assumed by St Nicholas, who become the patron saint of mariners.

There was a significance, too, in the fact that Nicholas came from Myra, located on the mountainous shores of the southern coast of modern-day Turkey. From Myra, ships sailed for Alexandria. Instead of taking a coastal route, as was usual in those days, they steered directly south, with no landmarks from which to take their bearings. It seems understandable that sailors and captains setting off on such a perilous journey – a "voyage into the abyss", as it was called – should imagine their port of departure as the home of their patron saint.

The story of St Nicholas saving the seamen is one of the oldest of all

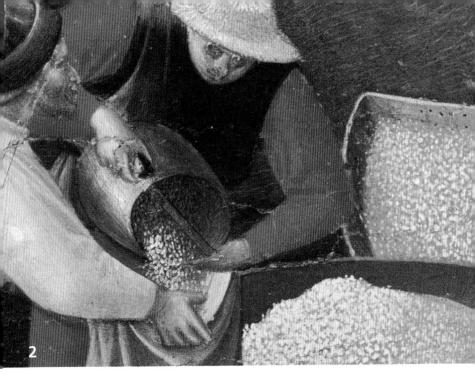

2

Nicholas asked each ship for one hundred measures of grain

the acts associated with his name, although in the *Golden Legend*, at least, we are given little information about the circumstances. The narrator is concerned only with telling us that the sailors prayed to St Nicholas, that he appeared, and assisted them "with the sails and ropes and other rigging of the ship, and the storm died down immediately." Fra Angelico sets a more specific scene: here, the ship has been driven against a rocky coastline in high seas and a sea-monster has reared its head out of the water. The miracle which St Nicholas is performing is to make the wind blow off the shore and cause the sails to billow towards the

stern. In practical terms, this latter is impossible, since the yard, from which the sail is suspended, is attached to the front of the mast and cannot twist round to face the back. But the saint touches the yard with his bishop's staff, and the impossible happens.

Nicholas was initially popular in the Byzantine Empire. With the arrival of Islam, Italian ships abducted the saint's remains from Myra and took them to the port of Bari, where they remained until 1087. From there his fame was spread by mariners as far as northern Europe; he became the patron saint of the Hanseatic League and of what would later be-

come New York. He is the only saint to have survived the Reformation in Protestant areas.

Only the Catholics have difficulties with him today, since he was never officially beatified. His halo is not legitimate.

According to the legend of St Nicholas and the famine, there were ships laden with wheat lying at harbour in Myra, preparing for their winter voyage. Nicholas "begged the ship's people to come to the aid of those who were starving, if only by allowing them a hundred measures of wheat from each ship." The sailors replied: "Father, we dare not, because our cargo was measured at Alexandria and we must deliver it whole and entire to the emperor's granaries." Then Nicholas said: "Do what I tell you, and I promise you in God's power that the imperial customsmen will not find your cargo short." And so it was. Nicholas also multiplied the wheat thus donated to Myra, so that "not only did it suffice to feed the whole region for two whole years, but supplied enough for the sowing."

It is a historical fact that grain consignments passed through Myra on their way from Alexandria to Constantinople. For many years grain served as a form of tax and as an important food staple for the imperial capital. Fra Angelico was not thinking of Constantinople, however, but of the capital of the Western Empire and his own Church. Thus one of the ship's pennants bears the letters "SPQR", the abbreviation for *Senatus Populusque Romanus* – The Senate and the People of Rome.

The object being used to pour the grain into the sacks is a measuring scoop, one of the most important pieces of equipment in the corn trade. Nicholas asks for one hundred measures per ship, and the narrator emphasizes that the wheat has been measured out in Alexandria and will be measured again upon its arrival in Constantinople. A great deal of attention was paid to measuring, because different regions used different dry measures – something often exploited to make a profit.

The situation which prompted Nicholas' miracle was characteristic of the period from which it dates, and one which explains its enduring popularity – famine. Everyone was familiar with it, and most people suffered it. Wheat was the most important food source, and although the towns and cities practised stockpiling, two poor harvests in succession were sufficient to empty the granaries. There were few ways of importing food quickly, but those who succeeded could make up to 400% profit.

Both bread and grain play a role in the legend of St Nicholas, and it is likely that early on the saint was assigned some of the functions of the pagan fertility gods. One of his attributes were three bread loaves,

which were thrown overboard when a storm was brewing in the hope that they would appease the ocean.

In the days when famine was a constant threat, wheat became a symbol of prosperity and Nicholas a prosperity-bringing saint. He was not only the patron saint of sailors, but also of merchants, especially corn merchants, shippers, weighers, millers, bakers and brewers. He offered protection against theft and loss of property, and he gave poor girls gold so that they could get married. The medieval Church, with its emphasis upon asceticism and the hereafter, no doubt needed a saint who didn't entirely disapprove of material happiness in order to enhance its popular appeal.

The present panel pays homage, not just to a popular saint, but also to seafaring and trade. Ships and goods occupy a large part of the picture. Mariners and merchants are depicted sailing across the seas in a threatening storm, while the captain facing the bishop is as large as the saint himself. Nicholas is thereby portrayed as a celestial fellow merchant.

This homage to trade, and in particular to international trade, reflects its crucial importance. It had undergone continuous expansion over the preceding century – in the shape of the Hanseatic League, for example – and had altered the balance of power within society. Cities of growing commercial and financial strength now rose up alongside the feudal lords of old, and within city republics such as Florence it was the bankers and merchants who held the reins of power. It was thanks to his banks and businesses that Cosimo de' Medici became political ruler of Florence, even if he never flouted his power in public. Like all Florentine merchants, he dressed in a plain red cloak and a simple black cap, like the man kneeling on the right in the group of supplicants.

Christian merchants had a problem, all the same: for a long time, their Church condemned all money-trading as usury, as the deadly sin of avarice. This was punishable by excommunication and, after death, the most excruciating torments of Hell. Even in the 12th century, the Canon Law of Gratian stated that: "The merchant cannot please God, or only with difficulty." In the 13th century Thomas Aquinas attempted to bring the Church's position up to date: "If we consider commerce from the point of view of the common weal, and if we wish to prevent a shortage of vital commodities, then profit, rather than being viewed as the goal, may be considered a due reward for effort."

Aquinas' dispensation was granted only to those goods essential to everyday living, and was thus strictly limited in its scope. Profit-oriented merchants continued to fall under suspicion of avarice. In order to avoid

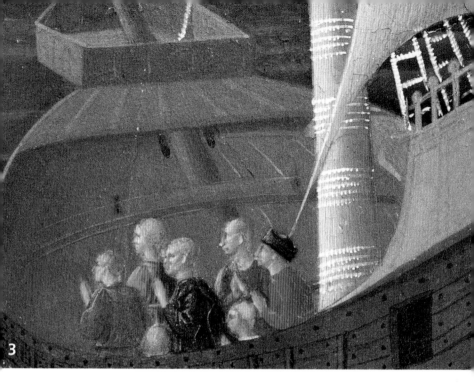

3

the torments of Hell (and often acting, too, out of a sense of social obligation), they became benefactors. Upon their foundation, Italian trading companies – metaphorically speaking – opened a cheque account especially to fund charitable works, and were not always paying mere lip service when they began their books and contracts with the words: "In the name of Our Lord Jesus Christ and the Blessed Virgin Mary …"

Most of their donations went to the Church or, via religious aid organisations, to the needy. Cosimo de' Medici endowed churches, chapels and monasteries, and for many years gave a home to Pope Eugene IV, who had enemies in Rome. In 1436 the Pope granted him permission to renovate a run-down building in Florence and to donate it to the Dominican monks in Fiesole as a monastery. Those monks included Fra Angelico, who was commissioned to decorate the new monastery. His frescos in San Marco are still one of the city's most important sights today.

A mountainous ridge separates the locations of the two miracles, but they are reunited by sea and sky, and appear to the viewer to be taking place at the same time. It was common practice in the Middle Ages to

A cheque account for God

portray several events unfolding within one and the same painting. The Church sought to impart a sense of eternity, and *sub specie aeternitatis* – from the point of view of eternity – differences in time and place were unimportant.

In the 15th century, however, real-life settings and real-life chronology began to command greater attention, also in art. For commissions were no longer awarded solely by the churches, but – with ever increasing frequency – by bankers and merchants. Their professions required them to think in terms of quarter days and trade routes; geography and elapsing time formed the bases upon which they made their calculations. Their sense of the reality of this life was strengthened by the rediscovery of the authors of antiquity. What we call the Renaissance was born.

An artist like Fra Angelico may have worked for the Church and his order, but his painting was financed over many years by Cosimo de' Medici, the most powerful merchant in Florence. Fra Angelico also painted the frescos in the cells in San Marco to which Cosimo withdrew to meditate, in order – or so his enemies said – to do penance for his greed.

The age in which the artist lived also influenced his art. Set against their gold backgrounds, the saints in Fra Angelico's main altarpiece are still entirely indebted to medieval tradition. In his predella panels, by contrast, the pious message is accompanied by a new attempt to invoke earthly reality in the picture and to lend depth to the whole through the use of perspective. In the chain of mountains rising up in the background, Fra Angelico was perhaps aiming to create an impression of three-dimensional space. He applied the laws of perspective only intermittently, however, as can be seen in the bowsprit of the middle ship, which seems to point vertically upwards rather than diagonally forwards, and in the ship on the left, whose front deck is portrayed from a different angle than its stern. And whereas the light – so important in the creation of spatial depth – strikes the mountains from the rear left, the figures in the foreground are illuminated from the front left. In yet another contradiction, the figures are observed in great detail, while the mountains and houses are portrayed in a strikingly simplified form.

What is so astonishing, not to say miraculous, about this panel is the fact that these contradictions cause absolutely no upset. It is as if we are looking at a scene from a dream, the portrayal of something supernatural taking place on our earth. Writing of Fra Angelico in the 16th century, the artist biographer Vasari observed that the monks' figures "are so exquisite that they really seem to be in Paradise".

From the point of view of eternity

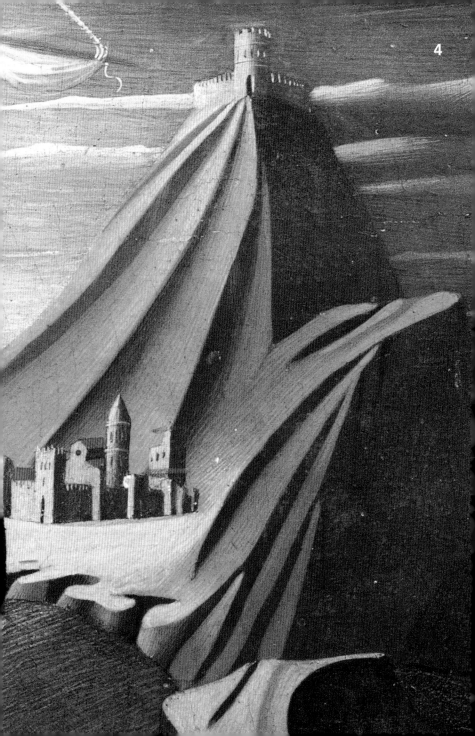

Jan van Eyck: The Virgin of Chancellor Nicolas Rolin, c. 1437

May God help the Chancellor

Although of low birth, Nicolas Rolin's cunning and lack of scruple helped him become chancellor of a realm. Under his strict rule, Burgundy became a major European power. Rolin sought to save his soul through acts of charity and ostentatious veneration of the Virgin Mary. In so doing, he struck an equal balance between humility and pride – as the portrait shows. The painting (66 x 62 cm) is now in the Louvre, Paris.

His hands folded in prayer, an ageing man kneels at a prie-dieu before the Virgin Mary. An angel bearing a golden crown floats above the head of the Queen of Heaven, upon whose lap the infant Jesus is enthroned. To document His majesty, the Holy Child holds an imperial orb of crystal in one hand, while blessing the kneeling man with his other. The pious scene, intended to remind the spectator of the hereafter, is lit by the setting sun. The painting is an example of the medieval donor portrait.

However, the picture is hardly devoid of earthly lustre. The man's mink-trimmed brocade coat shimmers more opulently than the Virgin's red robe. The setting is a magnificent palace, high up in the hills. The view through the arched loggia takes in distant mountains, a riverscape, the buildings of a town – the wealth of this world.

Dating from around 1437, Jan van Eyck's painting, now in the Louvre, departs from the medieval devotional tradition in a number of important points. While these herald the dawn of a new era, they also tell us something about the person who commissioned the work. The donor

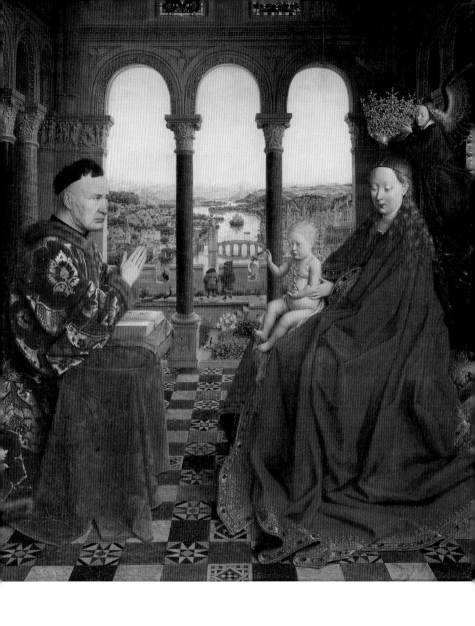

1

The sly fox knew no kindness

at prayer is not, as was usually the case, flanked by an intercessory patron saint. Instead he kneels alone, on a level with – and the same size as – the Virgin Mary herself. Rather than cowering in self-effacing deference at the lower edge of the painting, his figure occupies the entire left half of the composition.

In the life of the man shown kneeling, worldly values had always played a more important part than religion. He had every reason to be proud: according to the contemporary chronicler Georges Chastellain, Nicolas Rolin (1376–1462), Chancellor of Burgundy, had made his lord,

Duke Philip the Good, the most glorious ruler on earth.

During his 40-year period of office, Rolin expanded the boundaries of Burgundy to include an area six times as large as the original province of that name, thus creating a powerful state that was feared throughout Europe. Its foundation stone was a royal wedding in 1369: the bride's dowry was Flanders, while the bridegroom's portion was the Duchy and County of Burgundy, as well as his considerable political skills. He and his two successors profited from the ruin of France, which had been occupied and ravaged by the English

Jan van Eyck

during the Hundred Years' War. They created a kingdom which extended from the Swiss border to the North Sea, from Dijon to Bruges. The union of a French ruling dynasty with the spirit of the industrious Flemish and Netherlandish townsfolk prepared the ground for a highly sophisticated blend of courtly tradition and bourgeois culture.

Rolin, a Burgundian by birth, and the Netherlandish Jan van Eyck (c. 1370– 1441), a highly respected court painter, were contemporaries at the court of the third duke, Philip the Good (1419–1467). Both were of non-aristocratic origin. Van Eyck had been appointed to his post for life, his main task being to "execute paintings at the behest and according to the will of the duke". Unfortunately, not one of his court paintings survive. What we do have, besides several altarpieces, are a number of portraits of his contemporaries: a goldsmith, an Italian banker called Arnolfini, and Nicolas Rolin. The artist enjoyed a privileged position at court and was occasionally entrusted with political or diplomatic missions of a confidential nature. These brought him into contact with the chancellor, who, according to Chastellain, "was the supervisor of all things".[1]

A few years after van Eyck, another Netherlandish artist painted Nicolas Rolin. Rogier van der Weyden (c. 1400–1464) portrayed him in an altarpiece as the founder and donor of the hospital for the sick and needy at Beaune, in Burgundy. Even today, the hospice receives its income from the vineyards which Rolin donated. It is hardly surprising, therefore, that van Eyck painted stone vines carved on the loggia arches, or green vineyards in the landscape beyond the chancellor.

The gaze of the man, about sixty at the time, is solemn and withdrawn. "There was not one great prince," wrote one of his contemporaries, "who did not fear him."[2] This is perhaps surprising, since Rolin, born at Autun in 1376, was a parvenu of "humble origin".[2] The fact that his career should have been so successful at a court known for its obsession with chivalry and etiquette is due largely to qualities proverbial among the Burgundian peasantry: toughness, cunning and, above all, realism. "He was very wise … in the ways of the world," wrote the chronicler. "His harvest was always of this world."[2]

In 1419 Rolin's talents drew the attentions of the young Duke Philip of Burgundy, who had come suddenly to power following the murder of his father. Three years later Rolin was appointed chancellor. "It was his wont to govern alone," wrote Chastellain, "and everything, whether matters of war, peace or finance, passed through his hands." The chancellor used his great authority to increase the wealth of Bur-

and by the cleverness of his chancellor, who had made the centralisation and consolidation of state power his leading concern. Rolin standardized administrative and judicial practice while curtailing the privileges of both the nobility and the burghers, particularly in monetary matters. In order to finance Duke Philip's displays of pomp, the chancellor procured vast quantities of money through a never-ending series of taxes. The rebellions of Netherlandish municipalities against this enormous fiscal burden were put down mercilessly.

If Rolin was the most important man in the kingdom, he was also the most hated, mainly because of his greed. He was given to pocketing a share of the royal income, and had no qualms about accepting bribes. X-ray photographs show van Eyck originally portrayed him holding an enormous purse. We can only speculate as to what may have moved the artist to paint it over.

A Book of Hours lies open on the hassock – van Eyck apparently also painted miniatures for manuscripts of this kind, already much sought after by collectors. The Book of Hours contained prayers appropriate to certain hours of the day. It is impossible to decipher the text of the open pages, with the exception of the initial D.

The chancellor's white and well-manicured hands are folded in prayer directly above the open

Hands for praying, hands for grabbing

gundy through inheritance, marriage and purchase of land. He was thus responsible for the annexation of Namur in 1421, Hainaut, Friesland and Zealand in 1426, and the Duchies of Luxemburg and Guelders in 1443.

However, the different parts of the kingdom of Greater Burgundy were politically disparate and geographically separate. They were held together only by the duke himself,

pages. Just how fiercely these hands could strike out when it came to punishing defaulters or rebellious municipalities is documented by the French King Louis XI's remark on Rolin's charitable donation at Beaune: "It is only appropriate that one who has turned so many people into paupers while still alive should provide shelter for them after his death."[3] In a business transaction of not entirely unusual character for the times, Rolin attempted to buy his salvation through a spectacular act of charity. A description of the deal was recorded in the hospice's founding deed of 1443.

It is possible that van Eyck's painting is intended to commemorate a specific event in Rolin's life. Its execution coincides almost exactly with a climax in Rolin's career, the signing of the Treaty of Arras in 1435. This was a political masterpiece, reversing an entire system of alliances, ending a bloody civil war between France and Greater Burgundy, and further, exacting atonement from the French king for a murder which, though unforgotten, already lay many years in the past.

Under circumstances which have never been fully explained, John the Fearless, Duke of Burgundy, had been murdered on a bridge in 1419 by the heir to the French throne, or by the latter's friends and supporters. This had provoked Burgundy to seek an alliance with the English invaders during the Hundred Years'

War, helping them to occupy France. However, following years of humiliation for the defeated French, national resistance flared up again under the leadership of Joan of Arc. She had the French successor crowned Charles VII, and used his army to drive the English out of the land.

To avoid finding itself suddenly on the losing side, it was necessary for Burgundy to reverse its alliances without losing face. Rolin's achievement was to give to this complete about-turn the appearance of a Burgundian triumph. He convened a general peace conference at Arras and, to the considerable applause of those present, disassociated himself from the English, who had decided to stay away from the conference. At the same time, the French king ceded several strategically important border towns to Philip the Good, offered a solemn apology for the murder of his father and promised several sensational acts of atonement.

There was no further mention of the girl who had prepared the ground for the treaty, however, not even by the king who owed his crown to her. She had been burned at the stake by the English. The Burgundian army, capturing Joan, had sold her to the English for a horrendous sum of money. It is not unlikely that part of this sum found its way into the chancellor's purse.

One of the acts of atonement extracted from the French by Rolin was the erection of a cross at the scene of the murder, the bridge at Montereau. A similar cross is shown on the bridge in the landscape background of van Eyck's painting. This suggests that the picture was indeed intended to celebrate the Treaty of Arras.

Many unsatisfactory attempts have been made to localize the landscape with its intricate detail and population of some 2000 figures. The town on either side of the broad river has been variously identified as Ghent, Bruges, Geneva, Lyons, Autun, Prague, Liège, Maastricht and Utrecht. In fact, it is probably not meant to represent an authentic scene at all, but to gather together various impressions gained during van Eyck's travels. Effectively, the view thus stretches all the way from the plains of the Low Countries to the snow-covered Alps.

Only a few details can be identified: the tower of the cathedral at Utrecht, for example, or St. Lambert's Cathedral at Liège. At the same time, there would have been many more wooden buildings and straw roofs at Liège than are shown in van Eyck's splendid townscape with its large stone buildings and countless spires. The latter, set in a perfectly balanced landscape, provide the appropriate background for a devotional painting, as well as for the representative portrait of a chancellor.

Perhaps the landscape is intended to show an improved version of the wealthy Burgundian towns supervised by Rolin. Or perhaps it is a higher, spiritual place: "a celestial Jerusalem", the "Civitas Dei", the Kingdom of God, the realm of the Queen of Heaven.

The little garden beyond the portico, with its roses, lilies and magnificent peacocks, is equally ambiguous: it can be interpreted as an allusion to Rolin's luxurious possessions, or as the "hortus conclusus", or "garden inclosed", a commonly employed symbol for the Holy Virgin during the Middle Ages. The biblical scenes carved in relief on the capitals of the stone pillars also permit a number of different interpretations.

The ambiguity of the artist's "veiled symbolism" is intentional. Van Eyck was not only respected by the duke "for the excellent execution of his craft";[4] he was also considered a highly educated man, with some understanding of the obscurer aspects of humanistic learning. He wrote cryptographic Latin or Greek inscriptions on the frames of some of his pictures, painting hidden self-portraits as a kind of signature on others. It is therefore not entirely improbable that he painted himself and his brother Hubert as two figures leaning over the parapet at the bottom of the garden.

His honoured guest, the Holy Virgin, has settled on a modest cushion

3

in the chancellor's portico. Her body serves as a throne for the infant Jesus, lending a gentleness to the scene, despite her crown and royal purple. Perhaps her appearance offers the sinner at prayer hope of understanding and forgiveness.

The Virgin is portrayed as a graceful young woman in eight of van Eyck's extant works: "She is more beautiful than the sun," he wrote on the frame of one of these paintings, "and excels every constellation of the stars."[5]

This quotation from the apocryphal Wisdom of Solomon is included in the Office of the Virgin, a collection of prayers to the Holy Virgin which lies open in front of Rolin. In the 15th century many people said these prayers daily. Indeed, many of them, including contemporary spectators of this painting, would undoubtedly have been so wellversed in the biblical similes and flowery metaphors frequently employed to extol the Virgin that they would have had little trouble piecing together the textual fragments which may be deciphered in gold lettering on the hem of the Rolin-Virgin's robe: texts dedicated to the Virgin, "exalted, as are the cedars of Lebanon",[6] and to the glory of God's creation.

A kingdom at a glance

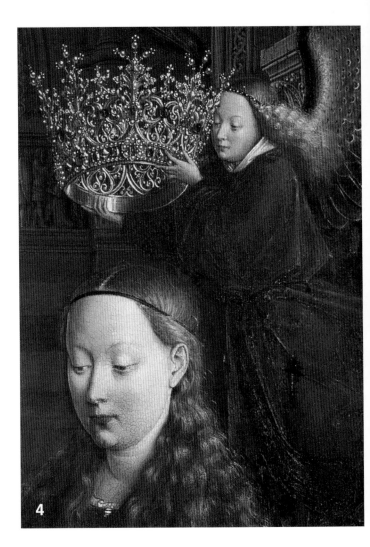

4

All his life, Chancellor Rolin devoted himself to obtaining the Virgin's forgiveness. In 1461 he bequeathed a silver statue of the Virgin, weighing more than fourteen pounds, and a "gold crown made at La-Motte-Les-Arras" to the Church of Our Lady at Autun. Perhaps the finely wrought, bejewelled diadem presented by the angel in van Eyck's picture is an allusion to Rolin's intended donation, or perhaps Rolin's gift was copied from the painter's design, who, as court artist, would

be required to have knowledge of the relevant craftsmanship.

Many documents testify to the chancellor's role as benefactor towards Our Lady at Autun. He had the church renovated and decorated and made a number of large charitable donations. Through a private passage, crossing a narrow street, Rolin was able to take a shortcut between his own house and prayers at Our Lady's. This was the church in which he had been christened, and it was here that he wished to be buried.

Van Eyck's painting was not originally intended as an altarpiece, but was hung commemoratively in the chapel where, as stipulated by Rolin's deed of foundation, a mass was to be held for his salvation every day until the end of time. This may, of course, be a sign of his great piety; it may, however, merely signify the shrewd precautions taken by a man of whom one of his contemporaries wrote: "As far as the temporal is concerned, he was reputed to be one of the wisest men of the kingdom; as for the spiritual, I shall remain silent."[7]

Rolin's political life-work, the state of Greater Burgundy, broke apart shortly after his death, ruined by the arrogance of its last duke, Charles the Bold. History is always the history of the conquerors: today, despite his position as one of the 15th century's greatest statesmen, and although, as the founder of an empire and loyal servant of its ruler, his stature can be compared with that of Bismarck, Rolin is practically forgotten.

His memory survives only in the work of his charitable trust, the hospice at Beaune, as well as in two works of art which, with unerring taste, he commissioned from the best two painters of the day.

What is Christ doing beside Lake Geneva?

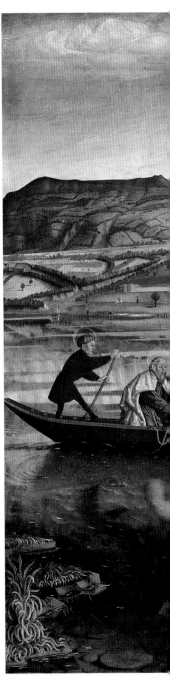

The story of the miraculous draught
of fishes is told by John the Evange-
list. Peter and some of the other dis-
ciples had spent the whole night
casting their nets, but had caught
nothing. Next morning, a stranger
standing on the shore called out to
them: "Throw out your net on the
right-hand side of the boat, and
you'll catch plenty of fish!" They did
as he instructed, and immediately
their net was filled with fish. One
of the disciples recognized the
stranger as Jesus. "When Simon

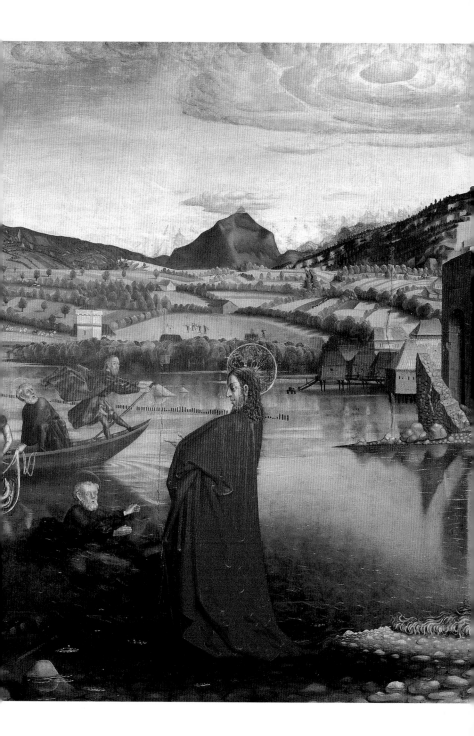

Peter heard that it was the Lord, he put on his tunic … jumped into the water, and swam ashore. The others stayed with the boat …"

What is important here is not the draught of fishes, but rather that this was one of the moments when Jesus, who had died on the cross, revealed to his disciples that he had risen from the dead. The site of this revelation was the sea of Galilee. Konrad Witz, however – or his patron – pictured the scene taking place on Lake Geneva.

The point at which the artist was standing can be specified fairly precisely. It was more or less where the Quai Montblanc now runs along the side of the lake, near the centre of Geneva. On the right of the picture, the river Rhône can be seen flowing out of the lake, on either side of a narrow island with a tower on it. Visible above the tip of the boat is the rock beside which there is now a large fountain. The far shore has long since been built up, of course, but the panorama of hills and mountains can still be clearly identified: on the right the Petit Salève, in the middle the Môle Pointu, on the left the tops of the Voirons, and in the background a snow-clad mountain range with the summit of Montblanc.

The 132 x 154 cm panel, which today hangs in the Musée d'Art et d'Histoire in Geneva, was originally part of an altar. In addition to the Latin signature of the painter, Con-

radus Sapientus, its frame bears the date 1444. To paint such a large panorama in such topographical detail was by no means common at that time. Spatial depth and landscape had only just been discovered. The brothers Hubert and Jan van Eyck had depicted elysian fields in their Ghent Altar of 1432, but these were imaginary landscapes. Paolo Uccello would do something similar in Florence: in his *Battle of San Romano* panels, executed around 1456, he attempted to position horses, lances and fields so that they corresponded with the laws of perspective, creating a sense of depth by following mathematical rules. The fact that he was thereby portraying an outdoor landscape was not important to him, however.

Konrad Witz, on the other hand, painted – probably for the first time in the history of European art – a realistic landscape. This innovative, avant-garde work arose not in Italy or the Netherlands, not in Ghent or Florence, the major art centres of the day, but in Geneva – in the heart of the provinces, so to speak. That, too, might be described as a miracle. In this case, however, one that can be explained.

Konrad Witz was born in Rottweil on the river Neckar between 1400 and 1410. He is first mentioned in records in Basle, where he became a citizen in 1435. Shortly after completing the altar with the *Miraculous*

Draught of Fishes for St Peter's cathedral in Geneva he died. His wife is described as a widow in 1446. Only 20 of his works have survived, most of them in Basle, and a number of well-regarded art historians have described Witz as a Swiss artist. That is incorrect, of course – not just because he came from the Neckar region of Germany, but because there was no Switzerland in those days, just a small Swiss Confederation to which neither Basle nor Geneva belonged.

The southern shore of Lake Geneva depicted by Witz was part of the Savoy, a duchy whose extent and power it is as difficult for us to visualize today as Burgundy in its former magnitude. These are vanished realms. In the 15th century Burgundy stretched from the North Sea coast of the Netherlands to the Jura mountains, and Savoy from the Jura to the Mediterranean. Through marriage to the Milanese Visconti dynasty, the dukes of Savoy became kings of Sardinia-Piedmont and, in the 19th century, kings of unified Italy.

As regards the situation in 1444, however, Geneva was enclosed by Savoy and more or less subordinate to the duchy. Although its bishop had a certain number of rights and its citizens many freedoms, the real power in the city was held by the Duke's appointed governor. He sat in a fortress on the narrow island, which starts with the tower on the far right of the picture. The island

was considered "the thorn in Geneva's flesh" by its citizens.

The crumbling walls in front of the tower point to fortifications that have fallen into decay. Documents show that in 1444 great efforts were

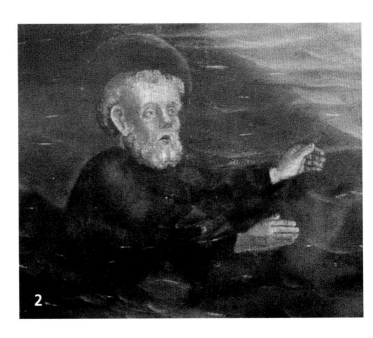

2

made to bring the city's walls and ditches back into good order. Behind the tower lies a marshy area in which the houses are built on stilts. The fields and hedges on the far shore give a peaceful and well-ordered impression. Washerwomen are bleaching their sheets on the shore, shepherds are grazing their flocks, and on a terrace, known then as now as the Pré l'Evêque (Bishop's Meadow), members of an officially registered confraternity are practising their archery.

A seemingly paradisaical landscape. Surely a region could only flourish as well as this under a wise regent? There is good reason to suspect that this landscape, rendered with such fidelity to nature, was

painted in praise of its sovereign of many years – a sovereign who in 1444, however, was no longer in power: Amadeus VIII, Duke of Savoy.

In 1434 "Master Konrad of Rotwil" bought his way into the guild of painters, stonemasons and goldsmiths not in the city of Geneva, but in Basle, having previously married – as was the convention – the daughter of a painter and guild member. He had settled in Basle a few years earlier, probably drawn to the city not least by the presence of the Council of Basle. It was a well-known fact that such theological councils brought foreigners into the city and boosted the volume of money in circulation. Accommoda-

tion had to be built and festivities staged, and this meant work – and pay – for painters. Councils also offered artists the chance to make themselves known to potential clients from outside the city.

The Council of Basle began in the spring of 1431, and was dominated by the dispute over who was the supreme church authority: the Pope or the Council? The Pope saw himself as the direct successor to St Peter, and his supporters based their defence upon the words spoken by Christ according to St Matthew: "You are Peter, and upon this rock (*petra*) I will build my church." His opponents argued that nowhere was it written that Peter had more authority than the other apostles, and that the "rock" was not Peter, but Christ himself.

It was not a question of authority, however, but of power. For centuries the papal throne had been a thoroughly secular institution surrounded by controversy. The popes had been forced to seek refuge in Avignon from 1309 to 1371, and from 1378 two popes reigned concurrently for 39 years, one in Rome and the other in Avignon. Amidst these battles between families and nations, the true, spiritual duties of the Church were increasingly neglected.

The idea of replacing the authority of the Pope with a Council was by no means new. Naturally, the Pope in Rome rejected the calls of the church leaders gathered in Basle. In 1437 he shifted the Council to Ferrara, and later to Florence. Only a few of those taking part obeyed. The others remained in Basle, and in 1439 declared the Roman Pope deposed and elected a new one: the ruler of Geneva and its surroundings, Amadeus VIII.

Amadeus is one of the more interesting figures in European history, and had Savoy remained an independent state with its own traditions he would be better known today than he actually is. Born in 1383, he consolidated his lands through strategic treaties, protected himself against the aggressive Burgundians to the north by marrying the daughter of a Burgundy duke, and extended his influence south of the Alps by marrying his own daughter to a Visconti. Amadeus ran what was, by contemporary standards, a model system of government, and – at the age of fifty and height of his power – handed over the running of the affairs of state to his two sons. That was in 1434.

His wife already having died, he left his lively and luxurious court in his capital of Chambéry and withdrew to a sort of monastery, built on his own instructions, on Lake Geneva. With the prior's permission, he dressed as a "hermit", and with a small number of companions lived a pious, modest, albeit not entirely ascetic life. Nor did he quite relinquish all his authority; his sons still had to consult him on all the most important appointments and

treaties. The Duke simply kept out of the tiresome day-to-day business of government.

His secular monastery was called Ripaille; *faire ripaille* in those days meant, unkindly, to "feast", "carouse" or "revel", as it still does in French today. The building is still standing; it can be found on the French side of Lake Geneva between Evian and Thonon.

This duke, hermit and wise lover of the good life was thus elected in Basle to be the successor to St Peter. Decisive factors in his election were his reputation as a judicious ruler and pious son of the Church, and the role of his duchy as geographical intermediary between France and Italy. No doubt the large number of Savoy clergy attending the Council also played a part. Since the Pope in Rome refused to be supplanted by the one in Basle, there were once again two popes. The Church was split a second time.

It was conventional for Peter to be portrayed with a beard, and the hermit Amadeus also boasted a famous beard, which is mentioned in several texts. In contrast to pictorial tradition, however, Peter's successor to the papal throne had to be clean-shaven, and so Amadeus had his beard shaven off. His beard undoubtedly lent him "a sort of dignity", wrote a critical observer, and without it his "slanting eyes … and flabby cheeks" made him look "like a very ugly monkey".

If we look more closely, it is clear that Christ is standing not on the shore but on the water. According to St Matthew, the disciples were out in their boat one stormy night when they saw Jesus walking towards them across the water. Peter wanted to go out to him, but lost his nerve on the water and started to sink. Christ reached out his hand to him and asked: "Why did you doubt me?"

Why the painter – or his patron – should incorporate a reference to this second biblical scene into the composition is unclear, but perhaps he was recalling the hesitation and doubt shown by Duke Amadeus. It was usual for the person elected Pope to decide within 24 hours whether or not to accept the elevated office. Amadeus, however, kept the delegation which had brought the offer from Basle waiting, as he stalled for time. He had to consider the good of the Church and that of his duchy, and in particular work out the financial implications of becoming Pope. The outcome was that he abdicated as duke and regent once and for all, accepted his election and took the name Felix V.

In 1440 he made his ceremonial entry into Basle and had himself crowned Pope. As his papal coat of arms he chose those of Savoy, a white cross with short, broad arms, as later adopted by the Swiss Confederation. A flag bearing this cross was carried in front of his missions. As the years passed, however, more and

3

more countries declared their allegiance to Rome, and in 1449 Felix V stepped down. Two years later he died. Witz' altarpiece was thus painted during his term of office. It was probably destined for St Peter's cathedral in Geneva. But who commissioned it?

The content of a painting – its so-called programme – was decided not by the artist, but by the person commissioning it, and since there are no other landscape portraits in Witz' œuvre, the idea of locating this biblical scene in Savoy must have come from the patron or his advisers. The fact that a pope was reigning not in Rome or Avignon, but on Lake Geneva, must thereby have been very important to them. It may be that the panel was paid for by Felix V himself. Researchers have come up with two other possible patrons, however.

One is François of Metz, Bishop of Geneva with his see in St Peter's cathedral, whom Felix elevated to cardinal immediately after being crowned Pope in 1440. A portrait of the cardinal is probably to be found on one of the other altar panels.

A second possibility is an Italian called Bartolomeo Vitelleschi. He was amongst those who had profited from the schism in the Church. His uncle, an Italian cardinal, had been suspected of treason by the Roman Pope and murdered in 1440; as one of his relatives, Bartolomeo was also pursued and fled with his uncle's savings to the newly-appointed Antipope, who first made

A white cross with broad arms

4

Under the seal of the fishermen

period of transition. The painters of this era were fascinated by humankind, by the richness of nature, by the representation of space in perspective. Their interest was directed towards their visible surroundings. For the artists of the Middle Ages, on the other hand, their physical environment and this earthly realm were relatively unimportant. It was their task to bring to life the events narrated in the Bible, to guide the viewer from the visible to the invisible, to what exists outside of time, to the hereafter, to God.

Witz, too, makes it impossible for the viewer to overlook the actual focus of his altarpiece: he shows Christ as much bigger than the disciples (even allowing for perspective, to emphasize his symbolic significance) and swathes him in a voluminous robe whose red mass ensures that he stands out clearly within the composition. Directly above Christ's head rises the Môle Pointu, with its summit encircled by a cloud – like the clouds which, in medieval painting, traditionally bore the risen Christ up to Heaven.

In order to lend the invisible more tangible expression for the viewer, the artists of the Middle Ages, including Witz, frequently employed symbols. At the front edge of the picture and beneath the two figures of Peter, a large stone rises out of the water: it represents either Peter the Rock, or the rock on which

him assistant bishop to François of Metz and later also a cardinal. The fact that Savoy, the land which had given him refuge, should appear on the altarpiece rather than some imaginary landscape, would have been particularly important to him. And like François of Metz, he owed the Savoy Pope a large debt of thanks.

Konrad Witz' *Miraculous Draught of Fishes* came at the end of the Middle Ages and the beginning of the Renaissance, and as such documents a

Konrad Witz

the Church is founded. One of the symbols for the Church was a ship. In a communiqué, the Council of Basle insisted that it wanted to avoid a fatal division in the Church and reach port safely in "Petri navi", Peter's boat. The fact that Witz placed his fishing boat directly beneath the hilly landscape of the Voirons, whose silhouette looks like the same boat turned upside down, is undoubtedly no less of a coincidence than his positioning of Christ beneath the cloud-capped mountain.

Fish, too, came into the category of symbols. Christ met Peter and his brother Andrew while they were fishing, and he "called out to them, 'Come, be my disciples, and I will show you how to fish for people!'" The fish became the secret symbol of early Christian communities; baptism was celebrated as a draught of fishes, and the Savoy Pope Felix V signed one of his missives "Datum Lausannae sub annulo Piscatorum" (Given to Lausanne under the seal of the fishermen).

According to St John, there were 153 fish in the disciples' nets, surely not a number he selected at random. Its symbolism was later unravelled by St Augustine. In Witz' panel there are only 16 or 17; was this significant, or was Witz simply trying to be more realistic with his smaller catch? His treatment of the individual fish can hardly be dismissed as stylized; rather, he portrays them from various sides and in various positions, not even forgetting their reflections in the water. We are given the distinct impression that the painter is concerned less with the metaphorical meaning of the fish than with recording what he has observed with his own eyes.

In contrast to *The Miraculous Draught of Fishes*, two of the other surviving panels from Witz' Geneva Altar have gold grounds. Thus, fully in line with medieval tradition, he affirms belief in the hereafter, the temporary nature of this earthly life, and the existence of God. More interesting to the modern viewer, is the way Witz' painting reveals a new awareness of the real world – something we consider a step forward. Seen through the eyes of the people of the Middle Ages, however, it signalled a downward slide: the hereafter was displaced by a panorama, the noble task of painting subverted by the reproduction of something already visible for all to see.

Petrus Christus: St Eligius, 1449
A Christian artisan advertises his craft

Three figures in a narrow interior. The convex mirror shows two men standing on the street outside. Like the spectator, they are gazing into the picture space: a goldsmith's workshop. Guild regulations demanded a shop be open to the street so that customers could assure themselves that a smith was not guilty of doctoring his precious metals.

The goldsmith is painted in the act of weighing a ring; a young, richly dressed couple looks on attentively. However, the eyes of the goldsmith are not focused on the scales in his hand but raised in an upward gaze. He is more than an ordinary artisan: he is the patron saint of goldsmiths, St Eligius.

The artist has added a Latin inscription to the bottom edge of the 98 x 85 cm panel. Translated, it reads: "Petrus Christus made me in the year 1449." This was unusual in the 15th century; artists tended to remain anonymous and rarely dated

their paintings. Little is known of the artist's life: he acquired the citizenship of Bruges on 6th July 1444; in 1462 he joined a brotherhood; he is mentioned seven years later as a distinguished member of the artists' guild, which also registered his death in 1473.

Petrus Christus was born at Baerle, probably in 1415. It is thought he may have been the pupil of Jan van Eyck (c. 1370–1441), and that he completed works left unfinished by the master at his death before founding his own workshop, for which he was obliged to acquire citizenship. 1449, the year in which he painted St Eligius, also saw the dedication in Bruges of the Chapel of Smiths, the guild to which goldsmiths belonged. Perhaps this event occasioned Petrus Christus's painting of St Eligius in his workshop.

In the 19th century the painting entered the collection of a German who claimed to have bought it from

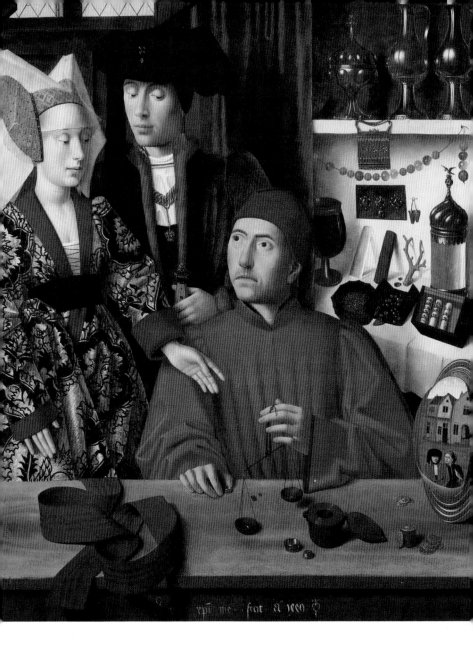

St Eligius, 1449

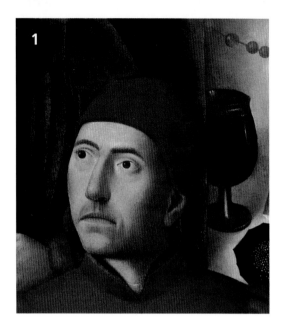

1

From blacksmith to minister

a Dutchman. The Dutchman had apparently claimed to be the sole surviving member of the Antwerp Goldsmiths' Guild. Antwerp had overtaken Bruges as a centre of trade and commerce in the late 15th century. Perhaps the painting followed the flow of money. Today it is in the Metropolitan Museum, New York.

The painting is a devotional work, but it also served as a kind of advertisement for the goldsmiths' craft and guild. Behind the pious man, Petrus Christus has arrayed a selection of rings, silver pitchers, a chain, brooches and pearls – luxury goods for which, in the year 1449, there was considerable demand in the wealthy town of Bruges. At that

time the town belonged to the Duchy of Burgundy, a kingdom amassed in three generations by the French dukes of Valois, extending from the French province of Burgundy, which bordered with Switzerland, to the North Sea. Its commercial capital, and indeed that of the whole of northern Europe, was Bruges. Ships sailed here from the Mediterranean, England and the Hanseatic ports. Bruges was a busy overseas trading centre for timber, cereals, furs and dried cod from the north, and for wine, carpets, silks and spices from the south. In one day in 1457, Bruges's harbour on the Zwijn at Sluis contained two Spanish and 42 British caravels, three Venetian galleys, a Portuguese hulk and twelve sailing ships from Hamburg. These were good times – not least for producers of luxury goods.

The merchants of the day devoted special attention to weighing goods, for different countries used different units of measurement and fear of fraud was widespread. In 1282, the merchants of the Hanse had managed to have one of their own weighing scales, constructed in Lübeck, set up in Bruges. That a saint should be painted in the act of weighing, in which trust played such an essential part, rather than executing some other form of work, is probably no coincidence.

Trade attracted finance, and Italian banks chose Bruges as a base for their northern branches. The gold

coins of many nations circulated in the town. On the saint's counter can be seen gulden from Mainz, English angels and, of course, the heavy "riders" of Duke Philip the Good of Burgundy (1396–1467), regent during Petrus Christus's lifetime.

Even today Saint Eligius is well-known to French-speaking children as "grand Saint Eloi" who, in a popular ditty, informs absent-minded King Dagobert that he has his trousers on back-to-front, to which the king replies that he will just have to turn them back round again then. In one sense at least the song is based on historical fact: Eligius really did act as personal adviser to the Merovingian King Dagobert.

Eloi, or Eligius, was born at Limoges in c. 588, completed an apprenticeship as a goldsmith and soon gained a reputation as a thrifty and skilful craftsman. Commissioned by the court to make a throne, Eligius, using the precious materials, gold and jewels provided, managed to produce two, whereupon the king appointed him minister and master of the mint. A coin, the "sou de Paris", bore his signature. Because Eligius was very pious, Dagobert also appointed him Bishop of the Diocese of Noyon, which included Bruges. As a bishop he is said to have led a lapsed population back to the Church. He founded several monasteries and chapels, and three churches in Bruges alone.

A number of miracles were ascribed to him, greatly strengthening his hand as a missionary. He is said to have started out as a blacksmith. When brought a particularly wild horse to shoe one day, so legend has it, he severed the horse's foot, fitted it with a new shoe, and put it back on again, whereupon the horse cantered friskily away. It became a custom on the saint's feast day on 1st December to provide large quantities of wine for the blacksmiths and everybody who worked in the stables.

Rather than displaying him in episcopal robes, Petrus Christus paints the saint in the clothes worn by the citizens who were his customers. Eligius became the patron saint of blacksmiths, goldsmiths and money changers. These shared a common chapel and marched together at processions under the banner of the blacksmiths, whose guild, though possibly not the most elegant, was certainly the most powerful.

The guilds emerged in the Netherlandish townships of the 14th century. Their purpose was to prevent ruinous competition, to guarantee high standards of workmanship and represent the interests of craftsmen. Thus goldsmiths were required to work at an open window but forbidden – according to a 14th-century Netherlandish document – to draw attention to themselves or canvass custom by "sneezing or sniffling". They were also bound to confine their business practice to one

place. Each guild had its own religious superstructure with a patron saint and, if wealthy enough, an altar or chapel of its own.

The medieval guilds of Bruges, like those of other towns, made a decisive contribution to the city's rise and fall. Originally progressive associations became clubs for the defence of privilege. Closing their ranks to new members and new methods of production, they constantly quarrelled with other guilds and thus were responsible for sapping the strength of the citizens' council, which, in turn, made it easier for the Dukes of Burgundy to bind the townsfolk to their will. When a revolt against the Duke's policies failed in 1436/37, the citizens were forced to beg on their knees for forgiveness.

By 1494, half a century after Petrus Christus painted his portrait of St Eligius, "trade in Bruges had come to a standstill". Some 4000 to 5000 houses were left behind – "empty, locked up or ruined". The merchants and bankers moved to the more flexible town of Antwerp, where medieval guild regulations were no longer applied in quite such a narrow-minded manner.

A ring, reputedly made by Eligius for St. Godeberta, was once kept at the Noyon Cathedral treasury (Eligius' see).

Wealthy suitors are said to have competed for Godeberta's hand, but her parents could not decide without the consent of the king, who may well have been interested in the girl himself. The matter was in council before the king when Eligius intervened with his golden ring, declaring the young woman to be a bride of Christ. Religious critics have inferred that the painting alludes to the legend. But rather than painting the saint as an opponent of worldly marriage, it is more likely, and probably far more in keeping with the patron's interests, that the artist wished to show him as a supporter and guardian of marriage. After all, the manufacture of wedding rings was a lucrative department of the goldsmith's trade. Eligius is seen weighing a ring in the painting. A traditional wedding girdle lies on the counter in front of the couple.

It is unknown whether the work – like Jan van Eyck's "Arnolfini" portrait – is the depiction of a particular couple. Both persons wear sumptuous, fashionable clothes only members of the Burgundian duke's court could afford, or the few wealthy burghers who mixed with the aristocracy. The lady's gold brocade with its exotic pomegranate pattern probably came from Italy; her golden bonnet is embroidered with pearls. Following a trend set by the duke, courtiers were richly adorned with jewellery. The lady's fiancé wears not only a heavy gold chain but a brooch pinned to his el-

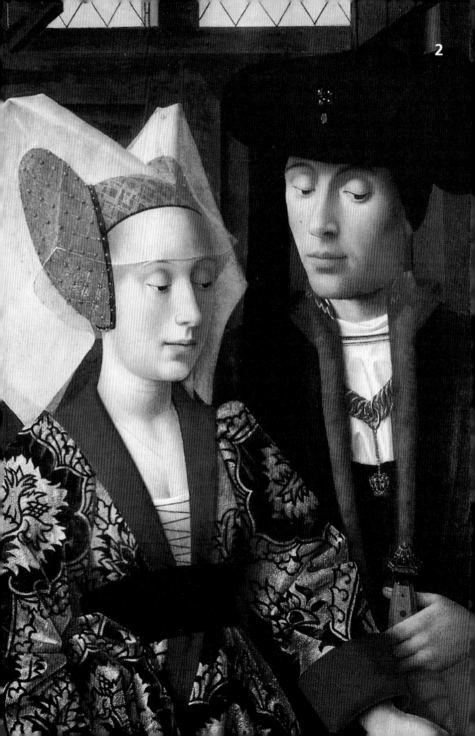

3

Not only was his festive table opulently laid for banquets, but tables along the walls, piled with plates and dishes and guarded by members of the goldsmith's guild, made a deliberate display of costly tableware owned by the Duke. A salt-cellar decorated with sirens was considered an especially valuable piece. It was valued at about 900 ducats, the equivalent of approximately 200 times the yearly wage of a craftsman.

There was a degree of pragmatism in this ostentation. Gold and silver demonstrated wealth, and wealth was an important pillar of power. Moreover, symbols of power had to be readily transportable, for like all great potentates, the Burgundian dukes were highly mobile, travelling constantly from one residence to the next. The treasure was carried from place to place, and it was quite common for services to be rewarded not with money, but with golden dishes, jewel-encrusted boxes or solid gold chains. In a manner of speaking, a goldsmith produced disposable assets.

Probably the most valuable of the artefacts ranged on the workshop's shelves were the tiny, dark, trowel-like objects pinned to the wall on thin gold chains. They were called "adder's tongues" or "glossopetrae"; in fact they were fossilized sharks' teeth. They were supposed to detect poison by changing colour on con-

Gems as a protection against poison

egantly bound headgear. He may well have been one of the goldsmith's better customers.

However, the Bruges jewellers' best customer was the Duke himself. In 1456 French visitors reported never having "seen the like of such wealth or such brilliance" as witnessed at the Burgundian court, and one chronicler described Philip the Good as "the richest prince of his day". Every object he used, from his cup to his toothpick, was made of solid gold, and he possessed a large collection of precious stones, brooches, rings and clasps.

tact. In view of their importance, "touchstones" like this were given an appropriately showy setting. The preference for drinking from coconut-shell goblets was based on a belief that the exotic fruit had the property of a counter-poison. A vessel of this kind can be seen on one of the shelves, half concealed by a curtain. The demand for "touchstones" was great, for princes led dangerous lives. Both Philip's father and his uncle were assassinated. Rumours of attempts to poison various other members of his family abounded, and there was evidence of an attempt to poison Philip's heir, Charles the Bold, in 1461. Rulers had servants whose job was to taste the food before they ate it, thus protecting them against poisoning. The vessels from which their food was served were covered by special lids to prevent anything being added *en route* between kitchen and table. The "privilege of lids" was a form of protection enjoyed solely by the ruling princes of the day.

Most of the objects on the goldsmith's shelves served a dual purpose: they were not only jewels, but a means of warding off evil. Magical qualities were ascribed to branching coral; it was supposed to stop haemorrhages. Rubies were said to help against putrefaction and sapphires to heal ulcers; the two oblong articles leaning against the wall were probably touchstones. Above them are brooches, a rosary of coral and amber and a golden buckle that would fit the wedding girdle. The vessel of gold and glass next to the branching coral was probably used to keep relics or consecrated communion wafers.

Religion, magic and symbolism have lent a particular aura to the art of the goldsmith. Besides their value and magical powers, precious stones were also seen as symbols of continuity and longevity. Gold was considered the quintessence of worldly riches, as well as a symbol of power. Whoever held power over the Germanic tribes gained possession of their golden treasure, as we know from the myth of the Nibelungs.

Tradition granted goldsmiths a special status as craftsmen. During the early Middle Ages they worked only for the church and for rulers, who were thought to rule by the authority of God. The most famous 13th-century goldsmith was a monk. In some Catholic regions the prestige enjoyed by goldsmiths may have survived to this day. A play published in 1960, for example, contains the figure of a goldsmith with highly unusual abilities and a particularly piercing gaze, a "marvellous" maker of wedding rings. "My gold balance", he explains, "does not weigh metal but the life and lot of human beings..." The play, entitled "The Goldsmith's Shop", was even turned into a film. Its author, Karol Wojtyla, became Pope John Paul II.

The weights for the hand-scales were evidently stacked inside one another and stored in the round receptacle with the open lid lying on the counter. The gold coins next to them may allude to the office held by Eligius: Master of the Royal Mint. In the 15th century Eligius was also the patron saint of moneychangers, an important profession in the banking town of Bruges; they also formed a sub-section of the goldsmiths' guild.

The convex mirror to the right of the coins reflects several of Bruges's characteristic red-brick houses. The two men outside the open shopfront are painted approximately where we might expect a spectator of the painting to stand. The trick with the mirror allows the artist to present a view taken simultaneously from within and without, enabling him to show what lies in front of and behind the imaginary spectator. The problem of spatial organization seems to have fascinated him. However, to judge by the angles of the shelves, the Bruges master was not acquainted with the mathematical laws of perspective recently discovered in Florence. Petrus Christus was still experimenting.

Convex mirrors, sometimes called "witches" for their "magical" powers, were frequently found in Netherlandish households; hung opposite a window, they could make a room brighter. Jan van Eyck paints a mirror of this kind in his "Arnolfi-

ni" portrait. Since it is probable that Petrus Christus was apprenticed to the older master, the mirror in the present painting may be a "quotation". As Van Eyck's mirror is presumed to show his own reflection, the present painting may equally contain a likeness of Petrus Christus in the figure of the man with the falcon, whose head is tilted in an attitude frequently found in self-portraits. Falconry was a favourite pastime at the Burgundian court, and falcons were imported from far and wide. For an artist like Petrus Christus, however, the sport would have been much too costly; he probably held a menial position at court.

Although the artist signed and dated this painting, his biography has remained something of an enigma to historians. The heart-shaped sign next to his signature may be a "master's trademark" such as was used in Bruges not by painters but by miniaturists and goldsmiths. Perhaps the artist was trained in one of these crafts. The biographies of several Renaissance painters, most notably Botticelli, refer to their apprenticeship to goldsmiths. If this were also true of Petrus Christus, it would explain his relationship to St Eligius and the artefacts, painted so accurately, in his shop.

Many of these objects had a short life. They were used by powerful people as a form of cash payment. Depending on the needs of their new owners, they might then be tak-

en apart or recast – much to the joy of the goldsmith, to whom it meant more work, and much to his sorrow at seeing his work done in vain. It is known that at least one goldsmith despaired to such an extent at the destruction of his artefacts that he threw in his trade and entered a monastery.

Little, too, has survived of the treasures once owned by the dukes of Burgundy. The last of the dukes, Charles the Bold, was defeated in Switzerland in 1476. The treasure he had with him at the time fell into the hands of Swiss goatherds who had no use for it. They sold the "Burgundian booty" below value, breaking the pearls and diamonds out of their settings and melting down the gold to make them easier to sell.

Benozzo Gozzoli: Procession of the Magi, 1459

A family sings its own praises

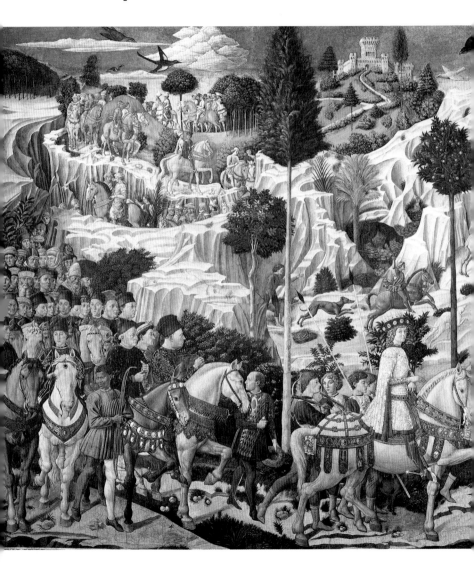

Benozzo Gozzoli

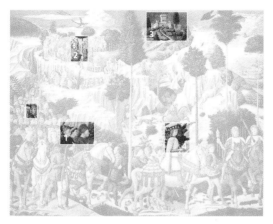

When the art-loving Medici family commissioned Benozzo Gozzoli (1420–1497) to decorate the chapel of the present-day Palazzo Medici Riccardi with a series of frescos, it had almost reached the summit of power in the medieval city republic of Florence. The artist, who started work on the frescos in 1459, used the Christian legend of the Procession of the Magi to create a magnificent monument to the proud and ambitious dynasty of bankers.

Festive processions were extremely popular in Renaissance Italy. Combining lavish display, fancy dress and self-publicity, they offered a welcome distraction from everyday life. The Florentines, in particular, adored such spectacles, and the processions through their city are supposed to have been the most dazzling of all.

They were organized by guilds and societies such as the charitable Compagnia de' Magi (Company of the Magi). Every 6 January, the feast

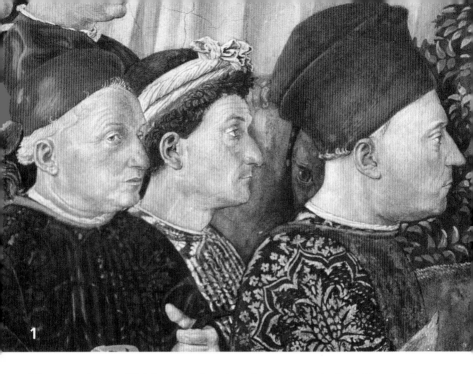

1

Money and modesty as stepping-stones to power

of Epiphany, members dressed up as the three wise men from the East and their companions and processed through the streets of Florence. Benozzo Gozzoli took such processions as his inspiration in his decorative scheme for the Medici's private chapel. He painted three sides of the chapel with frescos filling the entire wall, each depicting one of the three kings with his train. Only one of the frescos is still in its original state, the other two having been affected by subsequent building work. It is the fresco depicting the Medici family itself.

The Medici were members of the Compagnia de' Magi. They had another, more personal reason for sup-

porting its lavish processions, however: such spectacles kept the people happy, captivated their attention and thereby distracted them from the political problems of the day. Political philosopher Niccolo Machiavelli (1469–1527) observed that "giving the people something to take their minds off the State" was a deliberate Medici tactic. That something was festivals and processions.

By 1465 – six years after Gozzoli had painted his frescos – the feeling of dissatisfaction amongst the citizens of Florence had grown particularly pronounced. At the instigation of the Medici, the Compagnia de' Magi therefore decided to stage a Three Kings procession "so splendid

and magnificent, that its planning and execution preoccupied the whole city for several months", as Machiavelli noted. During this time, the Medici were able to implement their political plans and rule Florence without disturbance.

The elderly man on the left was the unofficial ruler of Florence: Cosimo de' Medici (1389–1464), to some people a despot obsessed with power, to others a "father of the Patria" worthy of the title. Riding alongside him are his two sons, both of them already mature in years: with the white band tied around his head, the gentle, food-loving Giovanni (1421–1463), who was destined to take over the running of the family bank; with the simple red hat, the elder Piero (1416–1469), who would inherit his father's political leadership.

All three were ill men, often laid out simultaneously by severe attacks of gout. While Gozzoli was working on his frescos, Cosimo was so stiff that in 1459 he was unable to kneel before Pope Pius II, who was visiting Florence at the time and was profoundly impressed by the 70-year-old. "It is he," wrote Pius, "who decides between war and peace and supervises law and order … The political problems are solved in his house. Official positions are given to those whom he choses. Title and ceremony are all that he lacks to be king." And further on: "He is very

modest; only one servant accompanies him when he goes out."

A proud reserve characterized Cosimo throughout his life. Even in this fresco, his simple black garb stands in contrast to the gold embroideries worn by his sons. Yet he had transformed the banking house founded by his father in 1397 into the biggest of its day, with branches across Europe. It was managed from the control centre in Florence, the Medici city palace, where the chapel containing Gozzoli's frescos is also found.

Cosimo used the profits from his banking operations to secure his position of power in Florence; he bought the allegiance of friends and clients with gifts and secured the favour of the masses with expensive festivals. Money was also at the heart of his foreign policy. He won the support of the Duke of Milan and the King of France in the north and created a balance of power vis-à-vis Venice and Naples which would ensure Florence's peace and prosperity. By 1459 Cosimo's ambitions were fulfilled, and it was now simply a question of handing over the reins of power to his sons.

When implementing his plans, Cosimo was careful to avoid offending those of his fellow citizens who still clung to the fiction that Florence was a republic. His motto, accordingly, was "Wisdom, moderation and courage", symbolized in his coat of arms by three ostrich plumes. Al-

though these plumes, and the balls which also form part of the Medici coat of arms, are not found on the bridle of Cosimo's mule, they can be seen on that of Piero's grey, and indicate to the identity of the rider. While there are no contemporary texts confirming that Gozzoli included portraits of his patrons in his frescos, it would have been conventional practice for him to do so. Donors of altarpieces, for example, frequently appeared in the paintings they had commissioned, naturally in a reverent pose and at a fitting distance from the saints – but not so far removed that they could not be seen.

Bearded types in exotic costumes and strange headdresses mingle in Gozzoli's fresco with smooth-shaven Florentine merchants. In the context of a *Procession of the Magi*, the presence of these Oriental figures is not implausible; but on the walls of the Medici chapel they also fulfil another, more specific function. They recall Cosimo's first international "coup": in 1439 he managed to entice a major ecumenical council to Florence.

Gozzoli probably watched the council fathers make their spectacular entry into Florence in person, as a 19-year-old youth. At the head of the procession rode the Byzantine Emperor John VIII Palaeologos, accompanied by Joseph, patriarch of the Orthodox Church. The painter prob-ably gave their trains to the two Magi depicted on the two other walls of the chapel. They were followed by 22 bishops and numerous other dignitaries, together with a whole crowd of servants, pedlars and prostitutes.

The Council was intended to end the tensions between the Catholic and the Orthodox churches and to unite Christians against the Turks. It was preceded by protracted negotiations; even the question of where to hold the Council was beset with problems. It had to be somewhere acceptable not just to the Pope and the Eastern Emperor, but also to the various Italian states. After much deliberation, Ferrara was eventually selected.

With a great deal of diplomatic skill, however, Cosimo succeeded in transferring the Council to Florence. The official excuse for relocating the event was an outbreak of the plague near Ferrara. Ultimately, however, the decision was probably precipitated by the fact that Cosimo, the wealthy financier, offered to assume part of the Council's costs.

The meeting in Florence was ill-starred. The agreement, reached after months of negotiations, whereby the Byzantine Emperor would submit to the authority of the Pope, was rejected in fury by the clergy and people of the Eastern Roman Empire. Emperor John died in 1448, shortly before his empire was conquered by the Turks.

Far more positive were the consequences of the Council for the citi-

zens of Florence. They filled their coffers with the money flowing freely from the hands of the council fathers, trade blossomed, and profits far exceeded Cosimo's investment. The venture had not only paid off in material terms, but profited the city in a less tangible way. The council members arriving from the East had packed a new culture in their bag-gage, so to speak, and brought it with them to the Arno –namely the language, literature and philosophy of the Greeks. For centuries, the Byzantine Empire had been alone in preserving Greek culture, but the visitors from the East now drew the attention of their Florentine hosts to this almost forgotten cultural sphere. Italian merchants soon started col-

The Orient comes to Italy

Procession of the Magi, 1459 93

lecting antique manuscripts while their children learned Greek. Florence became the centre of humanism and experienced the Renaissance of Greek culture within its own walls. When Turkish forces overran Constantinople in 1453, many fleeing scholars from the Bosporus sought refuge in the former council city with which they were already familiar. In Florence they were not only able to make a good living as teachers, but were treated "like princes". Cosimo de' Medici thereby set the example.

The success of his "Council operation" increased Cosimo's prestige and cemented his dominant position within the city. Venice, another major power in Italy, noted with ir-

ritation that "this money-shoveller" had the Pope and his Council in his pocket. And there was a danger, according to the Venetians, that half of Italy would soon disappear in there alongside them.

There were over 800 villas in the immediate vicinity of Florence of the sort portrayed by Gozzoli in the background of his fresco. They lay not in an inhospitable rocky landscape, however, but nestled amongst the gently undulating hills which surrounded the city. There, according to an enthusiastic contemporary, "there is little mist, no pernicious wind and everything is good, including the pure, clean water; and of the countless buildings, some are

Splendid palaces for the self-sufficient rich

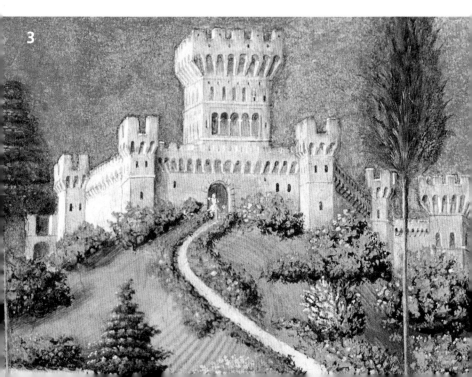

3

like princes' palaces, some like beautiful castles."

These villas were often converted from castles formerly owned by the aristocracy, who had long since fallen from power. They boasted fortified towers and crenellated battlements. In Gozzoli's fresco, the keep has wide, elegantly curving arched windows which are unlikely to date from the Middle Ages. They correspond to a new demand for light and air, for a view of nature. All the villas had shady gardens and were surrounded by agricultural outbuildings.

In their love of the rural life, the practical Florentines invariably remained profit-oriented; even the richest of them retired to their villas not just to escape from their business affairs and to find diversion in the beauty of nature, but to enjoy eggs freshly laid by their own hens and wine from the vineyards behind their houses. The prosperity enjoyed by the city dwellers thereby spilled over onto the peasants in the region, who made a good living as tenant farmers or labourers on townspeople's estates.

The Medici naturally owned several country estates. One such was the villa near Careggi, purchased by the family in 1417 and later extended and modernized by their favourite architect, Michelozzo (1396–1472), who also built their city palace. Perhaps it was this villa, or the so-called "Medici fortress" near Cafaggiolo,

constructed in 1451 also by Michelozzo, that Gozzoli had in mind when painting his fresco.

The members of the Medici family seem to have moved continuously from one villa to the next, depending on the season, the weather and their state of health. The gout-afflicted kinsmen were permanently fleeing from "pernicious winds" and searching for good air and "pure, healthy water". Their city palace, moreover, had been a building site for years, and no doubt Florence's rulers also liked to keep a certain geographical distance between themselves and their recalcitrant fellow citizens.

Cosimo, the head of the family, was particularly fond of living in the country and used his time in his villas to demonstrate to the rest of the world the simplicity of his republican lifestyle. Clad in the simple garb of a country dweller, he loved to cultivate his own garden. He would prune the vines while his in-house scholar, Marsilio Ficino, read aloud to him from the works of the Greek philosopher Plato. Cosimo usually received the members of the Platonic Academy, which he founded in 1459, in the country, too, beside a babbling stream which flowed through the shady villa gardens.

In the face of the youngest of the Magi – so tradition has it – Benezzo Gozzoli painted a portrait of Lorenzo de' Medici (1449–1492), who rep-

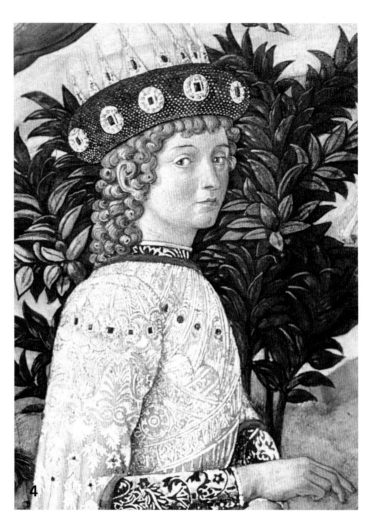

4

The clan becomes a dynasty

resented the third generation of Medici rulers. With him, the dynasty almost became a monarchy, and on the walls of this private chapel the banker's son wears a crown. Escorted by six armed young men, Lorenzo rides a horse whose bridle bears the family devices of golden balls and ostrich plumes. Lorenzo himself appears against a laurel bush – a play upon the Latin word *laurus*, from which his name was derived.

The harmonious features of the young king bear no obvious resemblance to known portraits of Lorenzo. When the frescos were painted,

Benozzo Gozzoli

Lorenzo was still a child with immature features, but he is nevertheless unlikely to have been as handsome as this. He was unabashedly ugly, with bulging eyes and a flattened nose. But he more than made up for his looks with his kindness, charm, intelligence and artistic talents – as an organizer of lavish festivals, too, he was allegedly unsurpassed. He came to power at the age of 21, and he entered the history books as Lorenzo the Magnificent.

The young Medici heir is already decked out in magnificent style in Gozzoli's fresco. The paradoxical requirements of Florentine politics demanded that the city's leaders should display both a modest reserve and an appropriate degree of pomp when representing the city on official occasions. During the state visit of Pius II, the 10-year-old Lorenzo rode on a white horse in the ceremonial procession. His robes of velvet and brocade, interwoven with gold thread, were a showcase for the most beautiful products of the Florentine textile industry, which was now exporting ever more exquisite, luxury fabrics in place of the simple wools of the past.

In art, too, modern tastes demanded gold ornament. It was something to which Piero de' Medici attached particular importance. From his villa near Careggi, he personally oversaw Gozzoli's work on the frescos. In the summer of 1459 the painter wrote to him asking for

an advance, so that he could negotiate a better price for the large quantities of gold and ultramarine that he needed to buy. "I would have come to speak to you in person, but I started applying the blue early this morning, the heat is great and the size is quickly spoiled." Gozzoli addressed his patron as "My distinguished friend" and did not hesitate to ask the Medici directly for assistance on another occasion, too, when he got into trouble because his apprentice had stolen two bed sheets from a monastery.

Although Gozzoli did not rank amongst the top-flight painters of his day – he had a few problems with perspective, as is evident in the hunting scene – he was one of those artists who followed their client's wishes to the letter. To the Medici, that was undoubtedly important. Gozzoli nevertheless seems to have possessed a healthy self-confidence, for he made sure that – in a work where so much is left to conjecture – one person at least can be identified in all certainty: the painter himself. Gozzoli included his own portrait amongst the members of the royal train and wrote, in gold letters on his cap, the words "Opus Benotii" – "The work of Benozzo".

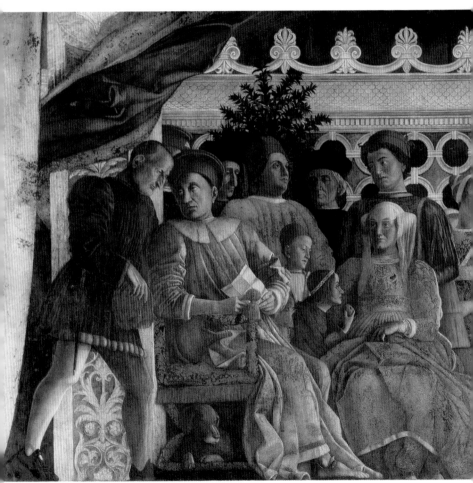

Andrea Mantegna

The splendours of a small dynasty

Their country was "marshy and unhealthy". They suffered from gout, malaria, rickets and a chronic shortage of cash. But the proud Gonzaga commissioned their family portrait from the "most modern" artist of their time. The fresco can still be admired in the reception room of the Ducal Palace at Mantua.

Gold-embossed leather curtains are drawn back to reveal a terrace. Here, a distinguished company is gathered before a marble screen among the lemon trees: the family and court of Marquis Ludovico Gonzaga of Mantua, in northern Italy.

Only the reigning couple can be identified beyond doubt. Ludovico is shown with a letter in his hand, conferring with a secretary. Marchioness Barbara of Brandenburg has a little daughter at her knee; behind her may be one or two of her ten children. The sombre officials in their dark clothes contrast starkly with the arrogant-looking courtiers, possibly Gonzaga bastards, or masters of ceremonies. They wear stockings in the red-and-white of the reigning house.

Rubino, the marquis's dog, and a dwarf complete the family portrait.

The Gonzaga, dressed in luxurious, gold-spun cloth and blessed with many children, present the image of a confident, successful clan. In the middle of the 15th century, the family had experienced a sharp upturn in fortune. In 1328, one of their predecessors, a simple but nonetheless wealthy landowner, had risen to the position of "Capitano" of the city of Mantua. The family had succeeded in retaining its foothold, amassing power and finally adding legitimacy to its position through the purchase of a ducal title from the emperor.

By the standards of the wealthy Florentine Medici, the income of

the Gonzaga was limited. Their small territory on the Lombard plains was modest by comparison with the powerful states of Venice or Milan. Pope Pius II gave a bleak description of Mantua in 1460: "Marshy and unhealthy ... all you could hear were the frogs."[1] Ludovico Gonzaga decided to find a remedy for this: he not only had the marshes drained and the town squares plastered over, but did everything he could to attract the best architects and artists to his court.

Three years to engage a painter

The architect and early Renaissance theorist Leon Battista Alberti (1404–1472) designed churches for the marquis in the very latest style – after the model of antique temples.

In the Ducal Palace Mantegna's frescos transformed a relatively small reception room, later called – for reasons unknown – the Camera degli Sposi or Bridal Chamber; his illusionistic painting appears to extend the real space of the room via the ceiling into the sky, and through the walls on either side into a terrace and landscape.

The writing on the sheet of paper held in Marquis Ludovico's hand could tell us something about the occasion for the group portrait, which was probably commissioned to commemorate a particularly significant event. Since it is impossible to decipher the letter, we can only speculate. What is certain, however, is that the letter bears testimony to a favourite pastime at the court of Mantua: the writing, reading and preservation of manuscripts. Owing to the work of countless clerks and secretaries, a huge archive and precise record of the most important events at Mantua has been passed on to posterity. The life of the painter Mantegna, who spent 46 years there, is thus more thoroughly documented than the life of any other artist of his time.

1

The documents begin in 1457 with the voluminous correspondence undertaken to attract the 26-year-old painter to Mantua. Marquis Ludovico spent three years attempting to engage him. Andrea Mantegna (1431–1506) had made a name for himself with frescos in Padua. Their bold use of perspective and confident return to recently discovered antique models astonished his contemporaries. It was said that his portraits showed the sharply defined contours of Roman coins. Ludovico was determined to draw this exciting, modern man to Mantua, which lacked its own artistic tradition at the time. At least he could boast the presence of one other innovator: the Florentine architect Leon Battista Alberti had recently been entrusted with the building of churches and palaces.

Mantegna was hesitant to assume the obligations that accompanied the position of court painter. These included a vast amount of time-consuming, routine work: the decoration of country houses, the planning and staging of court festivities. Moreover, if the testimony of the Pope could be believed, Mantua was hardly an attractive proposition. What could be used to attract Mantegna? For one thing, the sum, agreed by letter, of "180 ducats per year, a house to live in, enough wheat for six persons and firewood".[2] Owing to their chronic lack of money, the Gonzaga payments were often over-due (because of this, Mantegna later was forced to write countless reminders and requests for payment). The Lords of Mantua found it much easier to reward their ambitious painter with status symbols. In the course of the years, they conferred upon him the fine-sounding titles of Count Palatine and Knight of the Army of Gold.

The real reason for Mantegna's decision to go to Mantua in 1460 was probably the marquis's cultivated understanding of art, his ability to appreciate the innovations of the Renaissance and, not least, the solicitous attitude exhibited by this busy ruler towards the artists in his service, a quality also documented in the correspondence.

In 1465, for example, the marquis personally ordered "two cartloads of lime with which to paint our room in the castle":[3] frescos were painted on a ground of fresh lime. In 1474 he sent for gold-leaf and lapis lazuli, paints so precious that they were usually added only as a final touch. These letters were separated by nine years, during which time Mantegna was evidently decorating the Camera Picta, or Painted Room, for the renovated palace. For in 1470 Ludovico complained about the slowness of the artist, "who started to paint the room so many years ago, and still has not completed half of it".[4]

Marquis Ludovico's stockingless foot wears a slipper, and his simple house-

coat contrasts with the ostentatious gold thread of his family's dress. When Mantegna finally completed his frescos in 1474, the potentate was 62 years old, worn out by thirty years of government, and in ill health.

Ludovico had held highest military office. Initially serving the Venetians, he had eventually become general commander for the Dukes of Milan, a position he maintained for 28 years. His reliability and loyalty towards those he served contrasted favourably with the vast majority of *condottieri*, the mercenary generals paid by Italian princes to fight their wars. Unlike his peers, he was not interested in booty, nor in war as an art. Ludovico was a man of peace. He did not owe high military rank to martial prowess, but to the geographic and strategic position of his small state.

The river Po, used for transporting goods, flowed directly through the land of the Gonzaga. Mantua also controlled the approach to the Brenner Pass. Connecting Italy with the north, this was one of Europe's most important trading routes. Mantua, protected on all sides by water, was considered impregnable. The rival neighbouring powers of Venice and Milan therefore attempted to secure an alliance with the marquis, or at least his neutrality, and he was clever enough to play the two off against each other.

In order to achieve a certain degree of independence from both powers, the Gonzaga sought foreign support by marrying beyond the Alps. Ludovico was married to Barbara of Brandenburg, a relation of the emperor. For his heir, he himself chose a bride from the House of Wittelsbach. He maintained good neighbourly relations with Venice and Milan, and always commanded the army of whichever was prepared to pay him most. His wage as a *condottiere*, in reality a disguised reward for his alliance, was considerable, indeed it would occasionally exceed the income generated by his entire kingdom.

Without a separate, external income he could never have afforded such a lavish life-style at home. His princely suite would sometimes comprise more than 800 persons. He also had an expensive hobby: horse breeding. Of course, his Milanese ducats also permitted Ludovico to patronize the arts, to commission buildings and paintings. His investment proved worthwhile. Shortly after Ludovico's death, a man who was probably the greatest art expert among the Renaissance princes, Lorenzo de' Medici, also known as the Magnificent, travelled specially to Mantua to admire its paintings and collection of antiques. Out of a swamp where "all you could hear were the frogs" had arisen a town whose fame, within a mere twenty years, had spread far and wide.

The white-haired man standing between two of Marquis Gonzaga's sons had been dead for some time when Mantegna came to paint his frescos. Vittorino da Feltre owed his place in this fresco to the gratitude of his former pupil. Without him, Ludovico Gonzaga would probably never have become quite such a remarkable ruler.

Vittorino da Feltre (1378–1446) came to Mantua as a teacher and court librarian. His pupils included not only Ludovico and his siblings,

but also Ludovico's future wife, the German Barbara of Brandenburg, who had come to the Gonzaga court at the age of ten. With Vittorino's help this unattractive, but by all accounts clever girl became a ruling lady, fully capable of governing the state when her husband was away commanding foreign armies.

The reputation of Vittorino's "School for Princes" attracted pupils to Mantua from all over Italy, and many important figures of the Renaissance were educated there,

A cunning man of peace

Ludovico Gonzaga and His Family, c. 1470

3

A teacher who formed Renaissance Man

among them Duke Federico of Urbino. All lived together, with 60 poor, but gifted pupils who received a scholarship from the Gonzaga, in Vittorino's "Ca' zoiosa", or "house of joy". The contrast between this more modern institution and the grim monastic schools of the Middle Ages, where pupils had lived under the rule of rote-learning and the cane, was not solely atmospheric. Vittorino's educational ideas, derived from Classical models, were revolutionary for their time. He paid great attention to physical education, for example, and attempted to awaken in his pupils both a Christian sense of duty and a healthy respect for Classical virtues. His ideal was the "uomo universale", combin-

ing vigour and spirit to form a harmonious whole.

Ludovico Gonzaga came very close to Vittorino's educational ideal. He was an intellectual of high artistic sensibility, and a man of action who was single-minded in improving the fortunes of his family and town.

The marquis owed his political success to an inspired move: in 1459, following extensive preparations, he convened a conference of sovereign princes at Mantua, attended by the pope and by dignitaries from both sides of the Alps. Although this plunged Ludovico into debt for many years, it also gave him an opportunity to spin the threads of a cardinal's robe for his second son

Francesco (1444–1483). Following Francesco's elevation to the rank of cardinal in 1462, Ludovico greeted his son, according to one of his contemporaries, "with tears of joy";[5] it is possible that this was the triumphant occasion Mantegna's painting was intended to record. The paper in Ludovico's hand may be a letter of appointment bearing the papal seal.

Ludovico's two eldest sons, standing to the left and right of Vittorino da Feltre, although not educated by the great teacher himself, were brought up in his spirit. Cardinal Francesco, on the left, laid the foundations for a famous collection of Classical antiques. His older brother Federico, Ludovico's heir, despite spending the greater part of his few reigning years (1478–1484) on battlefields, was also a patron of the arts. Mantegna even worked under a third generation of Gonzaga. Ludovico's grandson, Francesco (1466–1519), had great respect for him: "an extraordinary painter, unequalled in our time."[6] He, too, had learned that "a ruler becomes immortal by knowing how to honour great men".[7] It was a lesson Vittorino da Feltre had taught Francesco's grandfather.

Dwarfs and other human freaks were much sought after as court fools; at some Renaissance courts they were systematically "bred", a practice otherwise restricted to dogs and horses. Marchioness Barbara, too, is said to have kept a Beatricina and midget Maddalena to amuse her. However, more malicious tongues have it that the dwarf in Mantegna's fresco was a daughter of the reigning couple. The proud ruling family of Mantua – according to retrospective medical diagnosis – not only suffered from gout and malaria, but also from arthritis and rickets, which often led to curvature of the spine.

The boy and girl at the marchioness's knee look pale and thin; only two of ten children enjoyed perfect health. Two, including Cardinal Francesco, suffered from obesity; one had rickets, and four, among them Ludovico's heir Federico, had an unmistakably hunched back, although the fresco hides this. Since little is known of the remaining Gonzaga children, it cannot be excluded that they were dwarfs.

The defect probably entered the family through Ludovico's mother Paola Malatesta, who had come to Mantua from the renowned ruling house of Rimini. Two of her children were deformed, and even her eldest son Ludovico hardly demonstrated Vittorino da Feltre's ideal of a healthy mind in a healthy body. He suffered from obesity, and was often ill. It was possibly only the strict diet and regular exercise imposed on him by his teacher that prevented him from developing curvature of the spine as well. His heir Federico was not so lucky: he was described

by one of his contemporaries as an "amiable, engaging man with a hump".[8]

The Gonzaga bore their ailments with composure, accepting humiliation when necessary. In 1464 the Milanese heir, Galeazzo Maria Sforza, refused to marry Ludovico's daughter Dorotea with the words: "These women, born of the blood of hunchbacks, only give birth to new hunchbacks and other lepers."[9] His first engagement, to Dorotea's elder sister Susanna, had been broken off at the first sign of developing curvature of the spine. Susanna had thereupon entered a convent, leaving Dorotea to take her place as the Sforza heir's bride. But as soon as the opportunity of a more advantageous match arose – with an heiress from the house of Savoy – Sforza made public knowledge of his feelings of disgust for the Gonzaga.

The insult threatened to cause a reversal of existing alliances, almost driving Ludovico into the service of Venice. In the end, however, the link with Milan proved stronger; over the years the marquis had become "like a son,… like a brother" to successive dukes: a true "guardian of the state of Milan".[10] On three separate occasions, when the fate of the troubled house of Sforza lay in Ludovico's hands, the loyal general commander hurried to their immediate aid.

Perhaps Ludovico Gonzaga took secret revenge on the Sforza family by commissioning Andrea Mantegna to paint a fresco showing the moment of triumph when a missive containing a cry for help had reached him from the impertinent Milanese. Of course, he would not grant the Sforza name itself a place in the picture. For they were to have no part in the immortality which the lords of Mantua hoped to secure for themselves through Mantegna's art.

Gout, malaria, rickets: complaints of the Gonzaga

Hugo van der Goes: The Portinari Altar, c. 1475

An empire collapses; the painter retreats

This altar, today part of the Uffizi in Florence, measures six metres wide and two and a half metres high. It was painted in Ghent, taken to Pisa via Sicily on a merchant ship, from there transported by barge up the Arno to the gates of Florence, and then carried to the church of San Egidio by 16 men. It reached its destination on 28 May 1483.

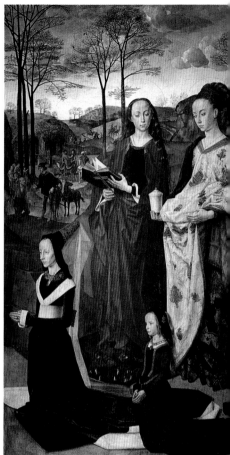

The Portinari Altar, c. 1475

Its safe arrival was by no means a foregone conclusion. Ten years earlier, a Florentine banker had attempted to send a *Last Judgement* by the artist Hans Memling back to his native city from Flanders. But the ship was seized by a Hanseatic freebooter and Memling's painting landed in Danzig, where it still remains today.

The church of San Egidio belonged to the Santa Maria Nuova hospital, which was founded in 1288

by the merchant Folco Portinari. The altar by the Flemish artist Hugo van der Goes was donated by one of Folco's descendants, Tommaso Portinari. Tommaso was manager of the Bruges branch of the Medici bank, and was also a councillor at the court of Charles the Bold, Duke of Burgundy.

Van der Goes portrays Tommaso Portinari on the left wing of the altar, and his wife Maria on the right.

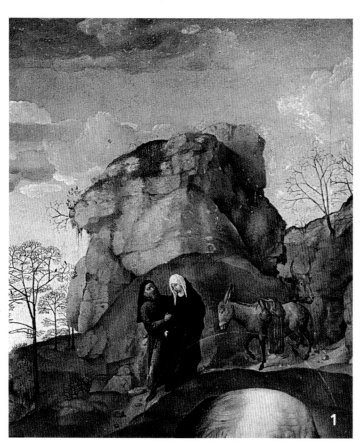

Hugo van der Goes

Their three children – Margherita, Antonio and Pigello – are kneeling behind them. The family are protected by their name saints, who tower over them: St Margaret has her foot on the dragon which, according to legend, once swallowed her; Mary Magdalene bears the jar containing the ointment with which she annointed Christ's feet; St Thomas has beside him, as his attribute, the lance with which he was killed; and St Antony Abbot, the father of the monastic order, is identified by his bell and rosary. The youngest son has no patron saint of his own; he was probably born after the contents and layout of the altar had already been decided.

In portraying the patron saints on a much larger scale than the donor family, van der Goes was following a well-documented medieval tradition, whereby size served as a symbolic indication of importance. He also obeyed medieval convention in another way, namely by ignoring time and space and bringing together, within one painting, episodes which occurred at different times and in different places. Thus we see not only the actual Nativity, but Mary and Joseph on their way to Bethlehem prior to Christ's birth. On the other hand, van der Goes executed many of the details with an extraordinary degree of realism and drew upon his knowledge of centralized perspective, as evidenced by the buildings in the background.

The Portinari Altar is a work full of contradictions and tensions. In Florence, where medieval tradition had long been overridden by the Renaissance and where saints and gods had been brought back down to a human scale, it must have attracted great attention. It came from another world.

Hugo van der Goes shows an inhospitable, northern December landscape, in which the trees spread their bare boughs against a grey sky. A rocky outcrop towers threateningly over the mountainous path which the pregnant Mary, supported by Joseph, must tread, as they make their way to Bethlehem for the census. The stony path points to the suffering which lies ahead for the Virgin and which she already knows she will have to bear.

In the central panel of the altar, an austere Madonna gazes down at the Christ Child with an expression which is almost that of a Pietà. The baby is lying not swaddled in a manger full of hay but naked on the ground, unprotected in a stable open to all four winds. Nor are the angels singing "Exultate Jubilate"; rather, they are looking with stern and serious faces at a sinful world. There is little in this altarpiece to indicate that, with the birth of the Saviour, they have a joyful message to proclaim.

One explanation for the gloomy atmosphere hanging over this holy

Nativity may lie in 15th-century events: at the time the altar was painted, the powerful Burgundian empire, of which the Netherlands was a part, was starting to disintegrate. There may have been more personal factors in play, too: the painter suffered from depression, at least in his latter years. This we know from the detailed records kept by Brother Gaspar Ofhuys, master of the sick in the monastery to which the painter withdrew in 1478.

Van der Goes was born around 1440 in Ghent. Little is known about the early years of his life. In 1467 he was accepted as a master into the painters' guild of Ghent. In 1468 he worked in Bruges – probably alongside Hans Memling and Petrus Christus – on the decorations for the marriage of Duke Charles the Bold. The great masters of Flemish painting, the van Eyck brothers and Rogier van der Weyden, were by now already dead.

When, in 1480, a charter described van der Goes as "the most outstanding living Flemish master", the Portinari Altar was already finished. It must have been shortly after completing this work that he entered the so-called Red Monastery near Brussels as a *frater conversus*, a rank between canon and lay brother. He embraced poverty, chastity and obedience and continued to paint. His known œuvre comprises some 40 works.

According to Gaspar Ofhuys, "one night, Brother Hugo was seized by a strange sickness of the imagination. He began to wail incessantly that he was damned and condemned to eternal damnation. He would even have inflicted a hurt upon himself, had not those around him forcibly prevented him from doing so." The painter's attacks expressed themselves in religious delusions in line with the beliefs of his day and his environment.

In retrospect, Hugo van der Goes appears as one of the first of a new breed of artist. In the Middle Ages, a painter was simply viewed as a craftsman who carried out the wishes of his clients, be they from the sacred or the secular sphere. He thus worked within clear and narrow bounds. In 1482, by contrast, the Florentine author Marsilio Ficino described the artist for the first time as an endangered melancholic genius, in turn inspired or cast down by Saturn. Creative zeal was followed by crippling despair. 1482 was the year in which van der Goes died.

The date of the altar can be deduced with some certainty from the ages of the Portinari children: the three portrayed by the artist were born between 1471 and 1474, and a fourth was born in 1476. The work was thus probably painted around 1475/76. The donor at that time stood at the pinnacle of his career – and shortly before its sudden end.

The donor was an ambitious but luckless banker

Tommaso Portinari was the representative in Bruges of what was then the biggest banking and trading house in Europe. Around 1470, in addition to their headquarters in Florence, the Medici maintained seven subsidiary offices (in Venice, Milan, Rome, Bruges, Avignon, Lyons and London). Bruges was important because it was here that trade was conducted with the Hanseatic cities of northern Europe.

Born in 1428, Tommaso Portinari had entered the service of the Medici at the age of 17. He rose through the ranks and in 1462 became head of the Bruges branch and simultaneously a partner in the Medici empire: he put up two-fifteenths of the business capital and received a quarter of the profits. Each time his contract was renewed, this extremely shrewd businessman negotiated more favourable terms for himself.

His independence grew following the death of Piero de' Medici, the experienced head of the family concern who had a profound distrust of Portinari. The running of the bank passed to Lorenzo de' Medici (later called Lorenzo the Magnificent), who was just 21 years old, and who was more interested in large-scale politics than in business.

Tommaso Portinari was granted an increasingly free hand. Although, in 1471, a fixed limit was still imposed on the amounts he could lend to the Duke of Burgundy, two years later this was dropped. Everything

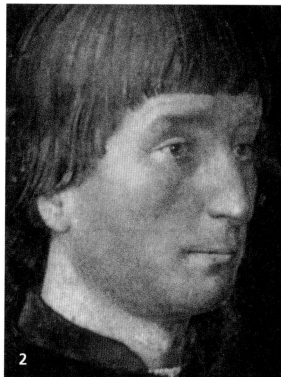

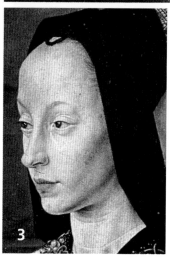

The Portinari Altar, c. 1475

was left to his own judgement. A dangerous development, for the banker loved risky speculation: around 1475 he invested large sums in a voyage of discovery mounted by the Portuguese, which set sail for the African coast and which ended up making an overall loss. Only two decades later, a similar expedition led to the discovery of America. Tommaso, meanwhile, continued to back the wrong horses: he miscalculated with some long-term wool contracts, and was lured again and again into granting massive loans to the Duke of Burgundy.

Bruges at that time belonged to Burgundy, a loose-knit empire which extended from the Swiss border to the shores of the North Sea. Duke Charles the Bold, its ruler since 1467, needed money to fund his magnificent court and countless wars. Tommaso provided it, "in order" – as Lorenzo de' Medici subsequently accused him – "to court the Duke's favour and make himself important", whereby he "did not care whether it was at our expense".

Like many others, the Florentine Portinari was bewitched by the charismatic Duke and dazzled by the aristocratic glamour of his court. He enjoyed cultivating an appropriately ostentatious image and persuaded the Medici to buy one of the most splendid houses in Bruges as the bank's offices.

In the altarpiece, Tommaso's wife Maria is wearing the austere costume of the Burgundian court, with a gold-embroidered pointed hat. The daughter of a good Florentine family, in 1470 – aged just 15 – she was sent to Bruges to marry Tommaso, 42 years her elder. Just a few years later she appears in this painting looking somewhat careworn, exhausted by childbearing and a strenuous life alongside her agile husband.

The code of conduct at the Burgundian court forbad uncontrolled gestures and the expression of personal feelings. The figures in this altar are portrayed accordingly. With one exception: the shepherds, who represent the "discourteous" people outside the court. In the background, one raises his clenched fist with a shout, while in the foreground, another throws open his arms. They make no attempt to conceal their curiosity. Large in size and realistically portrayed, they are an unruly bunch thrusting their way into the stable.

Never before had the shepherds been granted such a dominating role in a Nativity scene. Whether coincidentally or not, they call to mind the historical role assumed around this time by the shepherds and peasants of other lands.

Only shortly after this altarpiece was executed, the Swiss Confederation conquered the army of Charles the Bold and thereby destroyed the powerful duchy of Burgundy. The confrontation was sparked by the Duke's attempts to annex the re-

gion, which lay in between the individual parts of his empire. As a result, the neighbouring states were effectively forced to unite against him. France gave the orders, while the Confederates (in return for a great deal of money) did the dirty work. In true medieval fashion, Charles fought with heavily armoured knights; the Swiss shepherds and peasants came on foot. They were thus more mobile than their opponents, and they knew the terrain. In 1476 they launched a surprise attack on Charles near Grandson, and plundered his train and treasures near Murten. On 5 January 1477 Charles fell at Nancy.

After his death, France reclaimed parts of Burgundy for itself. Elsewhere in the empire, unrest broke out. Charles' daughter Maria and her husband Archduke Maximilian of Austria inherited a tattered Burgundy saddled with debt. It had lasted just a hundred years, but had seen a late flowering of medieval courtly culture.

The financial losses incurred by the Medici were enormous, and the consequences for Portinari catastrophic. Italian banks had already been ruined by loans to rulers in the past; the Peruzzi and the Bardi banking houses, for example, had lent "sums worth a kingdom" to Edward III (1312–1377). Lorenzo de' Medici disassociated himself from Portinari and forced him to continue the running of the Bruges branch, with its

low profits and huge debts, alone. Tommaso spent the rest of his life recovering loans and avoiding his creditors. He lived partly in Bruges, partly in Florence – always half on the run. In 1501 he died in the hospital to which, years earlier, he had donated the altar. His son renounced his inheritance, afraid that his father's debts would outweigh his assets.

Standing in the centre foreground, as if placed in front of a built altar, are two vases of flowers – carnations, aquilegia, lilies and violets. Normally they would never bloom in December; these bunches of flowers on the day of Christ's birth are a miracle.

The altar is full of symbolic and biblical references. The harp above

The shepherds, realistically portrayed, represent the people

the door of the palace in the background signals that this is the home of the line of David, to which Joseph belongs: King David once played the harp to King Saul, who was tormented by an evil spirit, and calmed him. The sheaf of wheat is a reference to Bethlehem, whose name means "house of bread", and also to the body of Christ, the "bread of life". The parallels between the body of the child lying on the ground and that of the wheatsheaf correspond to the belief that the one will transform itself into the other. The painter has thus already incorporated in his Nativity references to the death of Christ, and to Mass and Communion.

According to St Augustine, "the hidden meanings are the sweetest", and in the 15th century the masters of Netherlandish painting took his words to heart, filling their paintings with religious allusions and symbols. After van der Goes, however, these became rare. The need for a Christian superstructure in art was displaced by a Renaissance interest in reality.

In granting the two vases of flowers their central position in the foreground, the painter also accorded them a central significance. In the 15th-century language of symbols, violets stood for humility, modesty, and submission to God's will. Carnations were known in Flanders as *nagelbloem* – "nail flowers"; thus the three carnations recall the nails with which Christ was hammered to the cross. The orange lilies represent the blood of Christ, and the white and blue irises the suffering and purity of the Virgin Mary. St Bridget of Sweden (born 1303) wrote of the Virgin: "For she felt the sharp edge of this sword in her heart just as often as she foresaw the wounds and sufferings of her son in her mind …"

The aquilegia also point to the suffering ahead; they were associated with melancholy and their dark blue was the colour of mourning. Mary is also dressed in a dark blue robe, a further indication that this altar is announcing not the glad tidings of Christ's birth, but his future Passion.

It was painted as Charles the Bold was heading for ruin, as his duchy was collapsing. Perhaps something of the contemporary atmosphere of doom and gloom made its way into the altarpiece. Van der Goes was a subject of the Duke and his career was closely bound up with the House of Burgundy. He had documented its marriages, funerals and festive processions, and Charles's death, the collapse of his empire and the uprisings which broke out in Ghent must have affected him. These events may also have been the reason why the shipment of the altarpiece to Florence was delayed – and why the painter withdrew to the seclusion of a monastery.

The depressive van der Goes was probably also affected by the intel-

lectual contradictions of his day, and in particular by the conflict between medieval restraint and the more liberal ideas of the Renaissance. Although he never visited Italy, he must have seen works by Renaissance masters in the houses of Florentine merchants in Bruges. Tension is certainly evident in his Portinari Altar. While its subject and symbolism still adhere fully to medieval Christian tradition, its use of perspective and the realism of its shepherds point to the Renaissance. The way in which van der Goes portrayed the shepherds exerted its own influence in Italy, as can be seen in works from 1485 by the Florentine master Ghirlandaio – evidence of a reciprocal artistic exchange between Flanders and Florence.

The hidden meanings are the sweetest

Hieronymous Bosch

Hocus-pocus, Inquisition and demons

The name Hieronymous Bosch suggests images of pot-bellied demons and flying fish, spiderlike gremlins and gruesome half-animal, half-human beasties. In contrast to such nightmarish apparitions, the figures in this painting seem positively civilized.

The Conjurer belongs to a group of early works which Bosch probably painted c. 1475. The artist was born c. 1450, and was therefore about 25 when he painted these works. Demons may put in an appearance in some of them, but they have not yet gained the upper hand. The prevailing world-view is scathingly critical. In the *Ship of*

1

The thief and the Inquisition

Fools, for example, the artist paints a monk and nun indulging in gluttony and childish or erotic games instead of preparing for life in Heaven. The *Conjurer,* too, was probably an invective against the credulity of his contemporaries.

The arrangement is simple and easily surveyed. In the middle, a table with cups, balls and magic wand; also a frog, which appears to have sprung from the mouth of the large figure bent over the table's surface. A second frog appears poised between the person's lips, though this could equally be saliva. At the edge of the group of spectators a man in a monk's habit severs the purse strings of the person bent over the table. It is impossible to

judge whether cutpurse and conjurer are in cahoots.

There are five versions of the painting, as well as an engraving. Scholars are unable to agree on the original, or on which comes closest to an original possibly lost; however, the majority have settled for the present version. The property of the municipal musuem of Saint-Germain-en-Laye, near Paris, the painting measures 53 x 65 cm, is unsigned and rarely exhibited. The cautious city fathers usually keep their hallowed treasure in a safe.

Other versions of the *Conjurer* continue the story of the theft. In these the scene is not enclosed by a wall, but opens to houses in the background on the right. In one

Hieronymous Bosch

the monk is imprisoned, while the more distant background contains a gallows where the monk (whether genuine or an imposter) will soon hang. Thus justice is restored.

The engraving is inscribed with rhymed admonitions to the general public. The world, we are told, is full of deceivers who succeed with all kinds of tricks in making us spit wonders onto table tops; trust them not, it says, for "when you lose your purse, you'll regret it".

The present painting does without written injunctions, nor are we told the rest of the story. The high wall permits the artist to isolate the scene from its everyday environment, thereby giving it exemplary force. The question is whether delusion and theft really were all he wished to show.

Bosch was born c. 1450 at 's-Hertogenbosch, where he spent most of his working life. It is also likely that he derived his pseudonym from the name of his native town. To be named after one's place of origin was by no means uncommon. His real family name was van Aken, for his family hailed from Aachen.

's-Hertogenbosch, today a peaceful country town, was at that time one of the most important market towns of the Low Countries. The town had 2930 households in 1472; by 1496 there were 3456. This was equivalent to a population of approximately 25,000.

If statistics available for other towns can be believed, population growth went hand in hand with an increased rate of theft. The best form of protection against theft in stable communities was mutual supervision. People lived in close proximity; they knew their neighbours well. An influx of strangers made supervision more difficult. Even greater fear and suspicion were aroused by travellers. The term used for such people in French courts was "demeurant partout" – at home everywhere, in other words nowhere. A person of no fixed abode had bleak prospects in a court of law.

Among these travellers were storytellers, musicians, conjurers, clowns, surgeons and hawkers of medicines and remedies, who trailed from fair to fair in search of clientele. A rising town where money flowed across the counters in large quantities was particularly attractive.

The thief in the painting wears a robe that strongly resembles the habit of a lay brother of the Dominican Order. His belt and the top section of his garment, including the cowl, are missing, but his pale dress and black scapulary make his status clear enough. His head tire alone is typical of a burgher.

The Dominicans were powerful in Bosch's day; but their power was also the object of considerable controversy. It is therefore no accident that the artist alludes to them through the figure of a thief in a fri-

ar's habit. They were powerful because they controlled the Inquisition. In 1484, Innocence VIII had proclaimed in a papal bull that "very many persons of both sexes, lapsed from the Catholic faith, [have] entered unions of the flesh with devils, and, by means of magic spells, curses and other unworthy charms, [have] caused great distress to Man and beast". Belief in witches grew to an obsessive pitch, and the Dominican Order was the Pope's special anti-witch force.

They were powerful, but not all-powerful, and, in the Low Countries especially, the hysterical manner with which they persecuted their victims met with considerable resistance. When a Dominican priest declared a number of respected citizens of the city of Ghent to be heretics in 1481, he was promptly placed under arrest by the City Council. The Council also made it an offence to give alms to Dominicans or to visit their church services.

Fear of witches and the Inquisition alike were castigated especially by the humanists, whose spokesman, Erasmus of Rotterdam (1469–1536), courageously declared the "pact with the devil" to be "an invention of the Inquisition". Hieronymous Bosch possibly wanted to express something similar: the conjurer and the supposedly pious friar working hand in hand, the Inquisition feeding on the very heresies it was supposed to suppress.

The figure who appears to have spat out a frog is usually seen as a man, though the profile could equally belong to an elderly woman. The key hanging at the figure's side, the attribute of the housewife, would seem to confirm the latter view. The two Dominican authors of the so-called *Hammer of the Witches*, an infamous handbook for Inquisitors, would also have argued that the figure belonged to the female sex. In their opinion women were highly frivolous creatures, making it easier for the devil to draw them into witchcraft than men.

The conjurer influences the woman without touching her or, since his mouth is closed, speaking to her. He need only look into her eyes: that evil could be performed through eye contact was established within the first pages of the *Hammer of the Witches*. The authors of the book were apparently authorities on technique, too: an evil eye, they wrote, "infects the air"; and the infected air, upon reaching the sorcerer's victim, causes "a change for the worse in the body of the affected person".

The tall, black hat worn by the conjurer bears no resemblance to the headgear of the other men present. This type of hat was traditionally worn at the Burgundian court in the early years of the 15th century, later – as Jan van Eyck's *Arnolfini Wedding*, executed in 1438, attests – becoming fashionable among the wealthy urban middle class.

Hieronymous Bosch

By Bosch's day, however, this erstwhile symbol of courtly life and the wealthy bourgeois class was probably worn by vagabonds hoping to lend some semblance of dignity to their appearance. The conjurer in the painting – who evidently has hypnotic powers, and performs conjuring acts with cups and balls, as well as making his little dog leap through a hoop – is no exception.

But perhaps Hieronymous Bosch intended the hat to signify more than a *métier*. Like the garment worn by the thief, it may be an allusion: if the thief's habit insinuated the presence of Dominicans and the Inquisition, the hat may well have played on the worldy rulers of the age – the Habsburgs and Burgundians.

The town of 's-Hertogenbosch belonged to the kingdom of Burgundy, which fell to the Habsburg empire in 1477, just as Bosch was setting out to establish himself as an artist. Many Netherlanders had fought against the Burgundian dukes, objecting to their unscrupulous exploitation of their country's wealth. But the Habsburgs, too, were seen as tyrants and exploiters.

The Habsburgs prosecuted the pope's worldly and spiritual interests. In return for this service, they collected a tenth of all church benefices in their sphere of influence. In the Low Countries, the pope's most dedicated supporters in the struggle to suppress heresy were the Dominicans. It was thus only logical that

2

Archduke Maximilian, the first Habsburg monarch to rule Burgundy, should co-operate with the Dominicans as closely as possible. On visiting s'-Hertogenbosch, he would stay in the Dominican monastery, demonstrating to the inhabitants of the town where his true allegiance lay.

It is therefore quite conceivable that Bosch's main intention in this painting was not to criticize the Dominican Order but to expose the profitable alliance between spiritual and worldly rulers, who oppressed the people and stole their money.

The conjurer's tall hat

The Conjurer, after 1475

The animal in the conjurer's basket cannot ultimately be identified: it is either a guenon, a species of long-tailed monkey, or an owl. Monkeys often provided an interlude in the repertoire of fair-ground artistes. The owl, one of the artist's favourite birds, puts in an appearance in several of his paintings.

In the symbolic language of the period the monkey signified cunning, envy and lust. The owl was ambiguous: on the one hand it symbolized wisdom, on the other it was the bird of darkness, the companion of witches during their nightly flights. Whether monkey or owl, the animal must be seen as a reflection on the character of the man from whose belt it hangs.

Frogs and toads, too, frequently painted by Bosch, signified equally positive and negative qualities. A figure with a frog's head was revered in ancient Egypt as a goddess of resurgent life. The early Egyptian Christians adopted the figure, adorning it with a cross and making it the symbol of their belief in the resurrection of the dead on the Day of Judgement.

To some European church fathers, however, the frog and the toad were revolting creatures. They associated the animals' croaking call and habitat of mud and ponds only with devils and heretics. The frog is also a reference to the science of alchemy. The books of alchemists were full of pictures, for they used drawings and cryptograms to illustrate their methods and aims. Frogs and toads were part of the base, earth-bound element which was separated by distillation from its ethereal counterpart.

The aim of alchemy was the transmutation of human and material substance by the union of opposites. Bosch makes reference to this in his later works, showing couples copulating in alchemical retorts. The desired union was also represented through the conjugation of sun and moon: the sun as a circle, the moon as a sickle. This alchemical sign is hinted at in the top left of *The Conjurer* in the form of a round window which – strictly speaking – really ought not to be there.

A characteristic quality of the symbols used in alchemy (and indeed of medieval sign language in general) is their complicated multiple ambiguity. By contrast, our thinking today has adapted to the scientific demand for unequivocal precision. But even a shape combining sickle and orb did not always symbolize the unity of opposites; sometimes it was simply the moon.

The moon has an important role in a related discipline: astrology. Drawings of the "children of the planets", a precursor of the horoscopes printed today in various newspapers, were sold at fairs and local markets. At that time the moon was considered a planet. Among the moon's "children" were actors,

Monkey or owl – fun and symbol

singers, pedlars and conjurers. Surprisingly, at least one of the prints of the "planets' children" shows almost an exact replica of the motif used by Bosch: a travelling conjurer with a table and thimble-rig trick.

Bosch was acquainted with, and used in his painting, not only the sign languages of alchemists and astrologists, but also the symbolism of the tarot pack, cards used in games and fortune-telling. It has been suggested that gypsies brought tarot cards to Europe from Egypt or India in the 14th century. Other sources claim that the Waldenses – a southern French sect whose persecution by the Dominicans was especially bloody – used the cards as early as the 12th century. While the design of the cards has varied from century to century, the basic motifs – supposedly revealing, or rather concealing, the knowledge of the ancients – have remained unaltered. With the advent of science and technology, these mystical figures were condemned to oblivion, though they have recently been rediscovered by the followers of "New Age" esotericism.

Comparison reveals that the couple in Bosch's painting, one of whom has placed his hand on the breast of the other, can also be found on early tarot cards. The sceptical, sombre-looking man with black hair and a dark robe in the midst of the group of onlookers is also prefigured in the cards. One card shows a revolving wheel; above it an animal, possibly a dog, dressed in a costume. In Bosch's painting, the little dog does not sit above a wheel, but next to a hoop.

However, it is the conjurer with his table who bears the closest resemblance to similar figures on tarot cards and other contemporary pictures. Dressed in red, he is equipped with a magic wand and thimble-rig cups and balls. The trick of manoevering balls or small stones between cups or thimbles by sleight-of-hand had been performed since antiquity.

Cognoscenti would have recognized in the figure of the conjurer the Greek god Hermes, who, as a messenger between this world and the beyond, sometimes bestowed divine knowledge on human beings. Guides to the interpretation of tarot cards link this card with creativity, imagination and intelligence, as well as with delusion and disguise. It is called "The Magus" or "Conjurer" (French: "Le Bateleur"), resurfacing in later card games as the "Joker".

References to tarot – or alchemy and astrology – indicate that the painting's almost naive, anecdotal charm conceals more than a warning against tricksters, or against the combined forces of clerical and secular power. Though the demons that hold sway in so many of Bosch's later paintings may be biding their

4

time, restrained, as yet, from peering around corners, their otherworldly presence is nonetheless already palpable.

LE BATELEUR

The secret of the tarot cards

Master of the Transfiguration of the Virgin: The Virgin and Child with St Anne, c. 1480

The patrons watch over the city

Even though its massive cathedral still lacked its soaring spires, Cologne was the largest and most important city in Germany when, around 1480, its skyline provided an anonymous artist with the background for his painting of the Virgin and Child with St Anne, together with St Peter, St Gereon and St Christopher. This was the first time that a painting had presented a more or less accurate picture of 15th-century Cologne. The large altarpiece, which measures 131 x 146 cm, today hangs in the city's Wallraf-Richartz Museum.

This painting dates from the great age in Cologne's history. No other European centre at the end of the 15th century surpassed the city in terms of size, and none other boasted such a splendid and extensive city wall – 8 kilometres in length. The former Roman colony was rich in churches and art, and with its some 40,000 citizens it was also the

born, when there was still no Renaissance north of the Alps and when the unity of the Church still seemed free from threat. The artist portrays the city – from the Bayenturm tower overlooking the Rhine on the left to St Cunibert's church on the right – with a quite extraordinary degree of realism for his day. He has only made one correction: whereas the Rhine actually makes a gentle bend as it flows through Cologne, the painter here shows it running parallel to the wall-hanging against which the saints are standing.

St Christopher, seen on the far left with the Christ child on his shoulders, was particularly venerated by sailors and fishermen. Next to him stands St Gereon, martyr and patron saint of Cologne. St Peter, dressed in the robes of the Pope and adorned with gold and precious stones, symbolizes the power and the wealth of the Church. Amongst its most valuable relics, Cologne still possesses even today a section of the chains with which Peter was bound, and fragments of his bishop's staff. In their contrast to the apostle, the three figures of St Anne, her daughter Mary and the infant Christ (who thus features twice within the one painting) appear almost unassuming.

The saints stand protectively in front of the city. In later centuries, however, they would also do its citizens harm – by obstructing their

A soldier becomes a martyr

most heavily populated city in Germany.

The assembly of saints with Cologne in the background was painted around 1480, at a time when Albrecht Dürer was just a boy and Martin Luther had not yet been

Master of the Transfiguration of the Virgin

view of the changing world around them.

The Virgin and St Anne, St Peter and St Christopher continue to be venerated by Catholics of all nations. Gereon, on the other hand, the knight with the golden cross on his breastplate, remained rather more of a local saint. His legend is closely bound up with the history of Cologne, and with its first period of growth under the Romans. This began in AD 50, when the settlement was granted the status of a town and made a colony ("Colonia") of the Roman Empire. Agrippina the Younger, wife of Emperor Claudius and born in Cologne as the daughter of a Roman general, is supposed to have given her birthplace its charter. It was probably less of a gift, however, than a strategic move: the empress thereby demonstrated her ability to get her own way (she would later have her husband poisoned). As the capital of the newly-created province of Lower Germania, Cologne now assumed more importance. Its Roman title of "Colonia" evolved into the German "Köln" (Cologne).

Many gods were worshiped in the Roman Empire – Jupiter, Juno, Minerva and Isis (who originated from the Orient) as well as local deities; one often merged into another. For many years, however, this religious tolerance did not extend to the god of Christianity. Christians were considered enemies of the State and blamed for unrest, including the uprisings in Gaul at the end of the third century. The units sent to quell these revolts, however, themselves included secret worshippers of the Christian god. Such soldiers were considered a military risk. In order to root them out, pagan sacrifices were commanded. Those who would not take part gave themselves away. Every tenth man was executed as a form of general deterrent.

This measure, ordered by the commander-in-chief, was also in force amongst the legions stationed along the Rhine on Gaul's eastern border. At least 50 Roman soldiers are supposed to have been executed for their Christian beliefs before the gates of Cologne. According to legend, one of them was the cohort leader Gereon. The standard in his hand shows that he was more than just a simple soldier. Gereon was apparently supposed to kill the selected Christians, but refused and himself then suffered a martyr's death

In 1847 the remains were discovered in Cologne of 67 people who had died a violent death, and who became linked with Gereon's – still much disputed – execution. Beyond dispute, however, is the fact that the church dedicated to St Gereon is the only one in modern-day Cologne which was founded in Roman times. It dates back to the 4th century, when Emperor Constantine proclaimed Christianity the state religion. In

the Middle Ages it was the highest-ranking church in the city after the cathedral. According to an old manuscript: "And because the magnificent building with its mosaic decorations gleams like gold, the people of Cologne have taken to calling it 'The Golden Saints.'"

The city panorama is dominated by churches – something which was very much the case, but which is given particular emphasis here by the artist. The donors of this altar wing were clearly proud of what the city's inhabitants liked to call their "hilligen Coellen" – their holy Cologne.

The new cathedral was intended to be the biggest and most beautiful of all Cologne's churches. Work had started on the building a good 200 years before this picture was painted, but around 1480 had all but lost its momentum. The choir is finished, and partitioned off by a provisional wall so that it can be used for services. The north tower is missing, and only half of the south tower has been built. The wall linking the south tower and the choir was taken no higher than the 14 metres it has reached here. We know from other pictures that a massive crane was mounted on the platform of the south tower. Our painter has left it out, however – it probably didn't fit with his vision of the "holy city". The cathedral was only completed in 1880: not out of a sense of religious commitment, but out of

a new feeling of national pride – Cologne cathedral as a monument to historical German architecture.

Yet when construction began to stagnate, Cologne was not just the largest of the German cities, but also a Catholic city of particularly high standing, as evidenced by the prize relics in its possession: since 1164 Cologne had been home to the bones of the Three Kings. The ideal of a Christian kingdom was closely associated with these wise men from the East, and since it was the archbishop of Cologne who crowned Germany's newly-elected kings in Aachen, the devout image of the Magi transferred itself through him to the new regents.

Even more greatly revered than the relics of the Three Kings, however, were the rusty links of St Peter's chains and his famous bishop's staff, which (as we now know) in fact dates from the 4th century. Through these relics, the citizens of Cologne believed themselves directly connected with the apostle. Like the Roman Christians, they considered their cathedral to have been founded by Peter and perceived Cologne as the northern counterpart to Rome.

These perhaps not altogether convincing claims were underpinned with legends. Peter himself, for example, was supposed to have sent three men to the Rhine in order to spread the Word. One of them was said to have been called Maternus

and to have been the young man whom Jesus raised from the dead in Nain. When this same Maternus died in Alsace, his companions hurried back to Peter and beseeched him to restore Maternus to life. Peter gave them his bishop's staff, and when they touched the dead man with it, he was brought back to life a second time. Maternus continued to make his way up the Rhine, founding various communities as he went, including that of Cologne.

Naturally, the construction of the cathedral itself was also accompanied by miraculous tales. One such story concerned a man who, wishing to do penance, worked on the cathedral as a simple labourer. He was so industrious that his colleagues soon

came to hate him. They killed him and threw his body into the Rhine – but the fish brought it back to the surface. Through this miracle, the wicked deed was exposed and the murderers forced to confess.

Cologne cathedral is dedicated not just to St Peter, but also to the Virgin Mary. The painter shows the Madonna with her infant son and her mother, St Anne. This three-generation group was a very popular motif at the end of the 15$^{\text{th}}$ century, and one frequently treated in art.

The Crusaders brought the cult of St Anne to western Europe from Jerusalem and Constantinople. In 1481, i.e. at around the time this picture was painted, Pope Sixtus IV in-

The Rome of the north

The Virgin and Child with St Anne, c. 1480

troduced St Anne's day into the Roman calendar, and 100 years later she was given her own feast. For all their veneration of her memory, the question of whether St Anne conceived her daughter without the assistance of her husband remained the subject of dispute amongst theologians.

The issue was probably of less interest to the layfolk. They invoked St Anne's aid and intercession in a wide range of situations, many of them related to family matters: pregnancy, birth, marriage and widowhood, for example. Women wanting but apparently unable to have children, in particular, addressed their prayers to her, for according to her legend Anne herself remained childless for many years. Her husband Joachim, a shepherd, was taunted about this in the temple. Upon returning, troubled, to his flocks, he had a vision, at exactly the same time as Anne at home: an angel told him that he would have a child before whom the whole world would kneel in reverence. That child was Mary.

St Anne has religious significance solely as the grandmother of Jesus. This family connection made her worthy of veneration and was probably the reason why she was so popular amongst the middle classes. Certainly, the cult of St Anne grew with the rise of the bourgeoisie.

This aspiring class was only able to assert its identity in cities. In the case of Cologne, this took place in several, clearly identifiable stages. Since 953 the archbishops had also been the secular rulers of Cologne. It was against them that the civil movement towards emancipation was first directed. In 1074 the merchants rebelled; in 1106 the people of Cologne were granted military sovereignty; in 1288 they took up arms against their archbishop and defeated his army. From now on, the citizens of Cologne were allowed to rule themselves; their city became, albeit unofficially, a free imperial city and was subject only to the emperor.

A small group of wealthy families took over the running of affairs. Over the following decades, however, the merchants, craftsmen and less well-to-do citizens rebelled against this patrician rule. They organized themselves into *Gaffeln*, political associations, most of them dominated by individual guilds, and in 1396 overthrew the patricians. A new constitution was drawn up, which stated that in future the city council could only be elected by members of the *Gaffeln*, and not by members of the wealthy upper classes.

The middle classes – but not the masses of domestic servants, clerks and day labourers – had successfully asserted themselves. They owed their victory to a flourishing economy. Their rise was accompanied by an strengthening sense of family: with a house, money and a certain degree

4

A few years after their victory, the citizens of Cologne built themselves an architectural monument: the town hall tower. On a square ground-plan with sides a good 13 metres in length, they erected a massive building 61 metres in height with thick, fortified walls and a portal similar to that of a church. The tower was not merely a grandiose symbol of civic success, however, but also served a practical purpose as well.

The patricians had usually dealt with the affairs of government in their own, large houses, where they also kept the treasury, the official wine cellar and the archives. The new rulers did not own such houses; furthermore, they wanted to make a clear distinction between private and public affairs. So they built the tower with a wine cellar, conference chambers, and rooms in which to house the archives, the treasury and arms. Stationed at the very top were the tower trumpeters and fire wardens.

The new town hall tower, its stone still pale in colour, can be seen on the left of the picture beside the venerable church of Great St Martin. Were it shown in the correct perspective, the tower would actually appear very much smaller, as it lies further from the Rhine than the church. But perspective was clearly something in which the artist had little interest. He only hints at spatial depth. The city appears to run like a narrow strip along the river, whereas in truth it

A monument to civic pride

of independence could they start to build up a family tradition, something previously only possible for the aristocracy. Now ordinary citizens started to get even – with St Anne's help. Weavers and bakers and coopers might not be able to win glory on the battlefield, but they could gain a place on the council or be elected to an important post, perhaps even that of mayor.

Master of the Transfiguration of the Virgin

took the shape of a crescent, curving away from the Rhine into the background.

The topography of Cologne nevertheless only occupies a fraction of the painting. As a whole, the work remains firmly rooted in the traditions of medieval sacred art. Peace and prosperity are guaranteed not by the long city wall, the industrious citizens on the riverbank or the new town hall, but by the saints who dominate three-quarters of the picture. Consequently, the narrow slice of real world leads not into blue sky and white clouds, but into the traditional gold ground, a symbol of the omnipresence of the Divine.

In the centuries that followed the completion of this altarpiece, Cologne suffered a period of decline. Many of the reasons for this were beyond the city's control – the collapse of the Hanseatic League, for example, from which Cologne's economy had long benefitted, and the opening up of new trade routes: once mariners had found the passage around Cape Horn, goods from the East no longer reached northern Europe via the Mediterranean and the Rhine, but were shipped along the coast. Cities such as Antwerp and Amsterdam blossomed and usurped the place of the former centres of trade, quickly overtaking them in terms of size, too: right up to the 19th century, the population of Cologne numbered little more than 40,000.

Most of the internal reasons for Cologne's decline can be traced, directly or indirectly, to the Church. The ousted archbishops had set up residence in Bonn and Brühl; they took little further interest in Cologne and only returned to the city in 1821. Of even greater consequence than its ambivalent relationship with its prelates, however, was Cologne's rejection of Protestantism. Almost all the cities undergoing economic expansion were Protestant, or tolerated Protestant churches. Not so Cologne: even as late as 1787, it was still banning the construction of Protestant houses of God. If the Romans and, later, the Holy Roman Emperors had once fostered the standing of the fortified city in the north of their empires, after Luther Cologne remained merely a bulwark of the Counter-Reformation. Just as the city failed to embrace a new political vision, so the saints are looking away, preventing the intrusion of new, forward-looking ideas.

How the nymph became a goddess

Iron ore, in quattrocento Italy, was found solely on the island of Elba, where the mines belonged to a family called Appiani. In 1478 Lorenzo de' Medici wished to acquire the mining rights. Lorenzo was known as "the Magnificent", the uncrowned king of Florence. The respective contract was signed, and, in May 1482, there was a wedding: Lorenzo the Magnificent's cousin, Lorenzo di Pierfrancesco de' Medici, married Semiramide Appiani. There is no evidence to suggest that the wedding was arranged by Lorenzo the Magnificent and the Appiani family – common practice in ruling families at the time – to promote trade. It nonetheless served that purpose ably.

The conjunction of mine owners and mining interests, or perhaps – who knows! – the joining in wedlock of lovers, was the occasion which prompted Botticelli's *Primavera*. This, in any case, is generally assumed. Nor is it unlikely either: although undated, the style of the painting is that of Botticelli's other works of this period.

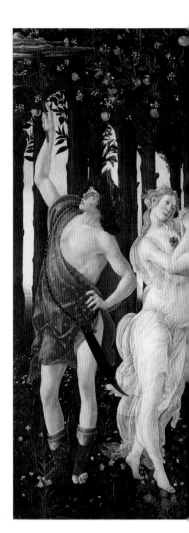

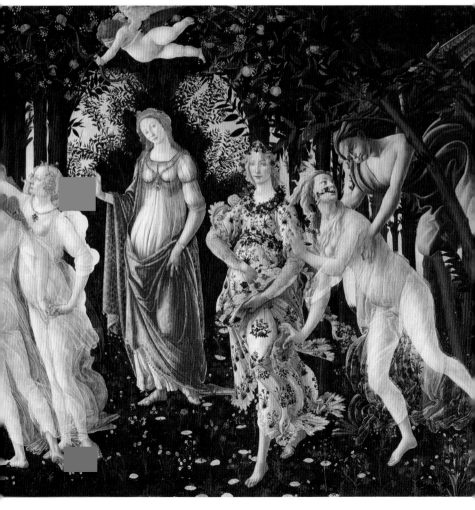

1

Chloris

It was usual in upper-class circles to provide newly-weds with a fully furnished home, including works of art. The painting was later listed in Lorenzo di Pierfrancesco's inventory, so that scholars now suppose it was executed for the younger Lorenzo (rather than for Lorenzo the Magnificent, as previously thought); it hung in the antechamber of the master bedroom.

Lorenzo di Pierfrancesco, like his powerful cousin and in keeping with family tradition, was a patron of philosophy and the arts. The great humanist Ficino supervized his education, while the poet Poliziano dedicated verses to him. Besides the *Primavera*, Botticelli painted *The Birth of Venus* and *Pallas and the Centaur* for Lorenzo. For thirty years, Lorenzo di Pierfrancesco was entirely dominated by his powerful and more "magnificent" cousin, who made him ambassador to the pope and gave him the task of conveying the official congratulations of the

ruling house of Florence to the newly crowned French king. At the same time, however, Lorenzo did everything he could to prevent his younger cousin from growing powerful. Tensions arose between them, and rivalry. When the Medicis were expelled from Florence after the death of Lorenzo the Magnificent, Lorenzo di Pierfrancesco was permitted to stay. He abandoned the Medici family name, calling himself "Popolano", after the "populist" party, instead. He died in 1503, at the age of 40.

He married at the age of 19, a time of life that is frequently compared to spring. *Spring*, too, or *Primavera*, is the title by which the painting is commonly known today. It was first described by the artist and writer Giorgio Vasari in the 16th century: "Venus, adorned with garlands by the Graces, annouces the Spring." During the 17th and 18th centuries the painting was called *The Garden of the Hesperides*. According to the ancient myth, golden apples grew in this garden. They were guarded by a dragon, and by the Hesperides, daughters of the Titan Atlas. There is no dragon here, and whether the dancing women really are Graces, or even Atlas's daughters, is a matter of some dispute. Venus stands at the centre of the painting. Zephyrus is the figure on the right, blowing pleasant breezes that bring eternal spring. The goddess Flora scatters her flowers, while on the left, the god Mer-

cury keeps watch, sheltering the garden against threatening clouds.

Besides obvious references to fertility and spring, there are two hidden allusions to the name of the bridegroom. On the right, laurel trees sway in the wind; their Latin name was *laurus*, in which contemporaries would have heard Laurentius, the Latin name for Lorenzo. Venus' golden apples are here painted as oranges, known in antiquity as the "health fruit": *medica mala*. From here to the name Medici is hardly very far. Allusions of this kind were the joy of an educated public.

Various 19th-century art buffs let it be known that the features of members and friends of the Medici family could be identified in the faces of Botticelli figures. There is no evidence whatsoever to support this claim. At the same time, however, the figures in Botticelli's paintings were certainly known to his contemporaries: not as individuals, but as figures from Greek and Roman mythology.

They knew that Zephyrus, a wind god, was pursuing the nymph Chloris in this picture. The story, familiar enough, was recorded by the Roman poet Ovid (43 B.C.–18 A.D.), who allowed the nymph to tell the story herself: "Zephyrus caught sight of me, I avoided him, he followed, I took flight; he was the stronger …"

Of course, the pursuit and rape of Chloris had a happy ending; we would otherwise be unlikely to find them in a wedding painting: Zephyrus turned the nymph into the goddess Flora, and married her. Botticelli paints Chloris and Flora as a couple. And indeed from then on, so Flora tells us, she had no reason for complaint:

"I enjoy eternal spring, a radiant season … At the heart of the land of my dowry lies a fertile garden in the mildest of climates … My noble husband filled it with flowers, saying: 'You, o goddess, shall rule over the flowers!'"

Flora thus became the goddess of flowers; Botticelli's blossoms look as if Flora herself has scattered them. Flora: "I often wished to count the colours arranged on the ground, but I could not. Together, they were greater than any number could be … I was first to scatter new seed over countless peoples, before then the earth had but *one* colour."

There is nothing in Ovid to suggest that flowers sprang from Chlo-

The flowers

2

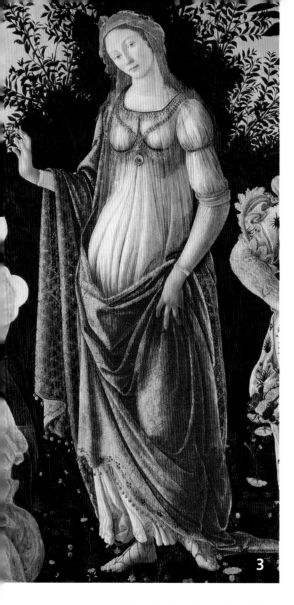

3

that passed her lips". Afterwards she ascended "into the mild air, leaving nothing but a light fragrance. One simply knew: a goddess was here."

This lovely story comes from Ovid's "Fasti", a Roman calendar. Ovid tells a tale about the god revered on each feast day. Flora's feast day, for example, was called Floralia. Botticelli is unlikely to have read the "Fasti"; as the son of an uneducated tanner, he probably could not read Latin. However, it is known that Poliziano, a poet employed by the Medici family, held public lectures on Ovid's festive calandar in 1481. The wedding took place a year later. It is possible that Botticelli was inspired by Poliziano.

The lectures on Ovid were enormously popular, coinciding as they did with the rediscovery by Poliziano's more progressive contemporaries of Classical antiquity. The majority of Greek and Roman writers had been committed to oblivion for over a thousand years. The ancient gods and heroes had been swept aside by the *one* God, by Christ, the Virgin Mary and the saints. But Classical authors now enjoyed a come-back. Their manuscripts were sought far and wide, and large sums were paid for copies. Ancient mythical figures began, in turn, to replace the Holy Family and saints.

In Florence, Poliziano was a major proponent of the rediscovery – or rebirth, for it became known as the Renaissance – of Classical art

ris' mouth when she cried for help. That is probably the artist's own invention. But when the goddess spoke, "spring roses were the breath

and literature. His real name was Angelo Ambrogini, born in Montepulciano in 1454. Like many humanist scholars and poets of his day, he gave himself a Latin name after his place of birth, the Latin word for which was Mons Politianus. He thus called himself Politianus, or, translated into Italian, Poliziano. It was he who coined the famous dictum: "Athens lies not in ruins, but brought her scholars, mice and men to set up house in Florence."

Not only was Classical antiquity discovered anew, but Nature too. Botanists have identified the species of flower that Flora, wife of Zephyrus, appears to scatter in the painting. Among them are forget-me-not, hyacinth, iris, periwinkle, pheasant's-eye and anemone. Around her neck the goddess wears a wreath of myrtle; in her dress she carries wild roses; in her hair are violets, cornflowers and a sprig of wild strawberries. Apparently, these flowers all blossom in Tuscany in the month of May. Whatever the dictates of mythology and style, Botticelli's choice was true to Nature.

Botticelli's botanic realism corresponded to a newly awakened interest in Nature at the universities, where botany had become an academic subject. Pisa and Padua, the university towns of Florence and Venice, were the sites of the first botanic gardens.

Besides all else, the special attention devoted to Nature also had a practical side. Any Florentine who could afford to do so had a country house and farm not far from town. Once there, they would eat vegetables and fruit grown in their own garden and use oil from their own groves. Lorenzo the Magnificent is known to have owned a country villa near Careggi where he bred Calabrian pigs; at one of his other villas he bred Sicilian pheasants. He also introduced a species of rabbit from Spain.

Even a relatively poor man like Botticelli's father bought a small villa near Careggi. On 19th April 1494 Sandro Botticelli bought a country house outside Florence, admittedly with the help of his brother and nephews. The price was 155 gulden. That was approximately what he was paid for one and a half paintings.

It was not uncommon in Europe for the inhabitants of towns to own agricultural land. However, the difference between Florentines and the majority of other town dwellers, especially those in more northerly climes, was that the former also liked to *live* out of town. A book published at the time states: "In the crystal-clean air and pleasant countryside around Florence are many villas with wonderful vistas …" In the same book we read: "A country house is like a reliable friend … It keeps your troubles at bay all the year round."

Venus stands at the centre of the painting. The space between the

Venus

Flora

would be rough, lacking in tenderness, worse than the life of wild beasts. Can there be anybody who disputes this? Women drive from our hearts all evil, all baseness, all worry, misery, sadness. They inspire our minds to great things, rather than distracting us ..."

It goes without saying that Botticelli clothed his Venus in the robes of a married woman: she wears a bonnet and, draped over it, a veil. Hair was considered the weapon of the seductress; only young girls were permitted to let their hair hang loose.

The figures of the three Graces allow the artist to display the elaborate artistry with which the women of his time arranged their hair. To make their hair seem fuller, women would often use silk bands, false plaits and other hairpieces. The most fashionable colour was a delicately tinted blonde, the product of strenuous bleaching and dyeing.

Under her dress and shawl, Venus wears a long chemise, of which the arms alone are visible. This was quite usual for a lady of Florence. However, it was unusual for a married woman to reveal her feet, or drape her shawl or cloak with such evident disregard for symmetry. Mercury's toga, too, is deliberately asymmetrical. This was thought to be in the antique manner, and Florentines would have considered it a token of Classical mythology.

What was utterly contemporary, and utterly 15th century, however,

branches of trees surrounding her head forms the shape of a halo. Her graceful pose and chaste clothes are rather more reminiscent of the Virgin Mary than of a goddess of sensual love. Classical antiquity ascribed two roles to Venus. On the one hand, certainly, she was the light-hearted, adulterous goddess, accompanied by her son Cupid, who (painted near the Graces in this picture), blindly excited passion with his burning arrows. On the other, she was all harmony, proportion, balance. A civilizing influnce, she settled quarrels, eased social cohesion. She was the incarnation of eroticism – a creative rather than destructive force.

The vision of a *Venus humanitas* informed the ideal of womanhood in 15th-century Italy. In his treatise *Il Libro del Cortegiano* Baldassare Castiglione (1478–1529) wrote: "It is surely beyond dispute that there could be no contentment in a life without women. Without them, life

was the ideal of beauty shown in Botticelli's paintings: eyebrows drawn as gentle curves rather than a double arch, foreheads no longer high and shaved, as they had been during the Middle Ages, but linear and Greek and twice as broad as long. A rounded, slightly protruberant belly was now considered graceful. The beauty of the hand was accentuated by exhibiting it against the background of a dress or shawl – as does Venus in the painting.

While in Rome to assess the qualities of a potential bride for her son, Lorenzo the Magnificent's mother, Lucrezia, mentions two characteristics that were highly treasured at the time: "She is tall and has a white skin." Almost all of Botticelli's women are large, indeed slightly elongated, if not unnaturally tall. And as for white skin, even country girls are said to have gone to some length in order to procure the ideal pallor, using tinctures, pastry packs, cosmetic pastes, and avoiding sunlight. If the three Graces dancing in the shadows in the present painting seem almost carved from alabaster, this cannot solely be attributed to idiosyncracy of style on the artist's part, for their appearance is fully in keeping with contemporary notions of beauty.

The Florentine ideal of womanhood demanded not only beauty, but education. In wealthier families, women were taught the Classical subjects alongside their brothers; they were expected to hold their own in a discussion, and to please their husbands with intelligent conversation. Besides this, a woman had to know how to run a household, an ability which the practically-minded Florentines held in high esteem. She had to be thrifty, keep a clean house and give sound direction to the servants. Only the cash-books were out of bounds.

Flora is smiling. Smiling figures are a rarity in Renaissance painting. Flora's manner is confident and full of natural charm, possibly resembling that of the young women who posed as the goddess on carnival floats. Perhaps Botticelli was inspired by a spring festival in which the figure of Love was celebrated with dancing, jousting and banquets in the streets. The festival is supposed to have lasted two months.

Festivals were especially frequent in Florence under the Medicis. Craftsmen had previously been responsible for large festivals in the

The brooch

5

town, but now the new rulers footed the bill. Tournaments in medieval style were highly popular, giving an otherwise unwarlike class of merchants the opportunity to show off their strength and skills, as well as demonstrate their adoration of women by performing various acts of chivalry. A tournament of this kind, in honour of Lorenzo the Magnificent, took place in 1469. Its motto was "The Return of Time": an allusion to the return of spring. This was followed in 1475 by a famous tournament in honour of Lorenzo's brother Giuliano. This time the motto was "She is Incomparable"; "she" was in fact Simonetta Cattaneo, wife of Vespucci. Naturally, it was Botticelli who painted Giuliano's standards, and Poliziano who composed a poem to celebrate the event!

There are good reasons for the festive spirit which flourished under Medici rule: firstly, there was the more general mood of revival, the sense of vision that existed throughout the Renaissance; secondly, the success, as well as youth, of the ruling family. Botticelli was 30 at the time of the 1475 tournament, Lorenzo the Magnificant 25, his brother Giuliano 21, Giuliano's lady Simonetta 22, Poliziano 21, while Lorenzo di Pierfrancesco was only 12 years old.

Simonetta died a year after the tournament. Giuliano was murdered, and Lorenzo the Magnificent wrote: "How sweet is youth, how swift its flight!" Ovid says much

the same thing. Flora advises us to "pluck's life's beauty while it blooms".

Botticelli's painting displays several examples of the goldsmith's art: Mercury's helmet and sword hilt, for example, or the brooches and necklaces of the Graces. Botticelli, once apprenticed to a goldsmith himself, was well acquainted with the craft.

This was not unusual at the time; several Florentine artists began their careers as goldsmiths. Painting pictures was considered the work of a craftsman – no different in status from the work of a smith. The term "art" had not yet gained currency. During the 15^{th} century the Italian word "arte" connoted manual skill, a trade, a guild.

But the Renaissance changed all that. The rediscovery of Classical antiquity drew the attention of Botticelli's contemporaries to the enormous respect accorded artists during antiquity. Michelangelo, a generation after Botticelli, was the first artist to leap to fame and riches. Pointing out that artists do not merely work with their hands, but also with their heads, Michelangelo set himself apart from the class of artisans.

Botticelli "uses his head" in a distinctive manner. Well acquainted with the theoretical trends and rediscovered myths of his day, he in-

corporates ideas – some veiled, some self-evident – into his paintings: he encourages his spectators to think.

One theoretical trend dominant at the Medici court, for example, attempted to bring Christian ideas into line with those of Greek philosophers. Botticelli allows this project to enter the picture in the shape of Venus, who bears a striking resemblance to the Virgin Mary. The figure's head is surrounded by a halo which can equally be seen as a space between branches.

Besides Cupid and the Graces, Venus' entourage also includes Mercury. He wears his traditionally winged shoes, and carries a wand with which to ward off clouds that might otherwise disturb eternal spring.

Contemporary symbolism made an upward gaze the sign of relations to the Beyond. This is congruent with the mythological attributes of Mercury, who acted as a messenger between humans and the gods and who guided the dead to the realm of shadows. But Mercury was also the god of merchants, and was therefore hardly out of place at a wedding with a commercial background. Besides this, he – together with the goddess Flora and countless painted flowers – provides a further allusion to the wedding month: Mercury's day in the Roman calendar was 15th May; his mother was Maia who gave the month its name.

The artist speculated on his con-

temporaries' ability to recognize such allusions. He played cat and mouse with the spectators of his painting, refusing to commit himself. Here, too, Botticelli is in tune with contemporary theorists, one of whom wrote: "Divine things must be concealed under enigmatic veils and poetic dissimulation."

Mercury

Hieronymus Bosch: The Haywain, between 1485 and 1490

A cart trundles towards damnation

At first sight an alienating picture – overcrowded with objects and figures, bearing little relation to one another. In the middle is a cart laden with hay, with a bush somehow growing on top. In front of the bush, three people are making music; standing beside them – and painted with equal realism – are an angel and a devil. Riding behind the wagon are an emperor, a king and a pope – as if high-ranking rulers had

ever provided a ceremonial escort for dried grass! The haywain is accompanied by men and women who, rather than trying to prop up the heavy load, are in fact trying to pull hay off it. They fight, and some of them fall under the wheels.

The wagon is being pulled by strange creatures – demons from the underworld. One of them is not quite a fish and not quite a man, but has something of both. Behind them, people are streaming out of a mound of earth with a wooden door. There is another contradiction, too, between the wasteland in the foreground and the rich landscape in the upper half of the picture, presented so beautifully and clearly as if to make up for the chaos in front.

The panel, which measures 135 x 100 cm, forms the centre of a triptych. The left wing portrays Paradise, and the right wing a sort of Hell. The haywain and its crowd of followers are thus moving away from the meadows of innocence and towards the place of punishment for

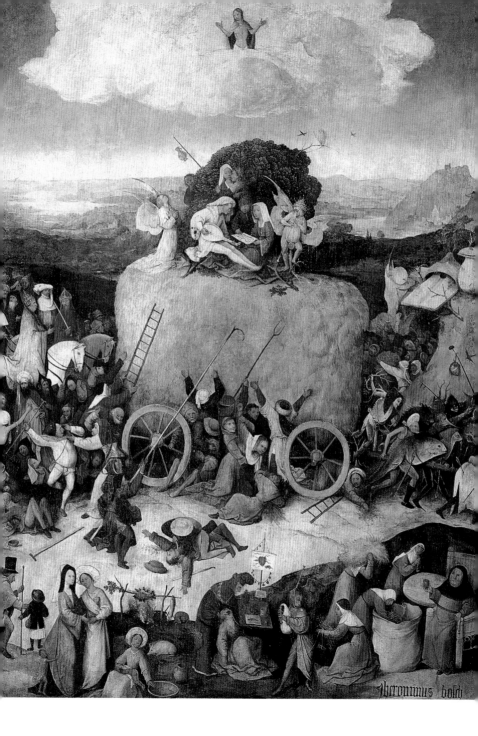

The world is a haystack

all sin. Never before, as far as is known, had a haywain formed the central focus of a painting. Together with its wings, the work resembles an altar. But at the point where Christ would normally be seen on the Cross, Bosch paints his farm cart, disproportionately large in relation to the surface area of the panel.

The work is undated, but leading Bosch experts place it between 1485 and 1490. In all probability, it was painted in s'Hertogenbosch, the artist's birthplace, from which he derived his name. Born around 1450 into a family called van Aken, he died in 1516. During Bosch's lifetime s'Hertogenbosch was a prosperous town of some 25,000 inhabitants,

albeit without its own university or bishop's palace. Its citizens wove linen, forged weapons, and traded, chiefly in agricultural products. Both then and over the following centuries, some 90% of the population worked on estates and in the fields. Bosch's painting thus stemmed from a time when a laden haywain would have been a familiar sight to the viewer, who would also have appreciated the value of hay as winter fodder.

The rise in s'Hertogenbosch's fortunes was accompanied, as in other Dutch towns, by social strife. Since the height of the Middle Ages, all skilled trade activities had been regulated by guilds. Now, however,

employers introduced new production processes and based their operations on what would later be termed early capitalist methods. Those who were successful made more profit than traditional masters of a craft, and they amassed large fortunes at the expense of real workers.

The acquisition of wealth was a topical subject in Bosch's day. The ruler of the Netherlandish provinces – the Hapsburg Archduke and later Emperor Maximilian – supported the new production methods, since he profited from the greater volume of taxes they yielded. His banner, with the double-headed eagle, can be seen behind the group of rulers on the left-hand edge of the picture.

Another highly topical subject was the decaying state of the Catholic Church. Bosch painted this picture of everyone trying to grab a handful of hay 30 years before Luther nailed his Protestant theses to the church door at Wittenberg. One of the chief reasons for Luther's anger at the Church was its secularization. The Pope behaved no differently to the princes. Material gain came before spiritual leadership.

The situation was similar in the churches and monasteries, which ranked amongst the biggest landowners. Many of the clergy and those living in monasteries considered their own well-being more important than the leading of a pious life. The annals of the day are full of scandals; the faithful felt themselves abandoned, and by the end of the Middle Ages there was a widespread sense of scepticism and pessimism. Symptomatic of this mood is Bosch's figure of Christ, pushed away to the upper edge of the picture and displaying his stigmata in a seemingly helpless fashion.

The decline of the Church, therefore, and the abolition of the guild system, together with religious and social uncertainty and a new wealth, characterized the society in which Bosch painted his *Haywain*.

Carts on which something was symbolically represented would have been familiar to the 15th-century viewer from festival processions, such as those staged during the annual Shrovetide carnival or to honour a ruler. It is not merely the load carried by the haywain which is important here, however, but also the fact that it is moving forward. The people of the Middle Ages thought and felt in eschatological terms: according to Christian teaching, humankind was heading for an ultimate destination – the resurrection of the dead, the Last Judgement, and eternal life for the blessed. On the Day of Judgement, each person would have to answer for his actions before the throne of God. Each person was heading inexorably, along with everyone else, towards that day of divine reckoning – including those who had lost sight of that fact

in the hustle and bustle of earthly existence. The haywain is rolling along. This motif of forward movement is also behind Bosch's *Ship of Fools*, in which religious and secular representatives of society are shown passing the time on board in frivolous pursuits. They pay no attention to the course they are sailing, and instead of landing in the harbour of salvation, they are shipwrecked off the coast of Fool's Land and are unable to stand before God at the Last Judgement.

The cart is laden with hay to a height which – from a realistic point of view – is impracticable. According to a Netherlandish proverb: "The world is a haystack, and everyone takes from it as much as they can grab." Although the proverb is only first recorded in the 19th century, it may be older. This is supported by the text of a Netherlandish song chronicled around 1470: God has piled up all good things like a haystack for the benefit of humankind; a fool is one who wants to have the whole haystack entirely for himself. Many of the figures in Bosch's painting are caught up in frenzied activity, trying to grab at the hay; only the rulers, accompanying the hay as if it were their rightful property, are calm.

The symbolic meaning of hay would have been familiar to Bosch's contemporaries who, from the Bible, would recognize this reference to the ephemeral nature of all things.

Psalm 37: "Don't worry about the wicked … For like grass, they soon fade away." Psalm 90: "For you, a thousand years are as yesterday! … You sweep people away … like grass that springs up in the morning. In the morning it blooms and flourishes, but by evening it is dry and withered." Isaiah 40: "… people are like the grass that dies away … The grass withers … but the word of our God stands forever." And in his first letter to the Corinthians, Paul writes of the value of worldly possessions: "… gold, silver, jewels, wood, hay, or straw … Everyone's work will be put through the fire to see whether or not it keeps its value."

With the hay on his cart, Bosch makes reference to ephemerality and greed. The thought or the sense of the transience of all things, of the unworthiness of humankind and of the approaching apocalypse was particularly widespread within the resigned atmosphere of the late Middle Ages. On the other hand, the introduction of early capitalist forms of industry made it possible for individuals to amass wealth on a scale unimaginable in the days of the old guild system. Bankers such as the Fuggers could decide the outcome of wars with their purses.

When the protector of this early capitalist economic order, Archduke Maximilian, visited s'Hertogen-bosch in 1481, the platform erected for him collapsed. This, it was said, was the revenge wreaked by crafts-

men who supported the old guild system. In Bruges in 1488 Maximilian was even held hostage by guild leaders. At times, the conflict between those who supported his rule, and with it the new order and the chance to get rich, and those who did not, came close to civil war.

In the left-hand wing of the triptych, Bosch portrays not just Paradise, but also the fall of the angels, as described in Revelations: "Satan … was thrown down to the earth with all his angels." Bosch shows the rebel angels as small, insect-like creatures, often with a tail, tumbling out of the clouds and disappearing into the earth. They reappear in the central panel as the demons pulling the haywain.

Revelations describes Satan as "the one deceiving the whole world". With the help of the hay, Satan's helpers are enticing the vain, greedy, warring inhabitants of Bosch's painting towards Hell. As always in his pictures, these demons are a mixture of human, animal and plant. One is a hooded man with branches growing out of his back; another is a fish with human legs, human arms and the face of a mouse.

It may well be that Bosch was here indulging his own distinctive, fantastical imagination. But there may equally well be a theoretical explanation for such figures: whereas God had separated the genera, the

bodies of Bosch's crossbreeds are clearly opposed to God's order.

For the majority of people in the Middle Ages, the devil and his helpers were real beings, as clearly emerges from the guidelines issued to help worshippers examine their conscience prior to confession, and from people's life stories and tales of mystical experiences. In the 13th century, for example, the abbot of Schöntal monastery reported that the world was full of evil spirits,

Opposed to God's order

who surged around every person like water around a drowning man. The abbot blamed these invisible beings for every indisposition, be it toothache, loss of appetite or a hangover after drinking. It was even they who caused every sort of involuntary noise, whether laughing, sneezing or sighing, for that was how they communicated amongst themselves. In 1487, around the time that this painting was executed, a Carthusian monk wrote that he had stumbled in his cell one night, and a ghost had caused him to fall. Was it the devil, he asked, or was it some poor soul from purgatory who wanted to make his presence known?

There are many records in which it is claimed that people felt themselves pushed or punched by ghosts, without them actually seeing any-

thing. As to the abbot in the 13th century, such spirits were real, but invisible. If they showed themselves, it was usually as animals. To one Eustochia Calafato, who died in 1485, they appeared "now in the shape of dogs, now in that of bears, now in that of pigs". In particular, they often came as unpleasant types of small animals and insects. Goethe adopted this idea into his *Faust*, in which Mephistopheles is the "lord of the rats and mice, the flies, frogs, bugs, lice …"

To nuns, monks and priests sworn to chastity they often appeared as the opposite sex, although of course they also came as deformed creatures with heads as large as cauldrons, crowned with horns. Hybrid figures were nevertheless the exception; they are sooner found as roof decorations or gargoyles on Gothic cathedrals than in written records. It seems they were never experienced at first hand in the shapes which Bosch created so skilfully and with such variety. His fantasies in paint were richer than those visited in person by apparitions from Hell.

Bosch's painting speaks, as we have said, of ephemerality and greed. Along the lower edge of the picture, he arranges people who clearly illustrate deception and theft, inspired by greed. The man standing on the left wears a tall black hat, identifying him as a travelling magician. He has a child in his cape, perhaps stolen. Next to him, a gypsy is reading an-

Jarring notes in a musical idyll

Hieronymus Bosch

other woman's palm, while her child tampers with the woman's dress. Further right, a quack doctor is tormenting a female patient. A nun is making up to a devil playing the bagpipes (a symbol of the male sex organ), while other nuns are stuffing hay into a sack at the table of a fat monk with a glass in his hand; they are swindling their church and breaking their vows. Beside the haywain above them, meanwhile, there is murder and death. Only on top of the haywain does Bosch seem to have included something of an idyll, in the group of three figures peacefully making music together: a richly-dressed lutenist, a young woman and a young man.

Half concealed in the bush, however, is a couple kissing, watched by an observer behind the bush. Is there a symbolism in this arrangement – in front those communicating chastely through music, behind those whose methods are more physical, and at the back the spy, the voyeur? For all the speculation, the scene remains an enigma. Only the significance of the peripheral figures is clear: the blue demon interrupts the love songs with the blast of his trumpet nose, while the angel looks beseechingly up to Christ. The angel is the only figure in this painting who is aware of the existence of Christ.

Man, caught between angel and devil – he must make up his mind. According to the teachings of the Church, humankind was by no means helpless against the devil, but Satan's power was great and there were many who made pacts with him. In Goethe, such pacts were written in blood on paper or vellum. In the Middle Ages, they were sealed with the sexual act. "Not without great sorrow", declared Innocent VIII in a papal bull of 1484, had he learned that "in some parts of Upper Germany … very many people of both sexes, deserting the Catholic faith, [had] entered into carnal union with the devil".

Those who joined themselves with the devil were witches and sorcerers, and in the same bull the Pope ordered that they be hunted out and destroyed. This became the particular task of the Dominicans, whereby two members of the order, Heinrich Institoris and Jakob Sprenger, were especially industrious. It was they who wrote the *Malleus maleficarum* (Witches' Hammer), an instruction manual on inquisitions and sermons. The three-volume work was first published in 1487 and quickly went into further editions. Sprenger was a prior in Cologne, the capital of the Dominican province to which s'Hertogenbosch also belonged. When Maximilian visited s'Hertogenbosch, he stayed with the Dominicans; sacred and secular power were thus closely linked – just as, in Bosch's painting, the pope, emperor and king follow close together behind the haywain.

The belief in witches, devils and demons, clearly already widespread, was furthered still by the Church. The latter was weak; many of the faithful were turning to sects or anti-Rome movements. By way of warning and as a means of countering desertion, such people were accused of being possessed by demons or in league with the devil.

Erasmus of Rotterdam, the great humanist, condemned the fear of witches incited by the Church. "The pact with the devil," he declared, was itself an "invention of the masters of the inquisition".

There are two versions of *The Haywain*. One hangs in the Escorial, the other – reproduced here – in the Prado. Whether both are by Bosch, or just one, or whether both are perhaps copies of a lost original, and whether the artist himself put his signature on the panel or someone else is unsure, but the fact that these questions remain unanswered does not detract from the quality of the painting. One of the two panels, like other paintings by Bosch, was purchased just 100 years after its completion by Philip II, the Spanish Habsburg king, and taken to El Escorial, his monasterial seat of government.

The years that gave rise to the *Haywain* also saw the completion in Florence of a painting of a very different nature, Botticelli's *Birth of Venus*. Botticelli celebrated – for the first time since Classical antiquity – the beauty of the female body, and with it prized the dignity and strength of humankind *per se*. He stylized the figure of Venus as a masterpiece of Creation. It is an optimistic work, an early testament to a new epoch, the Renaissance. Botticelli's *Venus* makes it clear that Bosch, his northern contemporary, was very much a painter of the resigned, pessimistic closing years of the Middle Ages.

There are no written documents, however, indicating to what extent Bosch himself shared the general mood, or whether he actually believed in demons himself. Did he feel hunted, threatened? Was painting his means of exorcising himself of nightmarish visions? Or of distancing himself from the Church through derisive caricatures? Both opinions can be found in the relevant literature. Bosch's work is open to interpretation. We do not know whether his relationship with the Catholic Church was close or distant. According to records, he was a member of the well-regarded confraternity of Our Blessed Lady, but that alone does not say a great deal. He received one commission from Philip the Fair, son of Maximilian, but little is known about his other patrons. What is certain is that he didn't have to live from his painting; he had married into a wealthy family.

While greed is given pride of place amongst the sins portrayed in

this triptych, gluttony also features. It is demonstrated by the stout monk with a glass in one hand and his rosary in the other. The arguments against over-eating today are based on considerations of health, not morality, and we perceive the battle for wealth, too, as a legitimate one. We have internalized liberal and capitalist ideas to such an extent that we are barely able to recognize the pious message contained in this picture: a warning against worldly possessions. It is a warning which runs through the history of Christianity right from the beginning. The fat-belly in the monk's habit demonstrates the reason why: someone who drinks wine and has hay gathered for him does not pray; his love of worldly goods reduces his love of God.

For social and economic reasons, this devout warning was particularly apt in Bosch's day. In a strange way, it remains equally appropriate today – not with regard to personal possessions, but to our treatment of nature.

Not unlike the figures in this painting grabbing the hay, people today are trying – both in cooperation and in rivalry – to seize and exploit the riches of nature for themselves. And like the haywain, one might say, they are thereby heading blindly towards the abyss, the destruction of their world. The crowded foreground in Bosch's painting is already desolate and empty, without

water or vegetation. The beautiful background bears witness to what is being lost.

A topical message for today

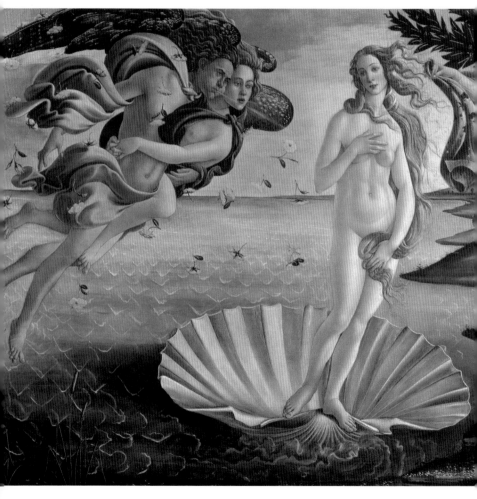

Fairest daughter of heaven and waves

Venus, a life-sized human figure, steps ashore from her shell; the female nude, banned for 1000 years, has returned to take its rightful place in art. Like Venus herself, the nude had been seen as the incarnation of sinful lust. The Renaissance rediscovered the beauty of the human body. The painting is one of the greatest treasures of the Uffizi, Florence.

It had been a thousand years since anyone in Europe had seen the like of it: an almost life-sized nude, the representation of a naked woman, a picture of perfect corporeal grace – Aphrodite, the Greek goddess of beauty and love, whom the Romans called Venus, reborn in Renaissance Florence. Arisen from the waves, borne on a breath of wind, she approaches the shore on a shell.

This pagan scene was painted around 1486 by the Florentine Sandro Botticelli, a devout Christian, whose studio concentrated largely on satisfying the enormous demands of the public for devotional pictures: saints, gentle-faced Virgins and the Holy Child. Practically all art had a religious content at the time. It has been calculated that

1

Decorative blossom for a cool villa

only 13 percent of art works had secular themes, the majority of them portraits.

At the peak of his career, Botticelli, the renowned painter of Virgins, decided to turn his hand to something new: four large-scale "mythologies" based on the pagan tradition of Classical myths and legends. One of them was the *Birth of Venus.*

The first male nude of the Renaissance, a young bronze *David,* had been modelled from life in 1430 by the Florentine sculptor Donatello. The fact that the *Birth of Venus* did not appear until over fifty years later is a testimony to the lasting effect of the Christian taboo against the portrayal of the naked female body. Previously, the only female nudes to dare appear in works of

art had been Eves with snakes and apples; punished for their sins, they had quickly been expelled from paradise, stooping under the burden of their shame.

Unlike these heavily stylized, Gothic figures of Eve, Botticelli's Venus is patently the product of anatomical studies, as well as the artist's adherence to Classical models. The influence of Greek Classical sculpture is visible in the way the weight of the goddess rests on one leg, in the attractive curve of her hip, in her chaste gesture. The Renaissance artist has drawn her proportions in accordance with a canon of harmony and ideal beauty developed by artists such as Polyclitus and Praxiteles. This included the measurement of an equal distance

between the breasts, between the navel and breasts, and between navel and crotch. The canon helped form countless nudes, from Classical Greek statues to figures on late Roman tombs. However, it later fell into disrepute and, eventually, oblivion, where it remained until its rediscovery by the Renaissance. It has influenced our taste ever since.

Botticelli's goddess of beauty is one of the great stars of the Uffizi, Florence. Only with difficulty can she be protected against the storm of her admirers. The situation has become worse since restoration of the work was concluded in the spring of 1987. A layer of varnish, added some time after the work was completed and darkened to a yellowish-brown patina with age, was removed from the 184 x 285.5 cm canvas. The heavens, waves and deities now shine out boldly and brightly in their original tempera.

Where the goddess of love lingers, roses fall from the sky. In the place where her foot first alighted on land – according to the Greek poet Anacreon (who lived from 580 until after 495 B.C.) – sprang the very first rose-bush. There are pale red roses, too, wound around the waist of the girl waiting to receive Venus on the shore. Perhaps she is one of the three Graces, thought in Classical antiquity to belong to the entourage of the goddess, or one of the three Horae, the seasons. The anemones at her feet and her cornflower-bespangled dress suggest she is the Hora of spring – the time of the year when Venus restored love and beauty to the earth after a hard winter.

The *Birth of Venus* could almost be called *Primavera*, or *Spring*, the title of Botticelli's other great "mythology" in the Uffizi. Here, too, a (clothed) Venus holds court in a garden, surrounded by gods of the wind, flower-girls and semi-nude Graces.

The painter and art biographer Giorgio Vasari mentions the paintings for the first time in 1550, when they hung together at Castello, a country villa near Florence belonging to Cosimo I de' Medici. Vasari, who was Duke Cosimo's architect, describes one as "The birth of Venus, and the skies and winds who lead her to the Earth, escorted by the gods of love; the other, Venus crowned by the Graces with flowers, announces the advent of Spring."[1]

Art historians have generally assumed that Botticelli painted the works for the owner of this villa. In 1486 the owner was Lorenzo di Pierfrancesco de' Medici, also known as "Lorenzo the Younger" to distinguish him from his cousin Lorenzo the Magnificent, the uncrowned king of the Republic of Florence. However, while a recently discovered inventory has verified the younger Lorenzo's ownership of *Primavera*, there is no trace in the

inventory of the *Birth of Venus*. It is therefore not known who commissioned it.

A link has naturally been sought between the painting and the two most famous Medici of all, Lorenzo the Magnificent and his brother Giuliano. The splendour, extolled by the poets, of their pageants and banquets has never ceased to fire the popular imagination. The *Birth* thus came to be seen as an act of homage to Simonetta Vespucci, the wife of a Florentine merchant. She had been the "Queen of Beauty" at a tournament organised by Giuliano in 1475, a fact which led various commentators to conclude that the nature of their relationship had been romantic; and since Simonetta was born at Porto Venere (Port Venus) on the Ligurian coast, Botticelli's goddess was said to bear her features. Both died shortly after the pageant: Giuliano stabbed by his political enemies, and Simonetta of consumption, adding a tragic note to the popular appeal of this account of events. Unfortunately, however, there is no real evidence to support the story.

Nor has it ever been explained how the painting later entered the possession of the Medici family. It is quite probable that it was intended for a country house outside Florence. The owners of these cool villas, bankers recuperating from business, noise and epidemics, preferred frescos and canvases with light-hearted themes to religious panel paintings. Botticelli probably painted the goddess for one of his Florentine contemporaries, many of whom were capable of combining an understanding of money and politics with a refined sensibility for the arts. His patron may even have been able to appreciate Anacreon in the Greek original.

Aphrodite, or Venus, was held in high regard by the Greeks and Romans. With the triumph of Christianity she fell into disgrace. During the Middle Ages she was seen as the incarnation of sinful lust and depravity.

The distrust in which she was held until well into the 14th century is documented by the Florentine sculptor Lorenzo Ghiberti (1378–1455). He wrote of an antique statue of Venus, a work "of great perfection", found in the neighbouring town of Siena. The citizens showed great

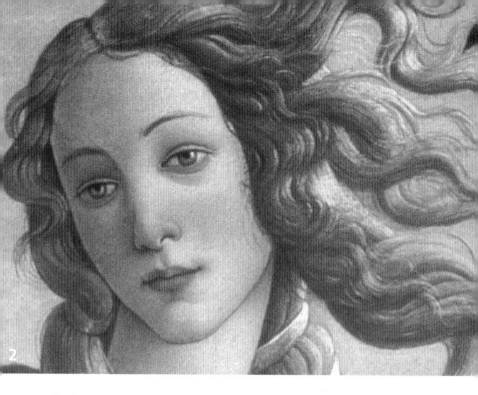

reverence for the statue, placing it on the town well. But when the town was afflicted by war, the mood changed dramatically. "Since idolatry is forbidden by our faith," warned one public speaker, "there can surely be no doubt who has caused our misfortunes."[2] On 7 November 1357 the councillors decided to "smash" the statue of Venus "to pieces" and to "bury its fragments within the precincts of Florence" in the hope that they would bring similar misfortune upon the heads of their enemies. The same Ghiberti was lucky enough to witness the rediscovery of a second Venus, which came to light in Florence "while they were digging under the Brunelleschi Villa". However, this statue did not suffer the fate of its Sienese cousin, for the religious climate in Florence had now changed. Tired of the conventions propagated during the Middle Ages, the Florentines sought new models. They found them in Classical antiquity: the movement which came to be known as the Renaissance had begun.

It is not known what inspired Botticelli, one of the second generation of Renaissance artists, to paint the *Birth of Venus*. He was undoubtedly acquainted with the Medici

Relatives: Venus and Mary

The Birth of Venus, c. 1486

3

Zephyrus makes their robes flutter

family's collection of antique gems with their Roman depictions of nereids and sea-goddesses. It was also at this time that translations by Florentine humanists first appeared in printed editions in Botticelli's native town. The *Homeric Hymns,* for example, were published in 1488: "Aphrodite, beautiful, chaste, of her shall I sing… who holds sway over the sea-washed embattlements of Cyprus, where the moist breath of Zephyrus gently bore her … to be greeted by the Horae with golden diadem and joy …"[3]

In his *Theogeny,* written in the 8th century before Christ, Hesiod tells of Aphrodite Anadyomene – i. e. "rising out of the waters": Dur-

ing the battle of the gods, Cronos defeats and castrates his father Uranus, the heaven; his seed flows into the sea, the union of water and heaven producing the goddess of love. The secret of her birth was considered a sacred mystery and was linked to a cult, whose symbols appear in Botticelli's painting. Thus the purple gown, held ready for the goddess on the shore, has not only an aesthetic, but also a ritual function. Its first appearance was on early Grecian urns, where it symbolized the border between two regions: both newly born babies and the dead were wrapped in cloth.

During the Middle Ages, the traditional attributes of Venus, her ros-

Sandro Botticelli

es for example, were passed on to another dominant figure, whose role was utterly opposed: the Christian Virgin Mary. This is also true of her shell. In connection with the pagan goddess, the sea-shell, like water, represented fertility. Its resemblance to the female genital organs made it also a symbol of sensuous pleasure and sexuality. But as the dome above the Virgin's head in Botticelli's St. Barnabas altarpiece, it can only symbolize virginity: it was thought that various kinds of mollusc were fertilised by the dew. The ambivalence of the symbols suggests that the dominant mythical female figures of Classical antiquity and the Middle Ages overlap. In any case, Botticelli evidently had no compunction about using the same model for both.

Homer's story of Venus refers to the chubby-cheeked god of the wind. His name was Zephyrus, the Wind of the West, on whose breath spring came to the land. The Roman poet Ovid tells of his companion Chloris, whose white legs and arms are clasped around Zephyrus' brown body: after he had raped her, the West Wind made her his wife, turning her into Flora, the goddess of flowers.

Where did the Florentine craftsman and tanner's son Botticelli receive his education in mythology? He was described in childhood as a sickly boy who spent much of his time reading.[4] But could an apprenticeship to a goldsmith, and later to a painter, really leave him as well-versed in Ovid and Homer as some of Florence's richer merchants? It seems unlikely, given the size of the library which belonged to the Maiano brothers. These artists came from the same town, the same generation and the same class background as Botticelli. According to an inventory compiled in 1498 they possessed a mere 29 books, half of them religious. The only Classical texts were a biography of Alexander and an edition of Livy's works. The scope of Botticelli's library was probably comparable.

Required to execute a history painting, the Renaissance architect and art historian Leon Battista Alberti (1404–1472)[5] recommended "… asking friends for advice." Through his neighbour, Giorgio Antonio Vespucci, Botticelli was well connected with the intellectual élite of Florence: scholars who, under the aegis of the ruling Medici, had set about rediscovering Classical antiquity.

Botticelli occasionally collaborated with the humanist and poet Angelo Poliziano (1454–1494). For example, he decorated a jousting banner for Giuliano de' Medici with allegorical motifs devised by the scholar. In a poem written in honour of the same tournament, Poliziano describes a *Birth of Venus* not unlike that by Botticelli. Possibly,

the painter's "mythologies" benefitted from Poliziano's expert advice.

However, Botticelli's adviser could just as easily have been the philosopher Marsilio Ficino (1433–1499). Ficino's life-work was an attempt to reconcile Classical philosphy with Christianity (even humanists attended daily mass!): a new doctrine sprung from the union of pagan ideas with medieval theology. "Celestial Venus", as opposed to the pagan earthbound goddess, was given a highly positive role in Ficino's system: she stood for humanity, charity and love, and her beauty led mortals to heaven.

Even if Poliziano or Ficino did not advise the artist directly, their society must have made the ancient divinities acceptable in his eyes, ensuring that a devout Florentine painter in 1486 could portray a naked Venus in good conscience, without having to fear that his work would be "smashed to pieces and buried".

Because we take pleasure "at the sight of flowing garments," the theorist Alberti advised painters to show the face of Zephyrus blowing down through the clouds and "robes fluttering gracefully in the breeze".[6] Botticelli followed his advice. In his *Birth of Venus* everything is in motion: the waves, the branches of orange trees in the backgound, the roses floating to earth, the robes of the different figures. It was also true of the figures' hair: Alberti had de-manded that hair be shown "in flowing curls which appear to form rings, or to surge like flames into the sky, or to be intertwined like snakes".[6]

The representation of movement as an expression of life and natural energy in rediscovered Roman statues and reliefs greatly impressed the artists of the Renaissance. They considered it important to take up the idea in their own work. In 1434, Alberti wrote a "modern" aesthetics based on Classical principles, entitled *On Painting*. Although unpublished until the following century, it was already known in Florence much earlier, probably becoming Botticelli's theoretical bible. Cennino Cennini's *The Craftsman's Handbook* had appeared in 1400 and would certainly have been used in Botticelli's studio. It explained how to crush lapis lazuli to extract blue colouring for the cornflowers on the Hora's robe, for example, or how to apply extremely thin gold-leaf to Venus' purple gown. However, Botticelli was an innovative craftsman in his own right. His *Birth* is not painted conventionally on poplar. Unlike the *Primavera* it is not a panel painting at all, but the first large-scale Tuscan work to be painted on canvas.

Although Botticelli still painted with tempera (Cennini advised using eggs from town hens, since country eggs made the colours too bright), he added extremely little fat

to the pigment, achieving exceptional results. His canvas has remained firm and elastic ever since, the paint itself showing very few cracks. Removing a layer of oily varnish that had been added to the painting after its completion, restorers discovered that Botticelli had applied his own, very unusual protective layer of pure egg-white. It was this, together with the "lean" tempera, which made the painting resemble a fresco, making it suitable for a country residence. Indeed, the fact that she was hung in a villa outside Florence may have saved this Venus from oblivion, for it soon seemed as though all the efforts of humanists to rehabilitate the goddess had been overtaken by history. The defeat of the Medici led to the monk Savonarola's strictly enforced Florentine theocracy from 1494 and 1498. On the night before carnival, Shrove Tuesday 1497, he ordered make-up, jewellery and false hairpieces of all kinds, as well as "lascivious paintings", to be burned on a "bonfire of vanities". Botticelli is said to have become a follower of this fanatic monk. True or not, he certainly stopped painting pagan mythologies and naked women.

4

Cornflowers of lapis lazuli blue

The Birth of Venus, c. 1486 167

The merchants of Venice

Carpaccio marginalizes the healing of the possessed. The object of his religious adoration is not a miraculous relic, but his own city: Venice. He shows the Rialto, the city's business centre, where the great trading nations owned houses and wealthy burghers paraded in their finest clothes. The painting (365 x 389 cm) is in the Galleria dell' Accademia, Venice.

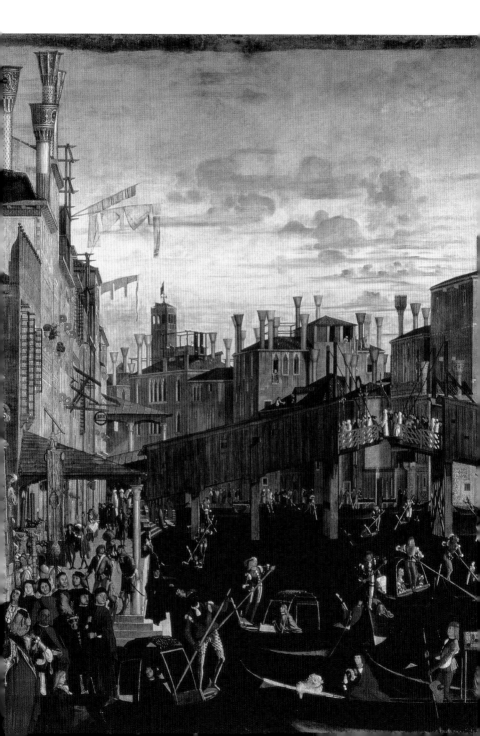

A procession in Venice: filing across the bridge, it disappears between the houses, then reappears from the left. The brethren at the head of the procession ascend the steps to a loggia, where they are met by the patriarch, the spiritual leader of the city-state. The brothers have brought him a reliquary containing a splinter of the holy cross. The patriarch holds it before a man who is possessed by a spirit – the man is immediately healed. Or so the story goes.

The relic, which belongs to the Brotherhood of San Giovanni Evangelista, was also responsible for a number of other miracles. In one case the splinter was supposed to accompany the funeral procession of a brother who had refused to recognize the sacred nature of the relic, whereupon the splinter, in turn, refused to enter the church where the dead man lay. The scene was painted by Giovanni Mansueti (c. 1485 – 1527). On another occasion, during a procession, the relic fell into a canal. Several brothers jumped in after it, but the splinter permitted only the leader of the brotherhood to remove it from the water. This incident is recorded in a painting by Gentile Bellini (c. 1429 – 1507). The work hangs beside Carpaccio's painting in the Accademia, Venice.

The patron of the works by Carpaccio, Bellini and Mansueti was the owner of the relic: the Scuola Grande di San Giovanni Evangelista. There were several such "schools" in Venice, societies devoted to charity, and named after churches, or patron saints. The Scuola di San Giorgio degli Schiavoni, for example, another of Carpaccio's patrons, represented the interests of a group of foreigners: Dalmatians who worked in Venice. The great Society of John the Evangelist (Giovanni Evangelista) looked after the old and sick, for whom they built a hospice. In 1369, they received a present from the High Chancellor of the King of Cyprus: a splinter of the Holy Cross. The gift was kept in a reliquary of quartz and silver. However, relics were not only significant in religious terms. The more valuable the relic, the greater the respect shown to the society or town that owned it. Conversely, the more powerful a society or municipality had become, the less it could afford to be content with a second-rate relic. Venice herself is a good example: in her early days she had managed to get by with a patron saint of local origin; as a powerful city-state, however, Venice decided to make St. Mark the Evangelist her patron saint. St. Mark's bones were stolen from Alexandria and, according to tradition, smuggled out of the Muslim country wrapped in pork. Thus the Venetians came into possession of one of the most highly-prized relics in Christendom.

By 1500, the cult surrounding relics was less widespread than dur-

ing the Middle Ages, at least among the upper classes, or among those who had enjoyed the benefits of a humanist education. To the latter, the original manuscript of a Classical text would have been just as meaningful as the most important Christian relic.

Carpaccio executed his painting in 1494 or 1495. In 1544, probably to accommodate new doors, several paintings, including Carpaccio's, were shortened by removing a section from the bottom. Before this was done, however, the Giovanni

Brotherhood consulted an expert for advice. A document now in the Venetian State Archive records the following: "The very wise Master Titian, the painter, a man whose great experience is known to all, was taken to the place. He recommended cutting some off the bottom of the said canvases ... saying the cut would not damage the said canvases in any way."[1]

A century later, the painting was lengthened again by 27 centimetres, an addition it is impossible to overlook.

The rooftops of Venice

Miracle of the Relic of the Cross, 1494/95 171

Domestic life in Venice partly took place on roof terraces high above the town. More simple terraces were of wood; others had brick walls. Some were even embellished with marble cladding.

It was here that the Venetians would beat carpets, or that women and young girls would bleach their hair; here, too, families would sit out on summer evenings and enjoy the cool air. Roof terraces provided an alternative to gardens, for space was severely restricted at ground level in the town centre.

Only on the nearby islands did people have small gardens. The wealthier Venetians made up for land shortage in town by buying a villa or palazzo on the mainland. At certain times of year they would move to the country, where normal life would continue in different surroundings.

In the 15th century, washing and clothes were not hung out to dry or to air on washing-lines, but on poles. In Carpaccio's painting these are shown protruding from the houses. However, the poles usually ran through rings which were fixed along the walls beneath the windows. The rings, too, are shown in Carpaccio's painting.

The funnel shaped chimney was a typical feature of the Venetian skyline. There is no practical reason for its unusual shape. Chimneys were

Two Turks and a Knight of St John

2

Vittore Carpaccio

probably given broad tops for aesthetic reasons, since this allowed their owners to embellish them. Chimneys were considered decorative objects. It is said that the poorer Venetians, like the rich, went to great trouble to paint their chimney-funnels, hoping, even if only in this detail, to compete with their wealthier fellow-citizens.

A man in a black coat with a white cross leans back casually in his gondola: a Knight of St. John. Like two other orders, the Knights Templar and the Teutonic Knights, the Knights of St. John had come into their own during the crusades, a mass movement from which Venice, with its large fleet of transport ships, had greatly profited.

The Knights of St John were the oldest of the three orders. Founded in 1070, two decades before the first crusade to the Holy Land took place, its purpose was not to fight, but to help. A small number of men had come together to found a hospital for pilgrims. They took monastic vows and called themselves the Brotherhood of the Hospital of St. John at Jerusalem. Forced to defend their property against the "infidels", they took up arms and became knights. They were sent presents and donations from all over Europe, becoming a large organisation who supported pilgrims not only upon their arrival in the Holy Land, but also during their pilgrimage. Like

other orders, they owned houses in most of the large ports – Venice included. The hospice of the Knights of St. John was near the Church of San Giovanni dei Friul. The Teutonic Knights kept their hospice near the Church of the Santissima Trinita, while that of the Knights Templar was near the Church of the Ascensione.

But all that had been many years before Carpaccio's time. In the meantime, the Christians had been driven out of the Holy Land, the Templars dissolved by the French king, while the Teutonic Knights had become totally insignificant. Only the Knights of St. John had managed to retain their organisational structure and power. They were based on the island of Rhodes, where they continued to foster their ideal, begun in the Middle Ages, of a life combining knighthood and monastic vows. It was not until 1523 that the island fell to the Turks, 30 years after Carpaccio had painted a Knight of St. John sitting casually in the middle of Venice. The main enemies of the order, and of Venice itself, were the Turks, two of whom, standing at the foot of the bridge in white turbans, are shown in the painting. Perhaps they were merchants, or diplomats. The Turks had conquered Greece and Albania, thereby occupying bases on the Adriatic, a region of primary strategic importance to the Venetians. Competition sometimes led to hos-

tilities between the two powers, sometimes to treaties; but trade between the two flourished whenever the opportunity arose. The governments of other states often found this difficult to understand.

The State Chronicles refer to an incident in 1496, when a horse, presented by a Turkish pasha, was led into the reception hall of the doge's palace. In 1500 there is a reference to Turkish ambassadors in Venice. However, in the same year the Venetians were defeated by the Turks in two sea-battles. A peace treaty was (provisionally) concluded in 1503, and by 1509 the Venetians were pleading with the Turks to help them fight their European enemies…

"The Venetians are more like Turks than Christians: shopkeepers with no religion!" said their European opponents. However, the Venetians had their own motives for entering the fray: "In fear of God, in the best interests of Christendom, for the honour of the Republic, for the benefit of the merchanthood!"[2] Although the "merchanthood" is mentioned last, its interests undoubtedly came first. The merchants were the Venetian aristocracy. Their success benefitted not only the ruling class, however, but the entire Venetian population.

Venice was governed from the district of San Marco, with the doge's palace and procurators' offices on St. Mark's Square. The business world met in Rialto, the district painted by Carpaccio. Rialto was the site of the great Venetian markets; it was here that sailing ships unloaded their cargoes and that great trading nations kept their warehouses. Rialto was also the site of the only bridge across the Canàle Grande. Behind the Rialto bridge, on the right, is the Persian warehouse. The German warehouse (Fondaco dei Tedeschi) was not built until 1505, ten years after the painting was executed. It still stands in the immediate proximity of the bridge, where today it houses a post-office.

The houses kept by various nations served foreign merchants as both warehouses and hostels. The Venetians treated foreigners with suspicion, while capitalizing on their own misgivings: foreign traders were forced to contract weighmasters, balers and real estate brokers from the government in San Marco. The position of broker, especially, brought a large quantity of money for very little work; it was therefore a sinecure for deserving Venetians. The broker at the Fondaco dei Tedeschi in 1516, for example, was the painter Titian (who allowed Carpaccio's painting to be shortened).

The middle section of the Rialto bridge could be raised, allowing larger ships to navigate the Grand Canal; the ropes attached to the drawbridge can be easily identified

in Carpaccio's painting. On the wooden bridge were tiny stalls with counters on the inside and small windows looking over the canal. In 1502, the bridge almost collapsed because of the number of pedestrians. In 1591, almost a century after Carpaccio painted the scene, a new, stone bridge was built; it stands there to this day. Sculptors and architects like Michelangelo, Palladio, Vignola, Sansovino and Scamozzi all drew up designs for the project; in the end, the work was commissioned from a lesser-known architect by the name of Antonio da Ponte.

Why the job was finally given to him, nobody knows. Perhaps it was because his plan suggested preserving the little shops and stalls on the bridge, whereas Palladio wished them removed.

Not only foreign trade was regarded with suspicion in Venice; a watchful eye was also kept on the practices of local businessmen. Meat, fish, cereals and oil were sold at fixed prices. Only fishermen over 50 were allowed to sell fish, an early form of insurance for old people. Any person selling bad fish was whipped the length of the Merceria, a street stretching from the Rialto bridge to St. Mark's Square. The culprit was forced to pay a fine, imprisoned for a month and forbidden to carry out his profession for four years. Dishonest innkeepers could expect similar treatment. The round

sign of an inn can be seen hanging from one of the houses on the left. The inn is called "The Sturgeon"; an inn of that name is known to have stood here.

Hygiene was taken particularly seriously in Venice, the first town in Europe with a public health authority: the Magistrato della Sanità. The office opened in 1486, exactly ten years before the picture was painted. Its main task was to fight the plague, which broke out about every eight years. The authority attempted to prevent its spread by isolating its

Rialto

Miracle of the Relic of the Cross, 1494/95 175

4

Officially, trading slaves was forbidden in Venice at this time; in practice, however, it continued until the end of the 16th century. At the end of the 15th century, a healthy boy between the ages of twelve and sixteen, or an untouched, healthy woman, would cost about 50 ducats. Men usually cost more. The slaves were generally North African or Levantine prisoners. Moors were considered highly fashionable.

Judging by contracts, slaves, like pieces of furniture or plots of land, entered the estate of their owners unconditionally upon purchase. They were christened and given a new name. Despite their lack of freedom, they were sometimes better off than hired servants, since the master was obliged to provide for them even after his death. A final will might read as follows: "The slave shall remain in my widow's service for six years, whereupon she shall release him with a legacy."

Whether slave or servant, the dress of the gondolieri in the painting is magnificent, indeed often more so than that of their masters. Servants were frequently used as a badge of family wealth. Exhibitions of wealth and ease were a popular

The Moor

victims in state-run hospitals where the sick were kept in quarantine.

The cause of the epidemic was unknown, but was thought to lie in refuse and filth. For this reason shopkeepers were prohibited from throwing their rubbish out on the street. From 1502, it was forbidden to let pigs on the streets of Venice; this contrasts with Berlin, where pigs were still permitted on the streets under the Great Elector (1620–1688). Scavenging was practised in Venice at the time of the painting, and the tidal canals pro-

Vittore Carpaccio

pastime among the Venetian upper classes in 1500. Once, they had devoted their energies to consolidating the power of the Republic and increasing the profits of the merchants, but those days were over. Venice was now on the defensive. The Ottoman Empire had grown powerful in the east, and Venice could not hope to compete with Spain and France in the west. The discovery of a sea passage around the Cape of Good Hope was also a factor in Venice's demise, for it meant that new trade routes could be opened between Europe and Asia. Spices, carpets and precious woods no longer had to be transported on camels to the Mediterranean coast before they could be loaded on ships; merchandise was shipped to the west directly, its destination no longer Venice, but Lisbon. It was from Lisbon and Seville that expeditions put out to sea for South America, too. Trading routes had changed; merchantmen no longer put in to Venice as a matter of course. The town had lost its leading position, and its merchants had nothing to do. They preferred being rowed about Venice in gondolas than sailing on the high seas.

Astonishingly, Venice continued to exist as a Republic for another 300 years. It was neither conquered from without, nor overthrown from within. This made it unique in Italy. There were three main reasons for its exceptional stability. The first was geographical. Its insular position made it difficult to attack. It was not until it had finally become too poor to employ a proper army that Napoleon's troops entered Venice without resistance. That was in 1797. The Republic had survived more than 1000 years.

The second reason for the long life of the Republic was its clever system of checks and balances. In Florence, Genoa, Milan and Rome, individuals frequently succeeded in usurping total power. This was not the case in Venice. Public office was made the subject of regular elections. Only the doge had life tenure, and he was usually an old man by the time he entered office.

The third reason for the stability of the Republic was a feeling, an attitude: reverence. The Venetians revered their town, their state. When they prayed to St. Mark, their patron saint, they were praying, through him, to a communal body which they inhabited.

We sense this reverence in Carpaccio's painting. He was commissioned to paint a miracle. But Carpaccio marginalizes the legend, using it as an excuse to paint a panorama of the Rialto. The pious brotherhood, also citizens of Venice, did not object.

The Republic

A message from the world of alchemy

In a marshy meadow, a semi-naked young woman with bleeding wounds is lying amongst the flowers. A faun bends over her, and a large hunting dog sits at her feet. Dogs and birds are seen on the shore of an expanse of calm water behind. Morning is breaking.

The "hazy atmosphere of a waking dream", the "poetic dreaminess" which infuse the scene have struck all who have studied this painting.

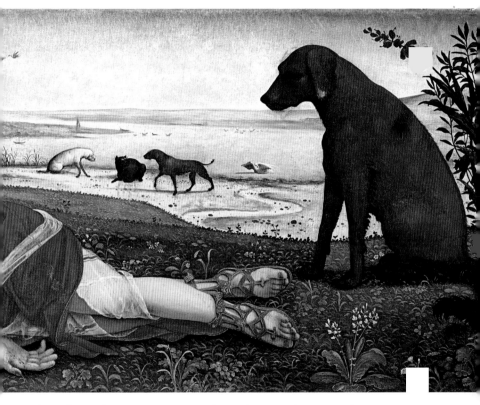

Speaking of Piero di Cosimo, to whom this unsigned and undated picture is attributed, the art historian Erwin Panofsky describes the "strange lure emanating from his pictures … their content as unusual as their style … not a 'great master' but a most charming and interesting one".

Piero di Cosimo (1462–1521) lived in Florence all his life. He saw the High Renaissance and the city's

The Death of Procris, c. 1500

flowering under its Medici ruler Lorenzo the Magnificent, and he saw its decline: the expulsion of the Medici in 1494, the reign of the monk Savonarola, occupation by the French, war and civil war, and finally, in 1512, the return of the Medici in the tow of the Spaniards.

In his *Lives of the Most Eminent Painters, Sculptors and Architects*, published in 1550, the architect and court painter Giorgio Vasari also included a biography of Piero di Cosimo. On the basis of reports by contemporaries who had known him personally, Vasari described the artist as "a spirit set apart and very different from other painters", and one "wildly inventive and fanciful".

At what date Piero painted this panel of the young woman, faun and dog is unknown. Some consider it an early work, others a late one. Its content is similarly a matter of dispute. It hangs in the National Gallery in London, where it bears the generalized title of *A Mythological Subject*. The custodians of the museum doubt that it shows – as most art historians believe – *The Death of Procris*, the final scene in an ancient legend told by the Roman poet Ovid in his *Metamorphoses*.

A victim of jealousy

1

It is the sad story of how mistrust and jealousy destroyed the happiness of the newly-wedded Cephalus and Procris. It all started when Cephalus allowed himself to be persuaded to put his wife's faithfulness to the test, by courting her while disguised as another man. She "wavered". When Cephalus then revealed his true identity, Procris fled, ashamed and enraged, to the goddess Diana in the forest. Cephalus eventually succeeded in winning his wife's forgiveness, but now it was she who mistrusted her husband. Jealously, she followed him out hunting one morning and secretly spied on him from behind a bush – and was fatally wounded by the spear thrown by Cephalus at what he thought was an animal.

Strangely, Piero di Cosimo has portrayed in this panel not Cephalus, but a dog, Laelaps, who only plays a secondary role in the legend. He was given to Procris by the goddess Diana. He now sits at his mistress' feet, the embodiment of faithfulness, a virtue so important to the two main characters in the story and yet one in which they had so little trust.

"Let this be a lesson to women: where there is jealousy, there is no more peace!" The moral of Procris' story is drawn not by Ovid, but by a "nymph" in the fourth act of *Cefalo*, a drama by Niccolo da Correggio. The play was performed at the Fer-

rara court on 21 January 1487. Correggio thereby made theatre history, since it was only the second play about a classical subject to have been seen in Renaissance Italy after Angelo Poliziano's *Orfeo*. It appeared in print in Venice around 1507, and Piero di Cosimo was probably familiar with it.

In those days, dramas based on jealousy with a more or less tragic outcome were not confined to the stage. Thus the author Matteo Bandello (c. 1485–1562) lamented: "If only we didn't have to hear daily stories about someone murdering his wife for suspected infidelity ..." If women "do something that displeases us, we immediately reach for the rope, dagger and poison". But the self-confident women of the Renaissance were no more ready than Procris to accept their husbands' extramarital escapades. In 1488, for example, the lord of Faenza, Galeotto Manfredi, was "hacked to pieces" on his wife's orders "because he was unfaithful to her".

The Procris legend was evidently considered appropriate as a way of warning a bride and bridegroom against mutual mistrust within their marriage. A performance of Correggio's play was given at a wedding held at the Este court. In this instance, however, the author deviated from Ovid and gave the story a happy ending as appropriate to the occasion: in the fifth act, a sympathetic goddess brings Procris back to life

and gives her back to Cephalus. Death is followed by resurrection.

Piero di Cosimo's panel may also have been intended for a wedding. The work is executed in tempera and oil on wood, and measures 65 x 183 cm – an unusual format for a painting, but one that would fit the front of a *cassone*, or bridal chest. In Florence between 1350 and 1530, almost every bride took one of these long, lockable wooden trunks with her into her new home. They housed her trousseau – laundry, clothes and jewellery – and were placed at the foot of the matrimonial bed. Those who could afford it had their *cassone* decorated by an artist.

Like his famous colleague Sandro Botticelli, Piero di Cosimo is supposed to have decorated several wedding chests, for example with the *Departure of the Argonauts to capture the Golden Fleece*. In these chests, artists could allow their imaginations a freer rein than in altarpieces and large panel paintings. Favourite scenes were thereby those from myth and ancient legend, and thus it was that *cassoni* provided the first forum for classical subjects in the art of the Early Renaissance – many are decorated with scenes from Ovid.

In view of its very long and narrow format, the *Death of Procris* might also have formed part of a series of wall panels, such as Piero – according to Vasari – executed for the apartment of a wealthy citizen.

Based on a philosophical programme, the panels portrayed the development of humankind through the theme of the *History of Fire*. Perhaps *Procris* also belongs to this thought-provoking ensemble, and contains a message other than simply a trivial warning against jealousy.

In his biography of Piero di Cosimo, Vasari repeatedly emphasizes the painter's "odd and original invention". For this reason he was much in demand during his youth for carnival masquerades. Under Lorenzo de' Medici (1449–1492) – who earned the name of "Lorenzo the Magnificent" not least for the glittering festivals which he staged – carnival processions assumed the scale of grandiose mythological and allegorical spectacles. Their ingenious invention and surprise effects are supposed to have stemmed from Piero.

Years later, at the carnival of 1511, the painter "filled the whole city both with terror and with wonder" with the spectacle of an enormous chariot: "over the chariot was a huge figure of Death, scythe in hand, and all around the chariot were a large number of covered tombs". When the procession stopped, the tombs opened, skeletons leapt out and all "sang to music full of melancholy the song … *Grief, woe and penitence*." Piero had a penchant for the macabre, morbid and odd; this is evidenced, too, in his drawings and

paintings, which are peopled with creatures of fantasy, dragons and sea-monsters "more bizarre" and "more fantastic", according to Vasari, than one could ever hope to find elsewhere.

The creations of this Mannerist were often, again according to

Vasari, "not … pleasing … but … strange, horrible and unexpected". Piero di Cosimo thereby fell outside the conventional bounds of the Florentine High Renaissance. For the works of his celebrated contemporaries, such as Botticelli, Ghirlandaio, Perugino and Sansovino, were

A landscape from the underworld

The Death of Procris, c. 1500

When Rosselli was summoned to Rome by Pope Sixtus in 1482 to help decorate the Sistine Chapel, he allowed Piero to execute the landscape in his fresco of *The Sermon on the Mount*. It is the younger artist's first known work. Piero di Cosimo's landscapes lend his portraits and more conventional paintings of saints their special charm, their atmosphere. That landscape did not have to serve merely as a backdrop, but that it could play a decisive role in determining the character of a painting, was a lesson which Italian artists at the end of the 15th century were learning from Netherlandish masters such as Jan van Eyck and Hugo van der Goes, whose Portinari Altar was installed in Florence in 1483.

The Death of Procris is characterized by an elegiac watery landscape beneath an indeterminate sky – a space without boundaries, devoid of the logical vanishing point offered by centralized perspective. Great white herons – birds which Pliny the Elder, the Roman natural historian, said shed tears in sorrow like people – stand on the shore of a grey river. Rivers such as this flowed through the ancient underworld to which Procris descended: Acheron, the river of woe, Cocytus, the river of lamentation, and Lethe, the river of forgetfulness.

Bent over the prostrate body of Procris is a creature with a turned-up

The artist lived like an animal

characterized not by bizarreness, but by the beauty of their figures, their measured proportions and their harmony.

Piero was apprenticed as a young man to a second-rate artist called Cosimo Rosselli. Although his painting soon surpassed that of his master, he remained with Rosselli for over 25 years, until the latter's death in 1507. Out of affection for his teacher, he called himself Piero di Cosimo, rather than Piero di Lorenzo after his own father.

nose and long pointed ears and horns – a goat-legged faun or satyr. In antique mythology, these instinctual natural spirits frightened herds of cattle or pursued nymphs with their unbridled sexuality.

There is no mention of a faun in Ovid's tale of Procris. In Correggio's marriage play, on the other hand, one plays a malicious role: because he covets Procris himself, he tells her that her husband is deceiving her, and thereby brings about her undoing. Now he sees what he has done and bends over her dead body with an expression of tender concern.

Piero portrays this wild creature with an extraordinary degree of sensitivity. He thereby reveals how close he was to the natural, untamed world. His fellow Florentines had a considerably more distant relationship with nature; they saw the hills around their city simply as a pleasant setting in which to spend their free time, and the fields of farmland as no more than vegetable plots. Piero, on the other hand, "was content to see everything run wild, like his own nature", as Vasari relates with some disapproval. "He would never let his garden be dug or the fruit trees pruned", and "followed a way of life more like that of a brute beast than a human being."

Piero di Cosimo, living in sophisticated urban Renaissance society, was fascinated by an animal level of existence. He painted more animals than most of his colleagues and populated his paintings with primitive creatures such as fauns, satyrs, field gods and bacchantes – most notably in his *Vulcan* cycle, in which he celebrated the power of fire.

Fire as a force of nature is also at the heart of a *Prometheus* cycle attributed to Piero. Erwin Panofsky diagnoses Piero as having a "fire complex" – but the artist's obsession with flames can also be interpreted in another way.

In Renaissance Italy there existed a small number of men who, like Vulcan and Prometheus, were proud of being the masters of fire. Their most important tool, it served them in their secret pursuit: it was kept burning beneath their ovens round the clock for over 40 days, as they attempted to make the magical elixir with which to turn base metals into gold. These were the alchemists, still searching – as in the Middle Ages – for the philosopher's stone. One of them was Piero di Cosimo's teacher, Cosimo Rosselli. "This artist took great pleasure in alchemy," reported Vasari, and "vainly spent what he possessed to this end … and thereby became very poor in his old age".

Those who dedicated themselves to alchemy had to be "taciturn and discreet" and "live far from other people". This dictate from an old treatise on alchemy might go a long way towards explaining the "bestial" existence of a man who "stayed all the time shut up indoors and never let himself be seen at work" and

who "would not even allow his rooms to be swept". It is probable that Piero di Cosimo dabbled in alchemy, at least as assistant to his master. What is certain is that it influenced his artistic œuvre: not just his *Death of Procris*, but indeed the majority of his motifs can be explained in terms of the pictorial language of alchemy.

Most peculiar, for example, are the three dogs in the background. The black dog and the white dog were familiar to alchemists as the "bitch of Coracesium" and the "Armenian hound" respectively. They symbolized two contradictory chemical states, the solid and the volatile, which are permanently in opposition. The attempt to fuse them by means of fire represented an important step along the path towards creating the philosopher's stone. In another experiment, it was sought to sublimate dead, "decomposed" matter in a phial into a "White Swan", also visible in the background of this panel.

The hunting dog appears twice in the picture. He is both supervising the battle between the opposites on the riverbank, and mourning at the feet of the dead heroine in the foreground. This is not simply the dog Laelaps from Ovid's fable, however, or the traditional animal symbol for faithfulness. It is also Hermes Trismegistos, the "three times great" inventor and patron of the art of alchemy, who is portrayed in alchemical texts in the shape of a dog, or least as a dog's head. He is the fusion of a legendary magician with the Greek god Hermes, messenger of the gods and intermediary between this world and the next. He is a guide to the realm of the dead and a teacher of the "hermetic" secret sciences. Alchemical doctrine thus explains why he is granted, in his symbolic shape, such a large and dominant position in this panel.

The prostrate Procris is wrapped in a red and gold veil, both symbolic colours of the "red-hot" philosopher's stone which transforms everything into gold. Her position and the structure of the picture bear similarities with illustrations commonly found in the 15th century on the last page of alchemical treatises. In these, the corpse of a man or woman, Adam or Eve, pierced as *prima materia* by Hermes' spear, lies stretched out horizontally. Growing out of it is a small tree, the *arbor philosophica*. The death of matter is followed by resurrection, liberation of the spirit, spiritual transformation. Making gold was only the lowest stage of the refinement of the body; the true goals of the alchemist went much further. Alchemy was also the science of immortality. Although the small tree in Piero's painting doesn't grow directly out of Procris' corpse, it sprouts up just behind her, above her shoulder and heart. Seen through the eyes

of an alchemist, this painting signifies victory over death – under the watchful eyes of Hermes Trismegistos and with the aid of the forces of nature, embodied by the "wild man". Perhaps it hung in an alchemist's study.

In order to communicate their secret knowledge, initiates used symbolic images which they borrowed from established tradition or classical mythology. Carl Gustav Jung sought to establish that these have their roots in the depths of the collective unconscious and are hence familiar even to modern man from his dreams. This may explain the sense of "dreaminess", the "strange attraction" which issues

from Piero di Cosimo's works. He was master – and this, too, is a definition of alchemy – of the "science of pictures".

The patron of alchemists

Appendix

Upper Rhenish Master
The Little Garden of
Paradise, c. 1410
26.3 x 33.4 cm
Frankfurt, Städelsches
Kunstinstitut

Photo: Artothek, Peissenberg

Lit.: Hennebo, Dieter and Hofmann,
Alfred: Geschichte der deutschen
Gartenkunst, Gärten des Mittelalters,
Vol. 1, Hamburg 1962. – Vetter, Ewald
M.: Das Frankfurter Paradiesgärtlein,
in: Heidelberger Jahrbücher, 9, np
1965. – Wolfhardt, Elisabeth: Beiträge
zur Pflanzensymbolik, Über die
Pflanzen des Frankfurter "Paradies-
gärtlein", in: Zeitschrift für Kunst-
wissenschaft, Vol. VIII, Berlin 1954.

Limburg Brothers
(1385/90–1416)
Paul, Jean, Herman Limburg
February miniature from the
"Très Riches Heures du Duc
de Berry", c. 1416
15.4 x 13.6 cm
Chantilly, Musée Condé

Lit.: Les Très Riches Heures du Duc
de Berry, Introduction et Légendes de
Jean Lognon et Raymond Cazelles. –

Chantilly/Paris 1969. – Les Très...
Facsimile Edition, Luzern 1984. Com-
mentary: ed. Raymond Cazelles and
Johannes Rathofer. – Contamine,
Philippe: La vie quotidienne pendant
la guerre de cent ans. Paris 1967. – De-
fournraux, Marcelin: La vie quotidi-
enne au temps de Jeanne d'Arc. Paris
1957. – Epperlein, Siegfried: Der
Bauer im Bilde des Mittelalters.
Leipzig 1975.

Notes:
1 from the epic poem "Ysengrimus,
the sly fox", c. 1150; cited by Epper-
lein, p. 61
2 Defourneaux, p. 29
3 Defourneaux, pp. 22, 29
4 Contamine, pp. 167/168
5 Epperlein, p. 89

Jan van Eyck (1390–1441)
The Arnolfini Marriage, 1434
82 x 60 cm
London, National Gallery

Photo: AKG Berlin

Lit.: Calmette, Joseph Les Grands
Ducs de Bourgogne. Paris 1949. –
Davies, Martin The National Gallery
London, Les Primitifs Flamands.
Antwerpen 1954. – Dhanens, Elisa-
beth Van Eyck. Königstein 1980. –
Lejeune, Jean Documents memoires
commissions: Jean et Marguerite van
Eyck et le Roman des Arnolfini. Liège

1972. – Mirot, L./Lazzareschi, E. Un
mercante di Lucca in Fiandra, in: Bol-
lettino Storico Lucchese XII. 1940. –
Panofsky, Erwin Early netherlandish
painting. Cambridge/Mass. 1953. –
Roover, Raymond de The rise and de-
cline of the Medici Bank. Cambridge/
Mass. 1963. – Schabacker, Peter H. De
Matrimonio ad marganaticam con-
tracta. Jan van Eycks Arnolfini-Portrait
reconsidered, in: The Art Quarterly
Nr. 35. 1972. – Swaan, Wim Kunst und
Kultur der Spätgotik. Freiburg 1978

Notes:
1 Calmette, p. 341
2 Dhanens, p. 193
3 His name was Tomaso Portinari,
he came to Bruges in 1464. De
Roover, p. 340
4 Jean de Meung, cited by Lejeune,
p. 54
5 Dhanens, p. 195
6 Panofsky, p. 203

Paolo Uccello (1397–1475)
The Battle of San Romano,
c. 1435
182 x 319 cm
London, National Gallery

Photo: The National Gallery, London

Lit.: Burckhardt, Jacob Die Kultur der
Renaissance in Italien. Zurich 1956. –
Griffiths, Gordon The political signif-

icance of Uccello's Battle of San Romano, in: Journal of the Warburg and Courtauld Institute, Bd. 41. 1978. – Pope-Henessy, John Introduction to National Gallery, Book no. 4: The Rout of San Romano – Paolo Uccello, Paintings and Drawings. London 1969. – Trease, Geoffrey Die Condottieri, Söldnerführer, Glücksritter und Fürsten der Renaissance. Munich 1974.

Notes:

1 National Gallery Catalogues, Bd. *The earlier italien schools.* 1961, 2. Ed., pp. 525-532
2 Trease. p. 10
3 Marcel Brion *Die Medici*, p. 174. Wiesbaden 1970
4 Aeneas Sylvius, cited by Burckhardt, p. 13
5 Machiavelli, cited by Trease, p. 182
6 Machiavelli, cited by Pope-Henessy, p. 2
7 Griffiths, p. 313
8 Griffiths, p. 314
9 Griffiths, p. 315
10 Burckhardt, p. 10
11 Griffiths, p. 315
12 Pope-Henessy, p. 8
13 Trease, p. 136
14 Diaz de Gomez 1405, cited in: M. Defourneaux *La vie quotidienne au temps de Jeanne d'Arc*, p. 193. Paris 1957
15 Pope-Henessy, p. 8

Fra Angelico (c. 1400–1455)

(Guido di Pietro)
St Nicholas of Bari, 1437
34 x 60 cm
Rome, Pinacoteca Vaticana

Photo: Scala, Florence

Lit.: Groot, Adrian de: Saint Nicholas, a psychoanalytic study of his history and myth, The Hague/Paris 1965. – Jones, Charles N.: St Nicholas of Myra, Bari and Manhattan. Biography of a legend, Chicago 1978. – Le Goff, Jacques: Marchands et Banquiers du Moyen Age, Paris 1972. –

Pope-Henessy, John: Angelico, London 1952.

Jan van Eyck (1370–1441)

The Virgin of Chancellor Nicholas Rolin, c. 1437
66 x 62 cm
Paris, Musée du Louvre

Photo: Artothek, Peissenberg

Lit.: Adhémar, Hélène: Sur la vierge du chancelier Rolin, in: Bulletin Institut Royal du Patrimoine Artistique, XV, 1972, Brussels. – Boehm, Laetitia: Geschichte Burgunds. Stuttgart, 1972. – Calmette, Joseph: Les Grands Ducs de Bourgogne. Paris 1949/79. – Dhanens, Elisabeth: Hubert und Jan van Eyck. Königstein 1980. – Périer, Arsène: Un chancelier au XVe s., Nicolas Rolin. Paris 1904. – Roosen-Runge, Heinz: Die Rolin-Madonna des Jan van Eyck. Wiesbaden 1972.

Notes:

1 Roosen-Runge, p. 17
2 Roosen-Runge, pp. 17, 18
3 Hirschfeld, Peter: Mäzene. Munich 1968, pp. 103–108
4 Dhanens, p. 218
5 Dhanens, p. 39
6 Roosen-Runge, p. 29
7 Roosen-Runge, p. 18

Konrad Witz (1400/ 1410–1444/1446)

The Miraculous Draught of Fishes, 1444
132 x 154 cm
Geneva, Musée d'art et d'histoire

Photo: Musée d'art et d'histoire, City of Geneva, Bettina Jacots-Descombes

Lit.: Deuchler, Florens: Konrad Witz, la Savoie et l'Italie; Nouvelles hypothèses à propos du retable de Genève, in: Revue de l'Art, no. 76,

Paris 1986. – Feldges-Henning, Uta: Landschaft als topographisches Porträt, Bern 1980. – Schmidt, Georg: Konrad Witz, Königstein 1962. – Teasdale Smith, Molly: Conrad Witz's Miraculous Draught of Fishes and the Council of Basle, in: The Art Bulletin, New York 1970.

Petrus Christus (c. 1415–1473)

St. Elegius, 1449
98 x 85 cm
New York, The Metropolitan Museum of Art, Rober Lehmann Collection, 1975

Photo: The Metropolitan Museum of Art, New York

Lit.: Comeaux, Charles: La vie quotidienne en Bourgogne au temps des ducs Valois, Paris 1979. – Metropolitan Museum of Art: Petrus Christus, Renaissance Master of Bruges, New York, 1994. – Pirenne, Henri: Geschichte Belgiens, 2 vols. Gotha 1902. – Prevenier, Walter and Blockmanns, Wim: Die burgundischen Niederlande, Antwerp 1986. – Schabacker, Peter: Petrus Christus, Utrecht 1974.

Benozzo Gozzoli (1420–1497)

Procession of the Magi, 1459
Florence, fresco in the chapel of the Palazzo Medici-Riccardi

Photo: Scala, Florence

Lit.: Cleugh, James: The Medici, a tale of fifteen generations, New York, 1975. – Gombrich, Ernst: The early Medici as patrons of art, in: Norm and Form, London 1966. – Lucas-Dubreton, Jean: La vie quotidienne à Florence au temps des Médicis, Paris 1958. –

Roover, Raymond de: The rise and
decline of the Medici bank, Cam-
bridge, Mass. 1963.

Andrea Mantegna
(1431–1506)
Ludovico Gonzaga and His
Family, c. 1470
Mantua, Palazzo Ducale
Photo: AKG Berlin

Lit.: Atti del Convegno: "Mantova e
i Gonzaga nella civiltà del Rinasci-
mento". Mantua 1974. – Camesasca,
Ettore: Mantegna. Florence 1981. – Co-
letti, Luigi: La camera degli sposi del
Mantegna a Mantova. Milano 1969. –
Catalogue: "Splendors of the Gonza-
ga", Victoria & Albert Museum, Lon-
don 1981. – Mazzoldi, Leonardo: Man-
tova, La Storia. Vol II, Mantua 1961.
Notes:
1 Catalogue, pp. 27/28
2 Catalogue, pp. 15/16
3 Camesasca, pp. 36/37
4 Camesasca, p. 37
5 Mazzoldi, p. 20
6 Catalogue, pp. 21/22
7 Catalogue, p. 15
8 Schivenoglia, in Atti, p. 311
9 Atti, p. 321
10 Equicola, in Coletti, p. 43

Hugo van der Goes
(c. 1440–1482)
The Portinari Altar, c. 1475
600 x 250 cm
Florence, Galleria degli Uffizi
Photo: Scala, Florence

Lit.: Hatfield Strens, Bianca: L'arrivo
del Trittico Portinari a Firenze, in:
Commentari, Rivista di Storia e di
Critica d'Arte, Rome 1968 IV. – Koch,
Robert: Flower symbolism in the
Portinari Altar, in: The Art Bulletin,
New York 1964. – Roover, Raymond
de: The rise and decline of the Medici

bank, Cambridge, Mass. 1963. –
Panofsky, Erwin: Early Netherlandish
painting, Cambridge, Mass. 1953. –
Swaan, Wim: Kunst und Kultur der
Spätgotik, Freiburg 1978.

Hieronymous Bosch
(c. 1450–1516)
(Jerome van Aken)
The Conjurer, after 1475
53 x 65 cm
Saint-Germain-en-Laye,
Musée Municipal
Photo: Artothek, Peissenberg
Tarot card: The Conjurer
Private Collection

Lit.: Fraenger, Wilhelm: Hierony-
mous Bosch, Dresden 1974. – Gere-
mek, Bronislav: Truands et Mis-
érables dans l'Europe moderne
(1350–1600), Paris 1980. – Brand,
Philip L.: The Peddlar by Hierony-
mous Bosch, a study in detection, in:
Niederlands Kunsthistorisch Jaar-
boek, Bussum 1958. – Schuder, Rose-
marie: Hieronymous Bosch, Wies-
baden nd (c. 1975). – Tolnay, Charles:
Hieronymous Bosch, Baden-Baden
1973.

Master of the
Transfiguration of the
Virgin
The Virgin and Child with St
Anne, c. 1480
131 x 146 cm
Cologne, Wallraf-Richartz
Museum
Photo: Rheinisches Bildarchiv,
Cologne

Lit.: Borger, Hugo; Zehnder, Frank
Günter: Köln, Die Stadt als Kunst-
werk, Stadtansichten vom 15. bis

20. Jahrhundert, Cologne 1982. – De-
hio, Georg: Handbuch der deutschen
Kunstdenkmäler, Rheinland, without
place of publication 1967. – Ennen,
Leonhard: Geschichte der Stadt Köln,
sources mostly from the city archives
of Cologne, Cologne and Neuss 1863.

Sandro Botticelli (1445–1510)
(Allessandro die Mariano
Filipepi)
Primavera – Spring, c. 1482
203 x 314 cm
Florence, Galleria degli Uffizi
Photo: Artothek, Peissenberg

Lit.: Cleugh, James: The Medici, New
York 1975, Munich 1977. – Dubreton,
Jean Lucas: La vie quotidienne à Flo-
rence au temps des Médicis, Paris
1958. – Levi d'Ancona, Mirella: Botti-
celli, Primavera, a botanical interpre-
tation including astrology, alchemy
and the Medici, Florence 1983. –
Lightbow, Ronald: Sandro Botticelli,
Life and work, 2 Bde., London 1978. –
Warburg, Aby: Sandro Botticelli,
Geburt der Venus und Frühling,
Hamburg, Leipzig 1883.

Hieronymus Bosch
(c. 1450–1516)
The Haywain, between 1485
and 1490
135 x 100 cm
Madrid, Museo del Prado
Photo: Museo del Prado, Madrid

Lit.: Dinzelbacher, Peter: Die Realität
des Teufels im Mittelalter, in: Peter
Segl, (ed.): Der Hexenhammer, Ent-
stehung und Umfeld des Malleus
maleficarum von 1487, Cologne/Vien-
na 1988. – Gibson, Walter S.: Hierony-
mus Bosch, Frankfurt/Berlin/Vienna
1974. – Hammer-Tugendhat, Daniela:
Hieronymus Bosch, eine historische

Interpretation seiner Gestaltungsprinzipien, Munich 1981. – Schuder, Rosemarie: Hieronymus Bosch, Wiesbaden undated. – Tolnay, Charles de: Hieronymus Bosch, Baden-Baden 1973.

Sandro Botticelli (1444–1510)

(Alessandro di Mariano Filipepi)
The Birth of Venus, c. 1486
184 x 285.5 cm
Florence, Galleria degli Uffizi
Photo: Artothek, Peissenberg
Virgin with Child, Four Angels and Six Saints (Detail), c. 1487
Florence, Galleria degli Uffizi
Photo: Raffaelo Bencini

Lit.: Burke, Peter: Culture and society in Renaissance Italy. London 1974. – Clark, Kenneth: The Nude, a study in ideal form. A.W. Mellon Lectures, np 1953. – Levi d'Ancona, Mirella: Botticelli's Primavera. A botanical interpretation including Astrology, Alchemy and the Medici. Florence 1983. – Lightbrown., Ronald: Sandro Botticelli, 2 vols. London 1978. – Uffizi, Studi e Ricerche 4: La Nascita di Venere e l'Annunziazione del Botticelli ristaurate. Florence 1987. – Warburg, Aby: Sandro Botticellis "Geburt der Venus" und "Frühling". Eine Untersuchung über die Vorstellung von der Antike in der Frührenaissance. Leipzig 1893.
Notes:
1 Vasari, Giorgio, cited in German in Warburg, p. 1
2 Ghiberti, Lorenzo: Denkwürdigkeiten. trans. J. Schlosser, Berlin 1927, Commentarii III, pp. 86, 89, 138, 139
3 Homeric Hymns, cited in German by Warburg, p. 3

4 Lightbow, p. 58
5 -Leon Battista Alberti: Treatise on painting, cited in Uffizi, p. 28
6 Warburg, pp. 1, 5, 6

Vittore Carpaccio (c. 1460–1525/26)

Miracle of the Relic of the Cross, 1494/95
365 x 389 cm
Venice, Galleria dell'Accademia
Photo: AKG Berlin

Lit.: Cancogni, Manlio/Perocco, Guido: L'opera completa del Carpaccio. Milan 1967. – Kretschmayr, Heinrich: Geschichte von Venedig. 3 Vols., Darmstadt 1964 – Lauts, Jan: Carpaccio, Gemälde und Zeichnungen, Complete catalogue. Cologne 1962. – Ludwig, Gustav/Molmenti, Pompeo: Vittore Carpaccio, La vie et l'œuvre du peintre. Paris 1910.
Notes:
1 Ludwig/Molmenti, p. 257
2 both cited by Kretschmayr, pp. 362, 360

Piero di Cosimo (1462–1521)

The Death of Procris, c. 1500
65 x 183 cm
London, The National Gallery
Photo: The National Gallery, London

Lit.: Hartlaub, G. F.: Der Stein der Weisen, Munich 1959. – Hutin, Serge: La vie quotidienne des Alchimistes au Moyen-Age, Paris 1977. – Lavin, Irving: Cephalus and Procris in: Journal of the Warburg and Courtauld Institute, no. 17, London 1954. – Panofsky, Erwin: Studies in Iconology, New York 1939/62. – Vasari, Giorgio: Lives of the artists, translated by George Bull, London 1965.

"Buy them all and add some pleasure to your life."